LIGHTS OF MANKIND

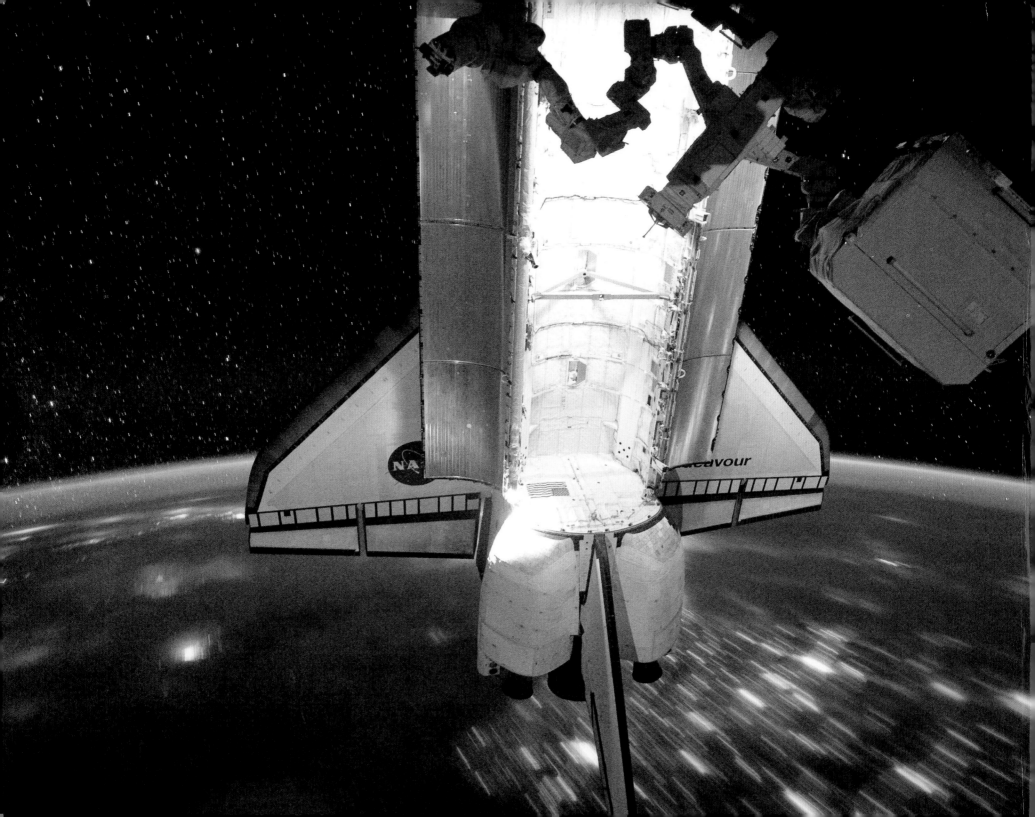

LIGHTS OF MANKIND

The Earth at Night as Seen from Space

L. DOUGLAS KEENEY

Lyons Press
Guilford, Connecticut
An imprint of Globe Pequot Press

Lyons Press is an imprint of Globe Pequot Press.

Text design and layout: Maggie Peterson
Project manager: Kristen Mellitt

Library of Congress Cataloging-in-Publication Data is available on file.

CONTENTS

More than one million astronaut photographs of Earth reside on the NASA servers at Johnson Space Center in Houston, Texas. There are daylight photographs, night photographs, and photographs of places in between (the terminator for one) but no more than 30 percent of them are cataloged by anything more descriptive than a roll number and a frame. The difficult job of identification is largely up to the researcher.

In perhaps the smartest decision I made in the course of writing this book, I enlisted the help of Peter Challupner of Graz, Austria. Peter is a translator by profession but a passionate student of the space program by avocation. Peter takes photo identification seriously. He has the software to determine what part of the planet the space station is over at any moment in its orbit. Add a pinch of experience and a seasoned eye and you have a name and a place almost 100 percent of the time. Peter was director of photo identification for *Lights of Mankind,* and his research was meticulous. For six months we tweeted our thoughts back and forth, sometimes disagreeing on an identification, sometimes making our case that this was "X" and not "Y." Peter is well known among the astronaut corps by his Twitter screen name @pc0101. If you see him pop up, say hello.

Some notes. A series of the pictures in this book involved massive computing resources and some dedicated scientists. I speak of Earth at Night NASA compositions. Satellites in geosynchronous orbits fly some 22,000 miles above Earth (versus 220 miles for the space station). These satellites are generally military satellites, and while they photograph the entire planet in excellent detail, for security reasons the pictures they release to us are no finer than a point of light. Nonetheless, the visual artists at Goddard Space Flight Center layered these points of light over an artificial globe in geographically correct orientations and with accurate magnitudes of relative urbanization.

Because night images of Earth are new to us all, you'll undoubtedly have some trouble comprehending scale just as we did. While we call these areas "cities," many are actually metro regions spread across several hundred square miles. It wasn't possible to include every city not only for editorial reasons but for practical ones, too. Night photography depends on good weather and an astronaut's work schedule, and the two don't necessarily coincide. Moreover, the space station's orbital path doesn't take it over the entire planet. That said, we were fortunate. We were able to include almost all of the major cities of the world, and, with the understandable exception of Antarctica, we left no continent dark.

This is the first book to document the only planet in the universe that transforms itself into a ball of light at night, and as it progressed we felt a sense of obligation to make it as complete and as definitive as possible. In an act most authors will recognize as being truly remarkable, Mary Norris, my editor, pleaded with her publisher to have the page count increased. My thanks go to Mary and Kristen Mellitt, of Globe Pequot Press. I also wish to thank Adam Shear of DeFiore & Company who had this project thrown at him midstream yet deftly sorted everything out.

A trip into space is one of the rarest of human experiences and will become even more so as the total number of astronauts that goes up drops to a mere six a year. Therefore, we thought it was important to let the astronauts tell us what they saw and felt as they viewed Earth at night. This was a departure from the technical jargon that has mired so many astronaut profiles in dense, unapproachable text. Our question was pretty simple: What was it like? The disarmingly honest answers that you will read on the following pages will put you on the space station just as surely as if you were an astronaut yourself. I thank astronauts Clay Anderson, Sandy Magnus, Don Pettit, Mario Runco, and Doug Wheelock for their time and their insights.

The happy circumstance of finishing a book is occasioned by the opportunity to thank those who helped along the way. NASA's James A. Hartsfield and Gayle Frere in the public affairs department at Johnson Space Center arranged my interviews and helped me with the nuances of NASA. Susan Runco explained to me the Earth observation function at NASA and consented to an interview that was filled with fascinating facts. (Did you know that night photography was so fraught with failure that until now NASA wouldn't even ask that it be attempted lest it demoralize the astronauts?) Thank you, Sue Runco.

Three more people played particularly important roles. My son, Alex Keeney, learned his history well at the University of Pennsylvania and gave me advice that kept me away from using generalizations to describe the habitation of one area or the absence of habitation in another. No good, he said; the habitation of Earth was the result of thousands upon thousands of unique events, most entirely unrelated to one another. Of course, my other son, Doug Jr., has a sharp eye for the unusual, and his comments not insignificantly influenced my finalists. Thank you, Alex and Doug.

Nothing about this book would be complete without acknowledging the better writer in the family, my wife, Jill Johnson Keeney. Jill shaped the narrative thread and read and reread drafts until I finally received her approval. Many thanks, and to you I dedicate this book.

A view looking south toward the Mediterranean: Lyon, France, foreground; Torino, Italy, middle left; Marseille, France, on the coast. The reflection of moonlight off the sea is called moonglint. Just above and to the left of the moonglint is Corsica. A small bank of clouds and snowcapped mountains are in the middle.

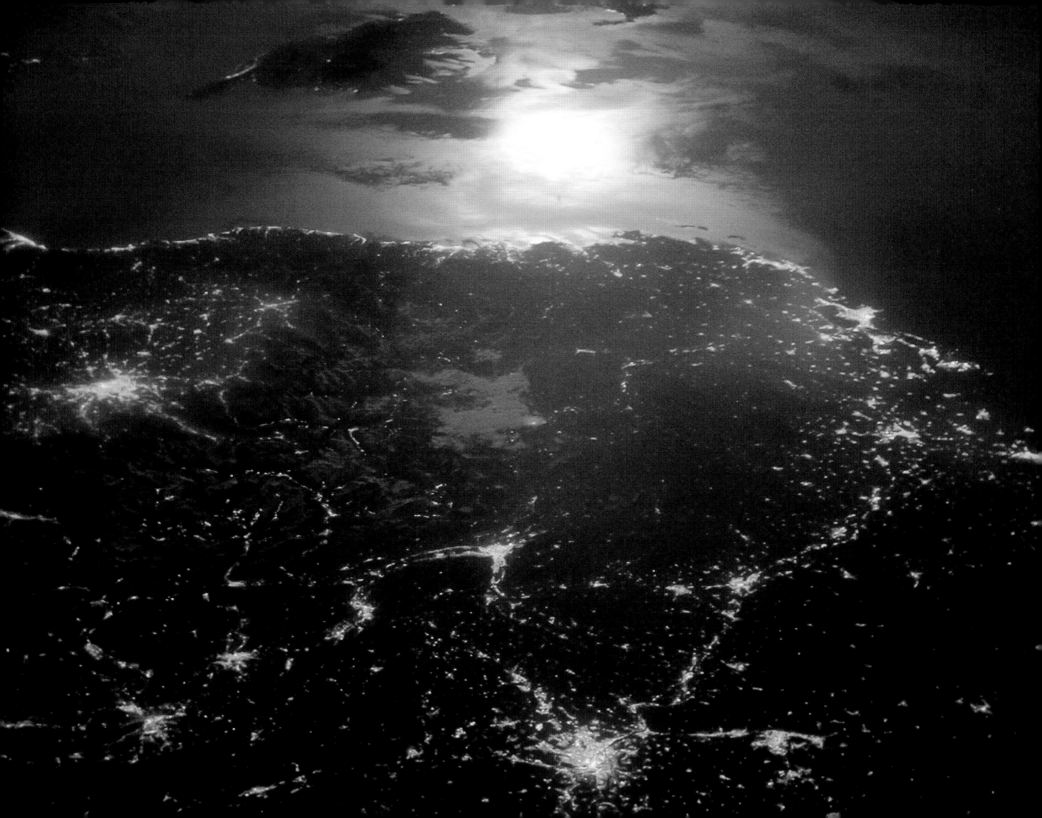

Of all the planets in the solar system, Earth is the only one that turns into a glittering ball of light at night. Seventeen billion megawatt hours of electricity a year broadcast our presence for all the universe to see. We radiate energy and sparkle brilliantly, the electric planet.

For more than forty years we have been fascinated by the daytime photographs of Earth as taken by astronauts in space. We have marveled at the colors and contrasts and the unusual features of our magnificent planet, a study in terrain and geography and oceans, a study of the beauty of our natural world. But alas it has always been a study devoid of our human footprint. By day, evidence of human habitation presents itself as scarcely more than a smudge of gray. Not so at night. At night there is life. At night our cities glow in patterns of light that speak volumes about how we inhabit this planet. And yet, through these many years of manned space flight, photography of Earth at night has been nearly impossible. Some 522 astronauts have seen for themselves what Earth looks like at night, but their attempts to photograph it for us were consistently frustrated by the incredible speeds at which their space vehicles traveled and the blurring that resulted when the shutter of a camera opened for even the slimmest fraction of a second.

All that changed in 2003, when astronaut Don Pettit built a camera tracker that largely compensated for the seventeen-thousand-mile-per-hour flight of the space station. During his several months in space, Pettit experimented with his tracker and photographed one city after another with excellent results. Because of his ingenuity, we finally had our first clear images of our cities at night.

Better cameras came next. New chip technologies steadily reduced the length of exposure required to make a photo until chips were so incredibly sensitive that tracking could be done by hand. Then

in 2010, the observation blister called the Cupola was installed on the space station, affording the astronauts a 360-degree view of the planet, complete with crystal-clear, high-technology glass. The results were spectacular. The astronauts photographed our nighttime planet in obliques—photos taken at an angle—and in panoramics and pointed their cameras in any number of directions. In 2010 we were finally able to see Earth at night the way the astronauts see it.

And what a place it is.

Mumbai weaves around islands and bays, as do Rio de Janeiro and San Francisco. The Emirates in the Middle East blend colors that create fanciful images we can only see at night. And then there is the darkness. How would we draw the continents if we were guided by what we see at night? At night, there is almost nothing in the interior of Africa between Cape Town and Tunis, and nothing in Australia between Perth and Darwin. And nothing surrounds them save the dark voids of the oceans.

Colors and lights create new patterns at night, and the photography demands our close inspection. How would we decipher the serpentine curves that trace the contours of Japan or the mosaic of golden threads that form the tapestry of Italy, unless we knew we were looking at Japan or Italy? How do we explain the difference between the efficient, gridlike patterns of the American Midwest and the untamed clumps of light that define the Low Countries of Europe? Such are the mysteries brought out by the photographs of our planet at night.

LIGHTS TELL A STORY

Scientists tell us that we humans have been the only global species on the planet for some thirty thousand years and yet we have selectively populated our planet. What makes us like this and not that, and live here and not there?

Lights tell us that story.

One hundred and sixty thousand years ago, *Homo sapien* (wise man) began his long migration out of Africa across the Mediterranean, into Europe and Asia, and over the land bridge of the last Ice Age down into North America through Central America all the way to the tip of South America, completing the colonizing of the six habitable continents some thirteen thousand years ago.

By 10,000 BC, ten million humans lived on planet Earth, and by 9000 BC, man began to settle down. He cultivated crops and domesticated the first animals and on the banks of the Mediterranean, he formed groups, organized and divided labor, and created societies that would blossom into civilizations. The great river Nile and the lands between the Tigris and Euphrates were the bookends to what would be known as the Fertile Crescent, an arc of soil brimming with nutrients from which fields of wheat and barley burst forth and on which herds of goats and sheep grazed. Emerging across the planet at the latitudes with climates similar to the Mediterranean were even more societies—hunter-gatherers coming together to cultivate crops in China, India, Central America, and eventually America. Villages were enclosed by walls, urban patterns of streets and ring roads were created, temples were built and gods celebrated, populations of ten thousand, twenty thousand and thirty thousand then dotted the planet, all on waterways or tributaries, almost all with neighboring farmers under some centralized control.

By 1500 BC, civilizations had armies and leaders, and leaders were becoming conquerors. By 200 BC, armies were powered by horses, and weapons were made from flint, bronze, copper, and steel. Empires, kingdoms, dynasties, shogunates, sultanates, and city-states would come and go and leave their marks through the birth of Christ and the next thousand years—the Sumerians, Hittites, Assyrians, Babylonians, Minoans, Persians, Romans, and Greeks;

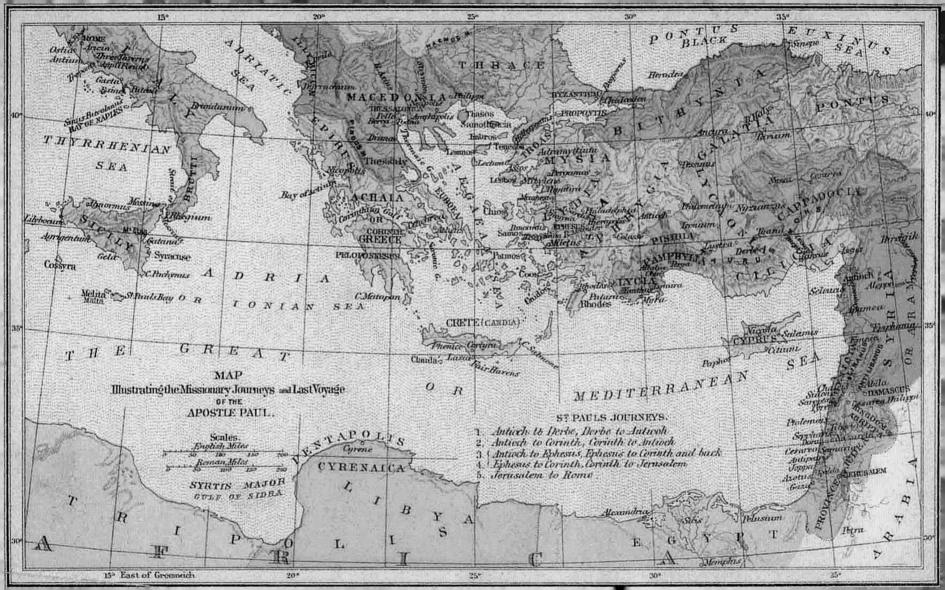

MAP
Illustrating the Missionary Journeys and Last Voyage
OF THE
APOSTLE PAUL.

Scales.
English Miles
Roman Miles

ST PAULS JOURNEYS.
1. Antioch to Derbe, Derbe to Antioch
2. Antioch to Corinth, Corinth to Antioch
3. Antioch to Ephesus, Ephesus to Corinth and back
4. Ephesus to Corinth, Corinth to Jerusalem
5. Jerusalem to Rome

Ming, Chosun, Incan, Mayan, Ottomans—rising to power, then fading away as man restlessly sought order, dominion, riches, or peace.

As civilizations took hold, trade grew in importance. Footpaths became trails, and trails roads, and new cities took root on the roads. Surplus raw materials moved from one continent to another; goods were traded for goods. Merchants, bankers, books, accounting, and the tools of capitalism—containers, units of measure, storage, warehouses, distribution networks, and finally legal systems and laws—came into being. Silk, pepper, sugarcane, fur, animals, foods, glass, porcelain, copper, iron, incense, cloth, carpets, ivory, gold, silver, and slaves moved along land and sea routes that connected the known world from one end to the other.

At sea, the Spice Routes connected the trading centers of Egypt, Turkey, Syria, and Iraq to the coastal countries of the Far East—Pakistan, India, Malaysia, Vietnam, China, Korea, and Japan. The sea routes were sailed as early as 2000 BC and were well traveled by 200 BC, when the Silk Road emerged as an alternate overland passage to the East. The Silk Road was a lengthy, difficult path that crossed the continents of Europe and Asia. No single caravan traversed the entire route from one end to the other; rather, goods were exchanged in a sort of tribal relay system of buyers and sellers that often resulted in a dozen markups or more before things reached their final destination. The bazaars, caravansaries, and trading ports on these trading routes became villages, and then cities. Some are now among the vibrant string of lights that are so visible from space. Some have faded back into nothingness.

Regional trading networks developed behind the international routes. Go up any river and at some point you'll find the right combination of sturdy ground, rich farmland, and transit routes that radiated outward. The Romans settled a trading post up the Thames River called London and another off the Left Bank of the Seine called Paris; Budapest took hold on the Danube, Salzburg on the Salzach. Up and down the rivers of Eurasia—the Rhine, Seine, Danube, Rhône, Yangtze, Yellow, Ganges, and Pearl Rivers among them—cities took hold where lights would someday glow. By AD 1400, there were some one thousand cities with populations of twenty-five hundred or more.

The exchange of goods and the transfer and accumulation of wealth allowed the organization and administration of cities by means of governments funded by taxes on profits. This in turn allowed even more division of labor into specialties—administrators, tax collectors, and soldiers; glass blowers, potters, weavers, bankers, warehouse owners, metalsmiths, musicians, seamstresses, and more. Empires grew in size as the equation of wealth began to include the control of landmasses and the resources found there.

But there were problems. Bad weather dogged the lengthy trading routes. The endless chain of middlemen added exorbitant markups, which gave rise to the hunt for new trading routes. Surely there had to be another route to the Far East.

Exploration became the new mantra. State-funded voyages were mounted to the west, into the uncharted Atlantic Ocean in hopes of finding a new way to India. Ships set out from ports in Portugal, Spain, England, The Netherlands, and Sweden, among other countries. At the helm were captains brimming with confidence that they would be the ones to find the route. Alas, what explorers found was the New World. The great leap across the Atlantic Ocean set in motion a colonization of peoples and lands unprecedented in world history. Literally tens of millions would flow into the New World. Some of the great cities seen today would emerge from the most tenuous of beginnings. From the original one hundred colonists, the United States would blossom into a country of more than three hundred million, an explosion of growth that would see the most powerful nation in the world emerge in a mere five hundred years.

The colonists came not to merely survive, but to better themselves. Many were driven by religious persecution back in Europe and set out to America to practice their faith freely. The Pilgrims arrived on the *Mayflower* and started Plymouth; the Puritans colonized Boston, the Catholics came to Maryland, the Quakers arrived in Pennsylvania; the Protestant Huguenots settled in the Carolinas; and the Mormons veered off the Oregon Trail to build Salt Lake City.

But the lure of profit was even more powerful. The Dutch settled Albany, New York, as a trading post and purchased Manhattan from the Indians to settle New Amsterdam for yet another trading post; the Swedes came to Delaware to do the same. Britain developed their colonies with land grants and promises of fresh starts and unlimited possibilities in a world free of the old pecking order. New emigrants were propelled across the Atlantic in pursuit of work and opportunity.

Sheltered harbors made good ports, and port cities sent back ships filled with tobacco, coffee, sugarcane, corn, furs, and other raw materials. In general, ports connected to navigable rivers into the interior grew faster than port cities that did not. The transport of goods on overland routes was decidedly tedious and took far longer than, say, an extra day's sail up the Delaware to deliver goods to Philadelphia or up the Chesapeake to reach Baltimore. Coastal populations thrived from Boston to Savannah, and new lights were ready to glow.

Colonization was, of course, not limited to North America. The Dutch colonized Indonesia and South Africa. The British had more than a quarter of the world's landmasses under their flag by the early 1900s. The Spaniards colonized South America, Central America, and parts of the United States. Colonies generated trade and profits, which flowed back to Europe. From the 1600s onward, the Age of Discovery would also be the age of prosperity, and by the 1800s most of today's world was settled and well on its way to the next step—industrialization. During the Industrial Revolution, large-scale manufacturing began. New cities sprouted like daisies the world over.

And yet, at night, the planet was dark. At night whale oil powered the dim streetlights. At night, like all of the other planets in the universe, Earth simply disappeared into the blackness of space.

THE LIGHTS

Although Earth was dark at night, there was a drumbeat to be heard—a drumbeat of innovation coming from the labs of inventors in England, France, Hungary, Germany, Austria, and, in particular, the labs of Thomas Edison, George Westinghouse, and Nikola Tesla. In 1878 Edison filed his patent application for a lightbulb and Westinghouse built his first electrical power generator. Lights winked on in Europe and America and Asia—and even in remote Alaska. By 1881 electricity illuminated the first residential house, the first commercial business, the first public building, the first commercial ship, and the city of Wabash, Indiana, which became the first "Electrically Lighted City in the World," or so it proclaimed. Westinghouse and Tesla developed an electrical solution that would become the backbone of today's power grids and distribution systems, and by the turn of the century Westinghouse's first generation plant used the energy of Niagara Falls to light up the city of Buffalo, New York, some twenty miles away. Streetcars, phonographs, radios, telephones—all powered by electricity—worked their way into the landscape of mankind. Today Earth hosts a population of 6.9 billion, and we consume 17.1 billion megawatt hours of electricity a year; the United States accounts for almost one-quarter of that total.

So why do we see light where we see it today? There are three common threads in the narrative of man's habitation of Earth. The first is water. The lifeblood of civilization and the growth of great cities have in some way been connected to water. The cities of the ancient world grew to prominence along major bodies of water; the cities of the modern world are connected by water. London, Paris, Zurich, and Rome. Cairo, Istanbul, Dubai, and Mumbai. Beijing, Singapore, and Sydney. Water is the common resource. There are exceptions, no doubt, but in that sacred evolution from hunter-gatherer to complex societies, rivers, lakes, or oceans are ever present. We live on water; we live by water.

Trade is the second common thread in the narrative of habitation. A good port city had a sheltered harbor; a great port city had an abundance of natural resources in the interior lands behind it. The more goods that came through a port, the more profits a city could tax and then spend on its own infrastructure. That meant money to invest in piers, harbor improvements, roads, culture. Carthage–Tunis had a port and started out strong but fell behind because it had only desert behind it.

The third common thread was a strong military. To prosper, a nation needed to protect itself and its colonies from foreign invaders and defend its overseas claims. Moreover, as nations extended their reach into new parts of the world they needed foreign ports to refuel their ships and foreign trading partners to acquire materials essential to mobility. Britain would build a trading post on land that would become Singapore, but the need for a naval base in that part of the Pacific was the catalyst that made Singapore into the great city it is today. Strong militaries also sheltered nations, allowing them to grow despite instabilities in the world around them.

From these influences rose our cities, but the precise shape of their lights, as astronaut Pettit put it, is an entirely local story based on society, technology, and geography—a volcano in the middle of Naples; an inviting climate that attracted millions of retirees to Florida; networks of canals and then railroads and then interstates that gave lifeblood to so many of the American cities where we see light today.

Some comments about the photography and the information in this book: It is very difficult to get a sense of scale at night. Unless we know a city, the night lights tempt us to jump to conclusions that may or may not be true. Mexico City looks scarcely different from Budapest, yet Mexico City's metropolitan population is twenty-one million versus Budapest's 3.2 million. Mumbai seems small, but the angle deceives. It is a city of twenty-one million. Be cautious, too, with dim lights. At night, Tunis appears to be a sleepy outpost on the edge of the Mediterranean, when by day it's a town bristling with commerce, luxury hotels, a magnificent port, and promenades offering the goods of the world.

Cities change shape, too. The marshes around Charleston, South Carolina, blend in with the surrounding waterways to create slices of emptiness that make the creeks, rivers, and the harbor appear larger than they actually are. The odd arrangement of farmland near Pisa, Italy, gives the appearance of a harbor at night. The mix of river washes and rocky basins creates a dark wedge that cuts into Rome; the slope of a plateau creates a puzzling image of São Paulo, Brazil, and a dark spot in Athens not seen by day.

Because the space station has a defined orbit, parts of the world are particularly hard to photograph at night. The space station never flies directly over Moscow, we are told, but the astronauts can see it in the distance and can photograph it obliquely with a long lens. Weather often interferes with an astronaut's photographic ambitions, as do work schedules. It takes the right day with the right weather and the right lens to make an image at night.

Airports are helpful identifiers and do provide some scale. At night you find airports not by the outline of their runways (runways are dark at night to prevent light from blinding pilots), but by the lights of the terminals. The circular terminals of Dallas–Fort Worth are brilliantly lit curves of orange easily seen at night, as are the rectangular terminals that mark the airports of Hong Kong, Beijing, Bahrain, and many others. Note that the Riyadh military air base in the center of the city looks like a black rooster amid a sea of lights.

Some areas are simply confusing when seen at night—the Strait of Gibraltar lacks definition, for example, and most of Africa, central South America, and central Australia simply disappear

The compositions of some of these photographs provide us with perspectives that we can't possibly see in the day. We have never seen the Washington, D.C.-Baltimore corridor the way we see it at night, nor have we ever seen such broad stretches of the Midwest, Southwest, or the Korean Peninsula, or Italy or the Holy Lands. Astronaut compositions allow us to see our planet in panoramic landscapes more than nine hundred miles across, all in sharp focus.

Because all of this is new to our human experience, what better way to celebrate this milestone collection of photography than to pick the seven most interesting displays of nighttime lights in the world? Watch for the Seven Wonders of the Nighttime World at the end of the book.

A final note: In many of the captions, we include a city's population. When we do so, we are using the metro area (usually verified by two sources) and not the smaller city-limits population. This tends to inflate population numbers but better reflects the large areas that are visible at night. In a like manner, the dates we use are usually a consensus, but there is much debate about such things as when the Roman Empire began, what event actually triggered the growth of Chicago, and when Moses led the Israelites across the Sinai Peninsula. Odd topics for a book like this, you might say, but read on: These are precisely the little known or long forgotten stories behind the *Lights of Mankind*.

—L. Douglas Keeney

TOP: Los Angeles and San Francisco are seen through the windows of the Cupola.

BOTTOM: Las Vegas is the brightest spot on planet Earth, but it is neither the result of early exploration, the migration west, nor geology—rather it was started to commercialize gambling as an industry. The dark boomerang-shape in the center of Las Vegas is the city's international airport.

GEOLOCATOR EARTH AT NIGHT

T he lights of mankind are spread across the globe in patterns that reflect not just populations but also population densities. A city of one million may appear faint if the population is spread out. If the population is highly urbanized, it will appear much brighter. The densely populated regions of Earth stand out in sharp contrast to the largely uninhabited interiors of continents such as Africa, Australia, and South America. Throughout this book we use Earth at Night images that were made by compositing data provided to NASA by the Defense Meteorological Satellite Program. The maps were made at NASA's Goddard Space Flight Center. They use false colors to provide contrasts and outlines to areas such as oceans and ice packs. (In true color photography, the black of an uninhabited area is indistinguishable from the black of the oceans.) The globes to the right are curved versions of these same maps.

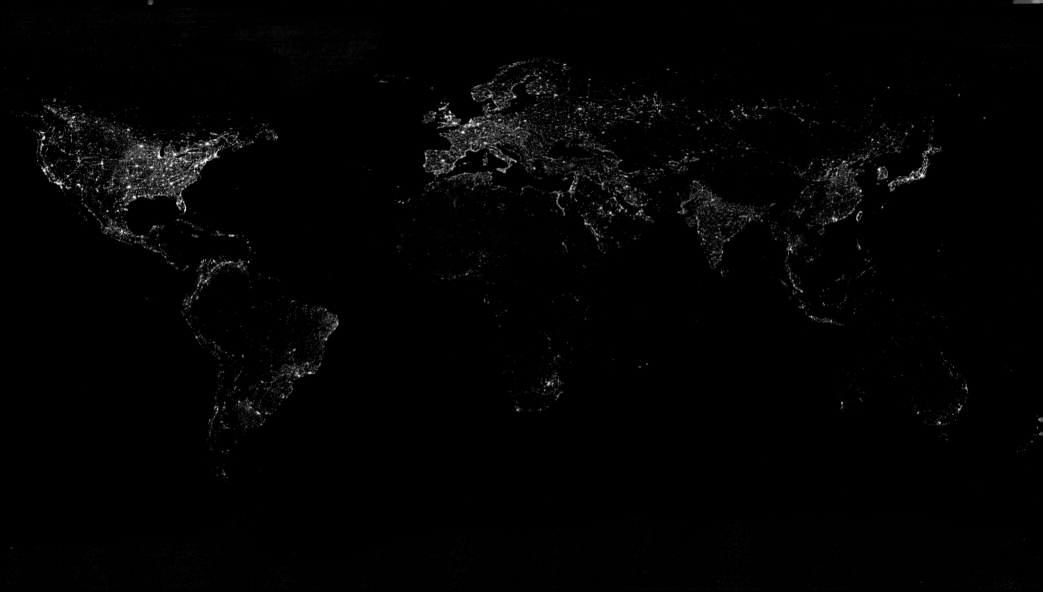

What We See:

"Earth presents itself as this raging explosion of light in a black, empty sea."

It is really hard to capture in words what we're seeing. When I went to space, looking out the windows, there were so many emotions that ran through me. Earth presents itself as this raging explosion of light in a black, empty sea. It's a ball of motion; it's new every time you look at it. The Earth is so present, so distracting.

During the day you go by a window and you look at the colors, and it sort of captures you. I remember during my space walks I was so hypnotized by Earth and I was like, please Lord let the sun go down so I can focus on my mission. And then the sun went down, and it's at night that you really, really realize what a raging place this is. You have the auroras and lightning and city lights and coastlines and—wow—it's even more dramatic. In the daytime, in the light of the sun, it's this explosion of color, and at night, it's an explosion of light. It's almost like a heart beating with the auroras moving and fingers of lightning shooting out hundreds of miles and puffs of lightning underneath the clouds—it's just breathtaking. Against the backdrop of deep space there is this energy everywhere. You can't get away from it.

I wanted to try to capture that, to photograph Earth and show people the way our human eye sees it. I wanted people to see what I was seeing, to feel what I was feeling. I wanted to pass along the sense of floating around this planet, and I think you can see that in my images because lots of my photos have the curvature of Earth in them. I gravitated toward oblique views, because that's how the naked eye sees Earth. Then I tried to express in words what those photos meant to me. I'm sort of a closet poet and I'm a person of faith as well, but I'm more of an engineer and a test pilot by trade. I actually wasn't going to do the

Twitter stuff because it's done on your own free time versus time that's budgeted and, going into space, I thought that I was probably going to be overwhelmed. Because this was my shot at being commander, I thought doing this Twitter thing might be biting off a little more than I could chew.

When I was over in Russia for a final trip, NASA asked me to take another look at this, because the tweets were really reaching people. They were shocked by the reaction we were having—we were suddenly reaching people whose lives are lived in sound bites, whose lives are so quick, so busy, that 140 characters are almost too many to read.

So I started talking to some friends of mine unconnected to NASA and asked them to pick a picture on our website that appealed to them. They found it difficult to find anything; things

this mission, if I did this, I wanted to find a way to reach as many people as I could and make this whole thing real to them. To take this incredible imagery and mix it with some thought-provoking dialogue and get it in front of the eyes of average people and let them start thinking with me. I wanted them to feel like they were on that spaceship with me.

So I started tweeting before I even left the ground, and I saw this following start to build. I made a pact with myself: I would not send a tweet unless I had a photo with it. I tried to avoid the clichés—you don't see political borders from space. So when I got this great picture of the Eastern Mediterranean from Cairo to Athens, you could see all the cities of Israel, Jordan, Syria, and up into Turkey. I thought, what am I going to say? Three of the major religions on this planet were right here in one view. I wanted to be careful, so the thought I tweeted was how peaceful this special place looked from space. Then I let people decide what those words mean to them, let them chime in with their own thoughts about peace.

The lights at night are absolutely breathtaking. I tried to do some cities at night next and I got a couple of good ones, like the one of Cairo and the Nile River I ran and got the others to see it. The Sahara desert is so dark and black, and the Nile is this snake of light that goes hundreds of miles down into the continent. You can see where the river bends and can see the Valley of the Kings, it's just breathtaking. I tweeted that image, too.

The nighttime photography—we're just getting these new Nikon cameras that allow us to capture these night images. Those cameras are so sensitive that you catch a lot of glare coming from a different module, so we basically had to black out the space station. In the Cupola I put a black T-shirt around the window and put the camera through the neck hole to keep any kind of glare from coming in there. It was my own little darkroom.

The footprint of mankind? At night you can very clearly see where man is, by the terrain, his technology, the access to waters, undeveloped areas, areas of major commerce—it's all mapped out for you, like a mosaic. At night, you can look at a patch of light and say that's this place or that place because you can see a coastline or dark spots or a huge, ominous mountain range or it's dimly lit because it's an undeveloped area.

The Korean Peninsula is an amazing example—Scott Kelly and I were trying to get that image for the longest time. Coming over that peninsula we usually had a lot of cloud cover. But when it opened up, wow. Seoul is this bright, shining, glimmering city and you can literally see the DMZ in lights, and then you look into North Korea and it's as dark as an ocean with this dim light that's Pyongyang. Knowing about the oppression of the North Korean people, you think to yourself, here it is, in mosaic form, a map of the contrasts in our humanity.

What did I feel sweeping across America? It made me feel like we could probably turn some lights off at night. Everything seems very neat and very clean over America. You can really see how technology reaches every corner of our country. Even over the Rockies and the Appalachians, you can see dots of light. In the Cupola I remember seeing Seattle out one side and looking down and seeing Memphis coming up and Florida's not far behind because you're moving pretty quickly. I tweeted an image of the Florida Peninsula (it's actually one of my favorites). You can see all the way out to the Keys and you can see the moonlight on the Atlantic. The lights outline the coast, they're so clear.

Looking out the windows you get a sense of how vast the Pacific is and how narrow the Atlantic is. You can almost see the lights of Europe as you cross over the Bahamas—you only have to wait a few seconds.

When you fall off into the darkness over the Pacific, or coming over Africa or parts of South

America, it's breathtaking. You really get a sense of population centers and where we live as people and where we really don't.

You can actually see the motion of the auroras. When I first saw that, I couldn't even hold the camera up to take a picture, I was so stunned; I'd never seen anything quite like it. I tweeted an image and tried in own my words to let readers imagine this dancing around. Some of it looks like rain coming down. . . . It looks like sheets of light coming down to Earth. . . . It's just crazy beautiful.

When I talk about creation or the creator, I try to be careful. NASA's policy is if you're asked about your faith, then share your faith, but we're a diverse place and I know that. The way I see it, it does take faith to believe in a creator. But you look down on this planet and then you look off into space and you see this blackness of space and you see the stars, so many stars you wouldn't even be able to count them, plus the billions and billions more that you can't see with your eyes. Then you look at our beautiful blue planet just hanging there. There are no wires, no strings; it's just hanging there spinning in this emptiness. And to think that came from nothing, that it just happened—I think it takes a lot more faith to believe that we all came from nothing than to believe in a divine creation.

So when I'm asked, if we go to Mars and we pick up some water and we find life there, what does that do to my faith? How tiny is my God if I believe He couldn't create something else, that He just created us? That's a fairly limited view of an omnipotent, all-powerful God. I believe in a God that created this universe—who am I to put limitations on the creator? If we found life on Mars, it would do nothing but strengthen my faith.

I had a book of poetry on board that I used for some tweets and I had a little booklet called *Bugle Notes* issued to me at West Point in 1979. It's tiny, the size of a pocket New Testament. It contains the code of conduct, the definition of discipline, and General Douglas MacArthur's final

speech to the Corps of Cadets—the Duty-Honor-Country speech. It's incredibly motivating. My last tweet came from that speech: I couldn't fit it all of it in there so I pulled out little excerpts.

"From the ISS Cupola reflecting on a life challenge I heard long ago—'Be strong enough to know when you are weak . . . brave enough to face yourself when you are afraid . . . never substitute words for actions. Learn to stand up in the storm, but have compassion for those who fall. Always have a heart that is clean, a goal that is high . . . learn to laugh but never forget how to weep.' Until we meet again . . ."

—Astronaut Douglas H. Wheelock,
Colonel, U.S. Army,
Flight Engineer Expedition 24,
Commander Expedition 25

THE MEDITERRANEAN AND NORTH AFRICA

The rise of proud societies and civilizations began along the banks of the Mediterranean Sea eleven thousand years ago. A near perfect combination of temperate climates, freshwater rivers, and rich, tillable soil led to the cultivation of crops, the domestication of animals, and a reliable food supply. That in turn allowed labor to expand beyond meeting the physical needs of ancient man to meeting his cultural and even spiritual needs, too. Once organized, civilizations expanded, armies were formed, and empires emerged. Of those conquerors that ruled the region, the Roman Empire stands alone as the largest. From Spain to Jordan, from Italy and Greece to Carthage (Tunis), around and across the Mediterranean was the Roman Empire—settling, building, trading, and ruling. Rome is one of the common propellants behind the emergence of the cities we encounter in the middle sea.

Three continents come together at the Mediterranean: Europe, Asia, and Africa. Africa accounts for half of the land abutting the Mediterranean and for one-fifth of the Earth's landmasses. Most important to the story of mankind's lights, it is where man originated. The etymology of the name *Africa* is telling. The Egyptians reverently used a variation of the spelling to mean "the birthplace," as in the birthplace of civilization. The Romans used a name given to Africa by the early Phoenicians and modified it to mean "a country of dust"— an apt description to those familiar with the billowing storms of dust that regularly blow off Africa into the Mediterranean. Much of Africa's interior is either uninhabited or lightly populated. That's why, for decades, it was called "The Dark Continent," something we affirm at night today.

Today, the countries of the Mediterranean are home to some of the most vibrant cities seen from the night sky. From fishing villages, walled hamlets, and small trading outposts, giants such as Cairo, Rome, and Istanbul have emerged.

The Mediterranean Sea, however, is more than twenty-two hundred miles long and one thousand miles wide at its widest, a scale that prevents even the astronauts from capturing it in one image. What they did capture is a beautiful, collective portrait of one of the most sacred parts of our planet.

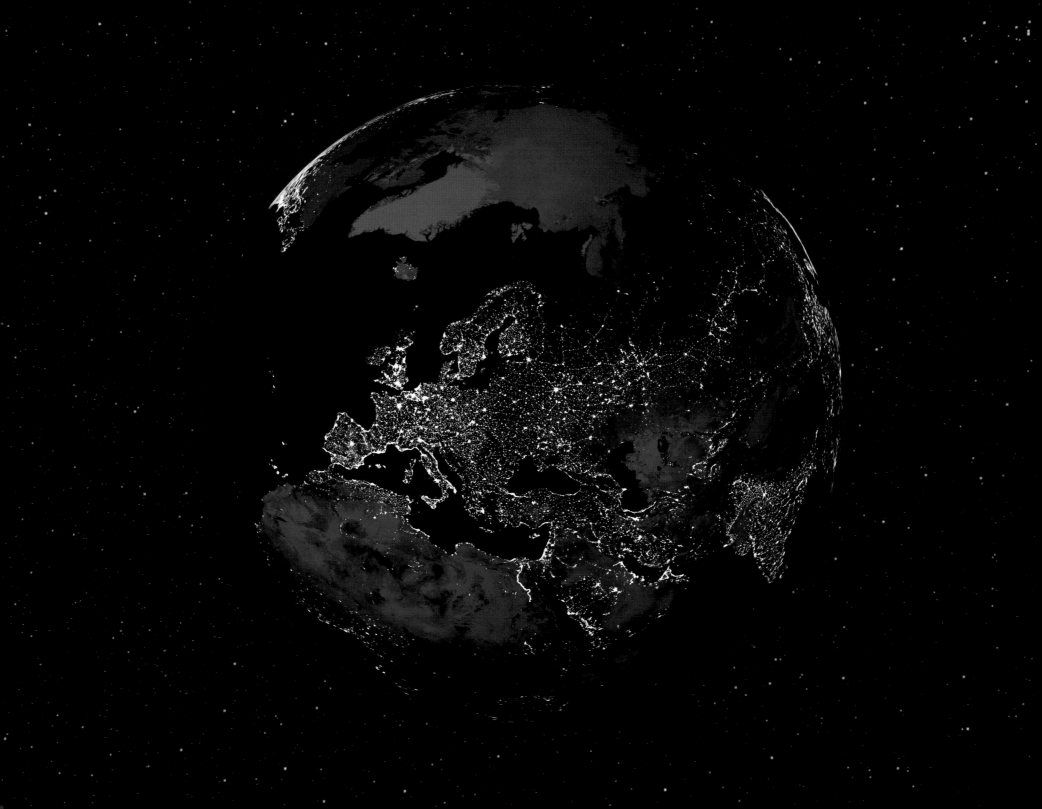

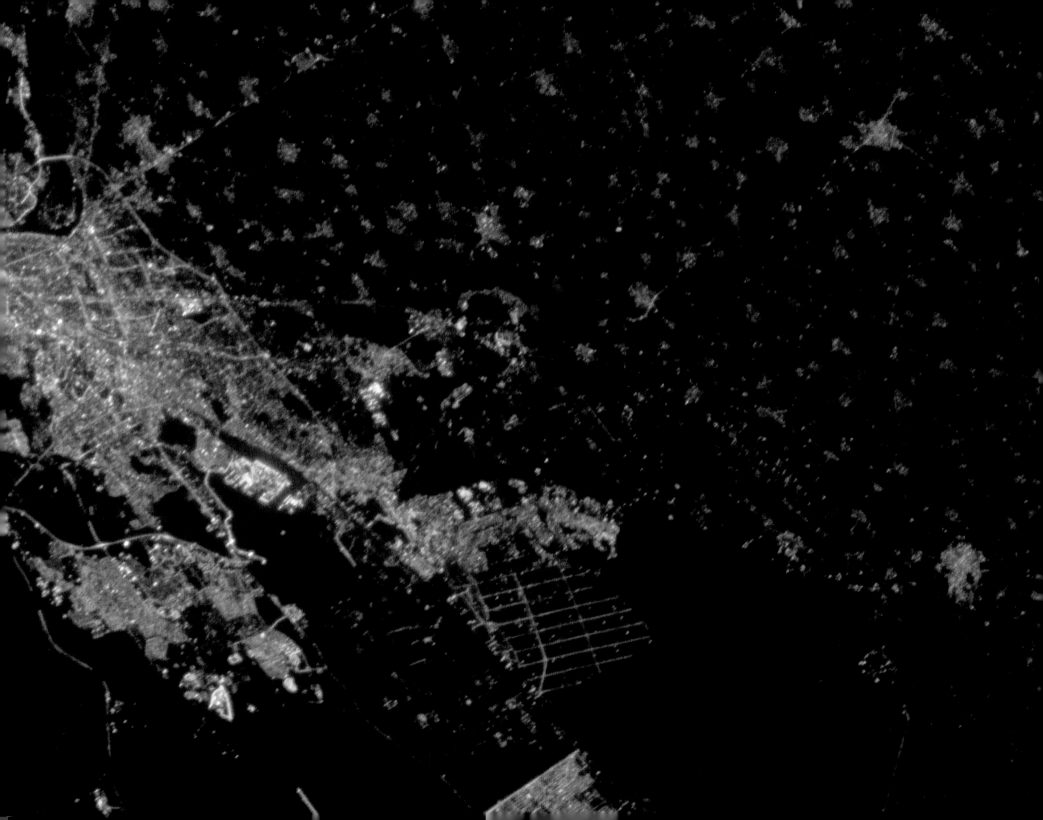

Egypt/Cairo and the Nile

The emergence of a crop-cultivating Egyptian society occurred some ten thousand years ago, and the appearance of hieroglyphics and the characteristics of a developed civilization occurred some fifty-five hundred years ago (3500 BC). The Great Sphinx and the pyramids were built between 2700 BC and 2100 BC, and by 1000 BC a confident Egypt was enlarging its empire. In 30 BC, however, Egypt fell to the Romans. It was ruled by various empires until it regained its independence as a nation in 1922.

irrespective of ruler or epoch, the lights we see today were sprouting millennia ago. Cairo, Alexandria, and the countless farming villages along the Nile River Valley were well established on the maps of the world more than twenty-five hundred years ago. Today, as in ancient times, the overwhelming majority of Egypt's seventy-nine million people live in the Nile River Valley, giving the country a shape more akin to a cobra than that of its true political boundaries. The greater metro area of Cairo has a

population of nineteen million, making it one of the most densely populated cities in the world. Egypt's territory includes the Sinai Peninsula, thus making it one of the few transcontinental nations (Africa and Asia). Downtown Cairo, opposite, is at the base of the "V" that is the Nile River delta. The port of Alexandria is the bright strip of light to the left of the delta.

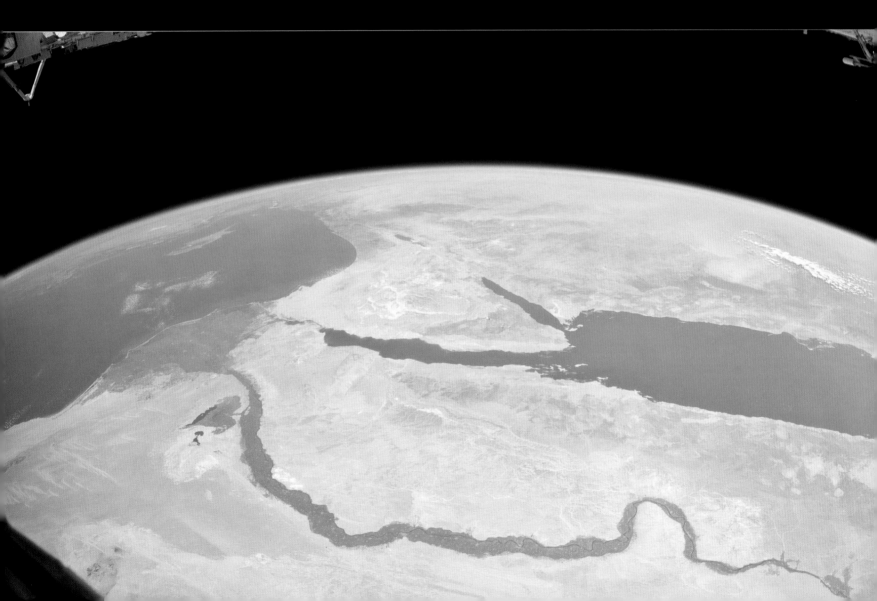

Egypt/The Nile River Delta

Egypt/Valley of the Kings

The Nile twists and turns but has only one complete
bend like this. From approximately 1500 BC to 1000
BC, members of Egyptian royalty were buried in the
valley walls directly inside this bend. More than sixty
tombs have been discovered here, including the
tomb of King Tutankhamen, thus this bend is called
the Valley of the Kings.

(RIGHT) The soft points of light along the Nile River
Valley speak to the countless hundreds of farming
villages that surround the Nile.

Turkey and Cyprus

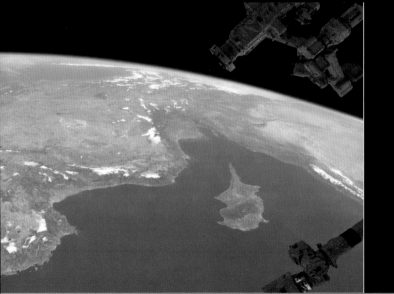

(OPPOSITE) Ankara, Turkey. Ankara was an ancient trading center located at the intersection of the earliest north-south and east-west trading routes across Turkey. Today, Ankara is a major distribution center serving the Black Sea and the Mediterranean. Most westerners know this capital city for its mohair and angora wool. Sodium vapor streetlights give Ankara its hues of orange. Dark areas include two universities, and the Ataturk Forest Farm and Zoo.

(BELOW) Cyprus. A restive country caught between its Greek and Turkish heritage, the Republic of Cyprus is an island nation of 1.1 million with a sophisticated infrastructure and a robust tourist trade.

Turkey/Istanbul

Byzantium. New Rome. Constantinople. Istanbul is an ancient city of commerce with layers of civilizations and cultures that thrived at this unique intersection of land and sea trading routes. Today, Istanbul is a major port city with a busy harbor and a large manufacturing base in industries as diverse as textiles, pharmaceuticals, and automobiles. With thirteen million people, Istanbul is the only city in the world to straddle two continents. Workers on the European side commute to the Asian side and workers on the Asian side commute to the European side, and that's exactly how they say it. The brilliantly lit, 4,934-foot-long Bosphorus Bridge extends over the Bosphorus Strait and connects Europe to Asia. The bridge is the deceptively short blue line over the strait. The mountainous regions around the city are visible as dark spots in both the day and night shots.

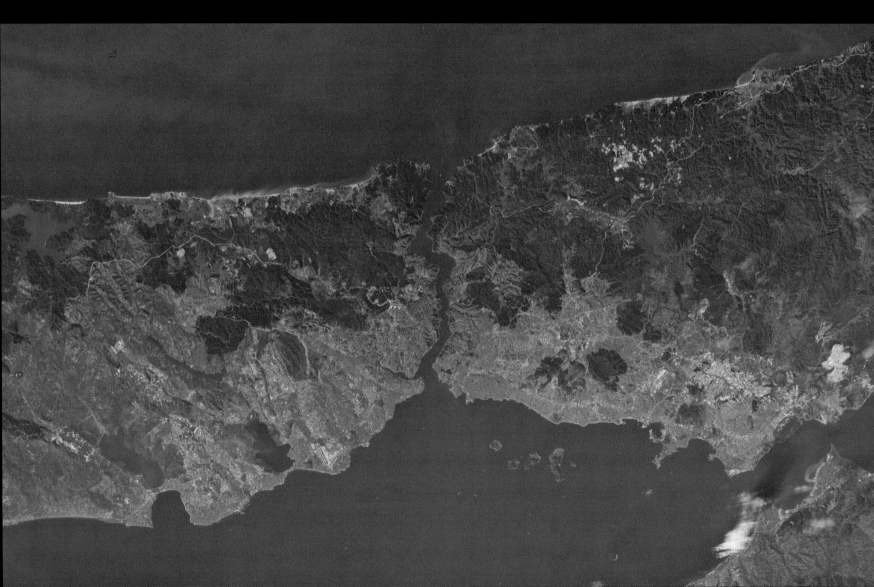

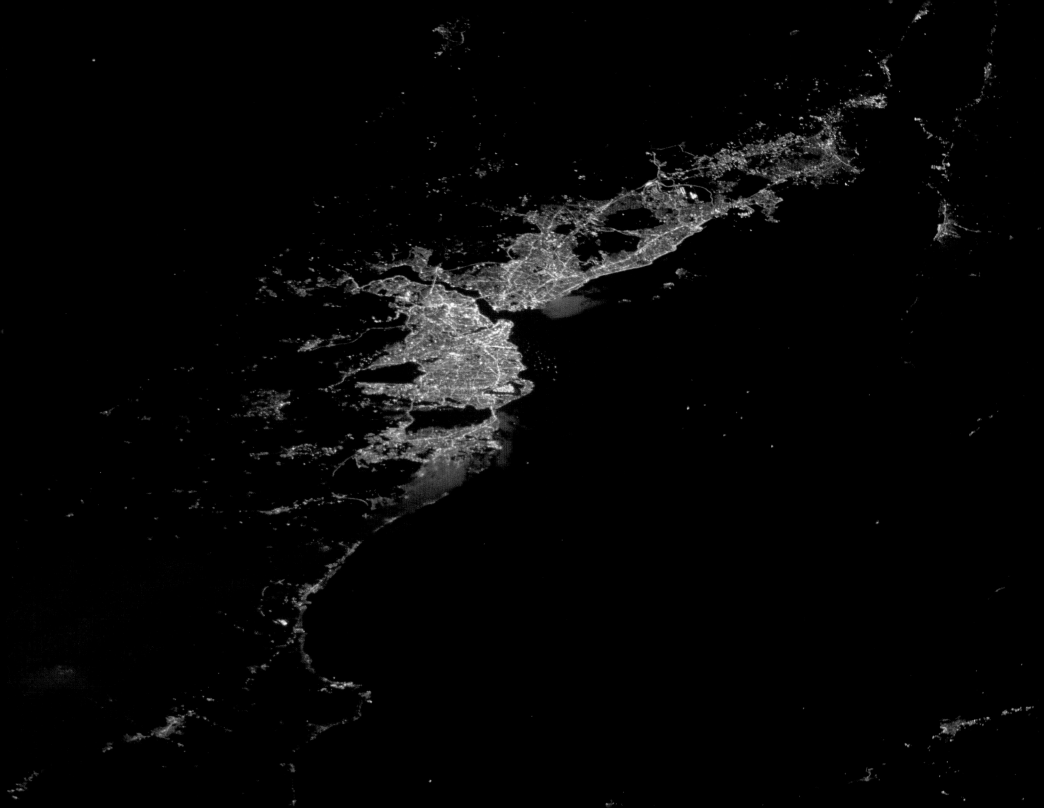

Istanbul to Athens

Istanbul remains in these images as the space station crosses one of the most ancient of human civilizations.

(BELOW) The Greek Isles. It's difficult to distinguish Athens from the low hanging clouds, but an experienced eye will see the city in the center of the photo. Athens is on the Attica peninsula, which juts down from southern Greece into the Mediterranean. Istanbul is in the upper right-hand corner of this photo.

(OPPOSITE) One of the most beautiful nightscapes on the planet unfolds in these subtle hues of gray as the space station flies over the Black Sea. The moonglint in the foreground sharpens the contrasts between land and sea. The Bosphorus Strait and the lights of Istanbul are clearly visible in the middle of the photograph. Constanta, the oldest city in Romania and a major port on the Black Sea, is the small point of light on the coast in the foreground. Bucharest is inland to the right; Athens is visible ever so faintly at the top right.

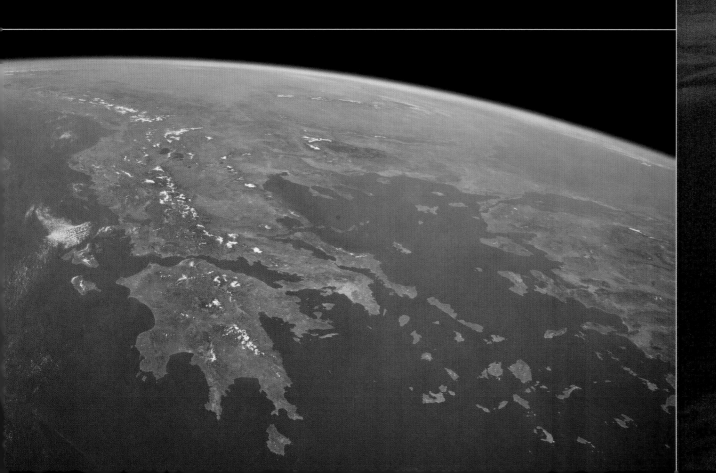

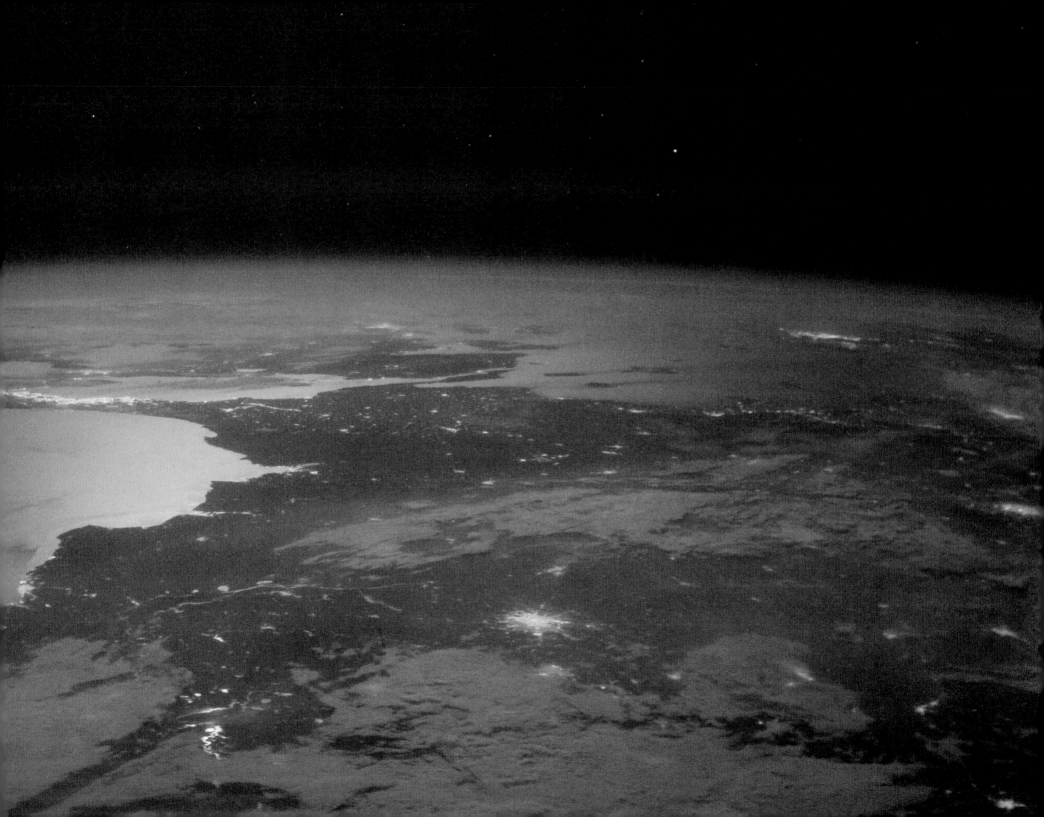

Greece/Athens

The modern nation of Greece was established in 1830, but ancient Greece should be considered the birthplace of democracy and the cradle of western civilization. Here our human footprint dates back to 2000 BC when the first Greek societies emerged. By 700 BC Greek city-states were flourishing and boats were launched from every port as this seafaring nation traded with its neighbors. By 420 BC the Parthenon had been completed, democracies were established, philosophers were flourishing, and Athens was the center of the Greek world.

(BELOW) Athens is the bright wedge of light at the tip of the peninsula. Thessaloniki is the curved cluster of lights closer to the camera and in the middle.

(OPPOSITE) Athens is bracketed by mountain ranges and hills that are seen as dark areas on either side of the city center. The terminal buildings of Athens International Airport are just below the city proper and are visible as a thin strip of orange lights. Metro Athens has a population of more than three million.

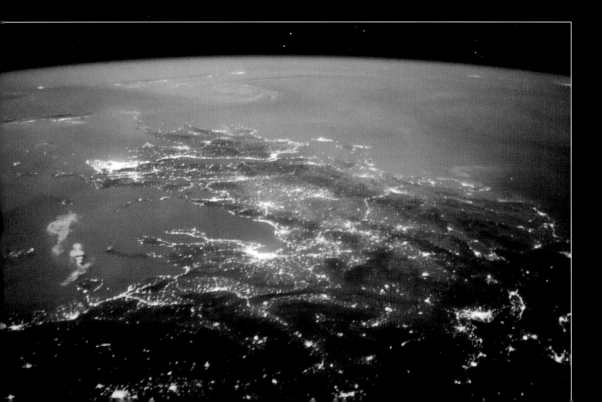

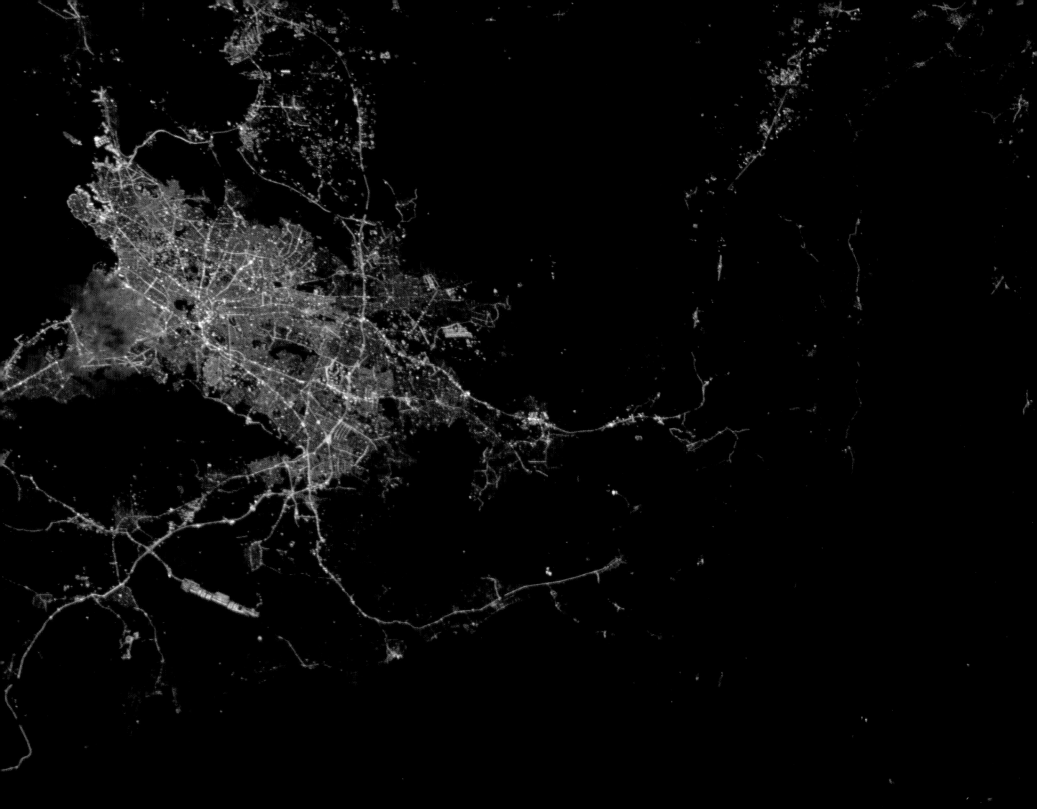

The Adriatic

A light cloud cover combines with moonglint on the Adriatic Sea to create this mosaic of soft colors. Below, the countries of Slovenia, Croatia, Bosnia Herzegovina, Montenegro, and Albania pair with the boot of Italy to enclose the Adriatic Sea. The lights of Zagreb, Croatia, are in the foreground.

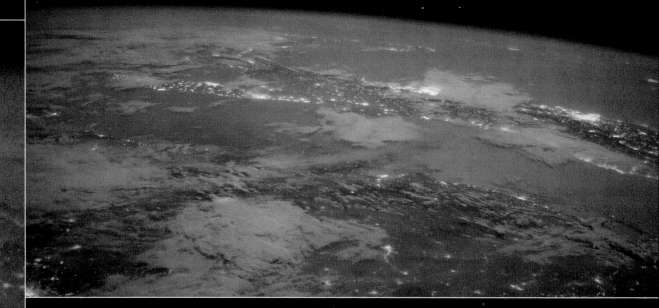

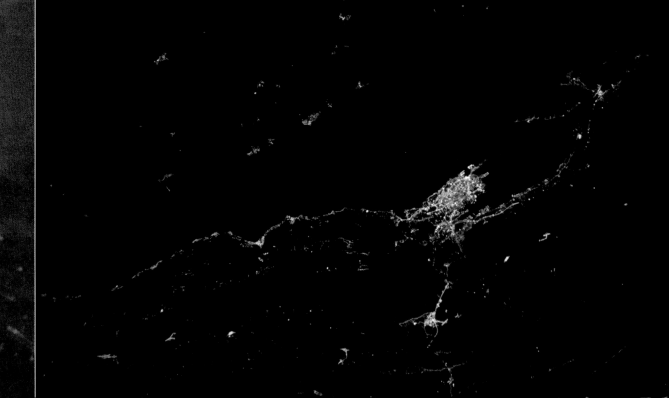

(TOP) Rome and Naples on the far side of the Italian peninsula.

(BOTTOM) The well-sheltered city of Split, Croatia.

Italy

From the Strait of Messina to the Italian Alps, night lights trace a near perfect outline of one of the most geographically distinct countries on Earth. Home to one of the oldest civilizations on the planet, Italy was blessed with both natural harbors and rich natural resources—and because of this early societies thrived. The Roman Empire, which at its peak ruled all of the lands around the Mediterranean, started around 44 BC with Julius Caesar's ascension to emperor, peaked in AD 470, and then fell. The emergence of city-states that followed gave rise to concentrations of populations and power where we see the brightest lights today—Rome, Naples, Milan, Venice, Florence, and Genoa among them. City-states were too weak to survive, and in 1861 the Kingdom of Italy was created, which after the capture of Rome in 1870, led to the unification of Italy and the nation we know today. In this southern view, moonglint off the Venetian Lagoon begins a pathway of light that extends across northern Italy up to Milan.

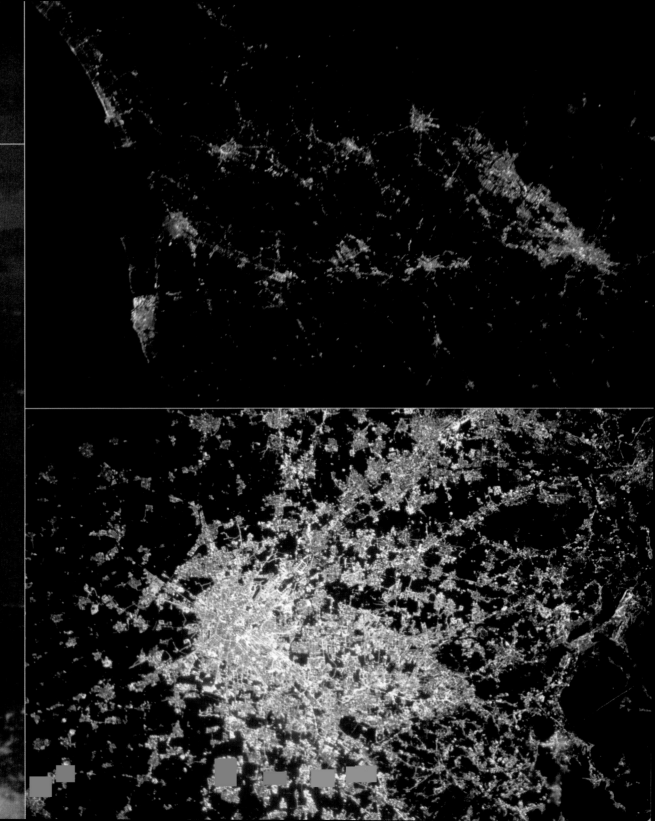

(TOP) In this photo Florence is the large city to the right. The lights lead left to Pisa and then spread out north to Viareggio and south to Livorno. Farmlands and vineyards are seen as the dark area in between.

(BOTTOM) Quilted in a patchwork of golden threads (smaller villages alternating with farmland), the former city-state of Milan is a beacon to the nighttime sky. The metro area has a population of some four million.

Italy/Rome and Naples

Looking over Italy toward Sicily. The two brightest lights on the far side of the peninsula are Rome, right, and Naples, left. Both face the Tyrrhenian Sea and trace their origins back some three thousand years.

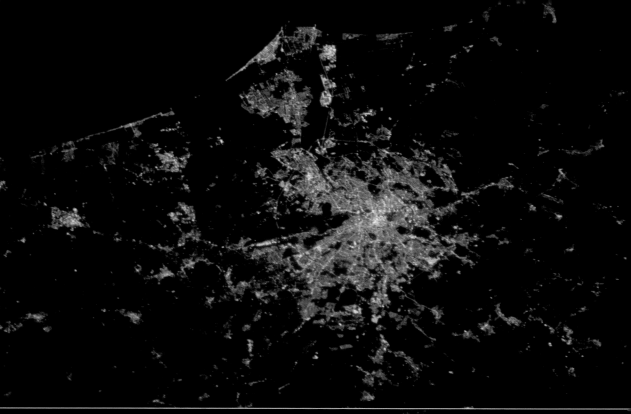

(TOP) The Tiber River traces a thin line through Rome before it spills into the Tyrrhenian Sea. The dark, L-shaped area to the left of Rome points to the Coliseum. It is a confused mix of floodplains, washes, farmland, forests, vineyards, and undeveloped terrain that grows ever larger to the south and east. The metro area of Rome is home to some 2.8 million.

(BOTTOM) Naples surrounds Mount Vesuvius, seen as the black circle in the city. Naples is a densely populated metro area with some 4.4 million.

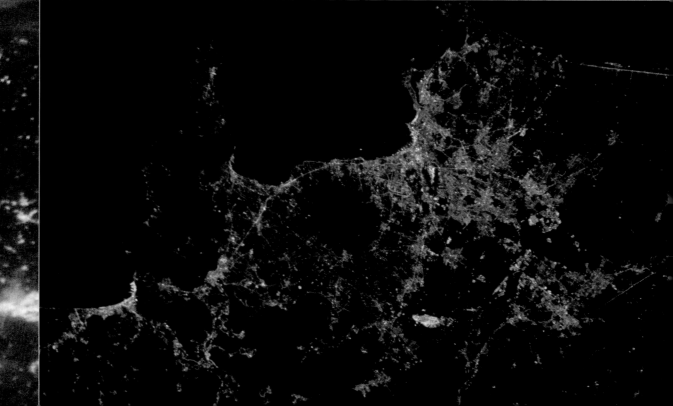

Italy/Venice and Lake Garda

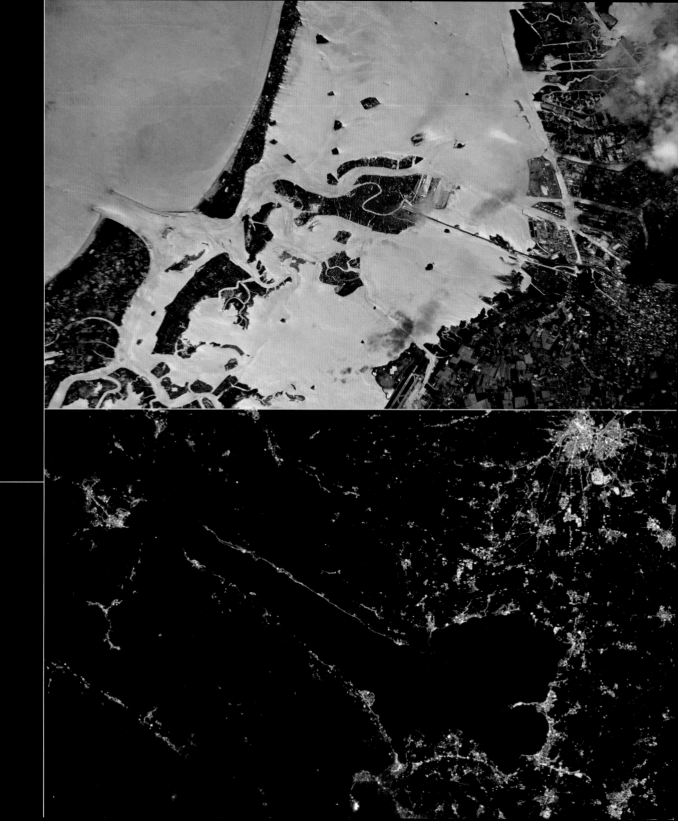

(OPPOSITE) A favorite city for tourists is Venice, Italy. This panoramic view shows Venice and the surrounding area. Scale is difficult to determine. Venice can be seen just inside the Venetian Lagoon. The fish-shaped island has a spot of blue light, which are the piers of the maritime port. The line of lights connecting Venice to the mainland is the auto-rail bridge. The Grand Canal weaves through the center.

(TOP) Venice by day.

(BOTTOM) Lake Garda, a glacial lake thirty-two miles in length, is the largest lake in Italy. Verona, Italy, is the city seen at the top of this photo.

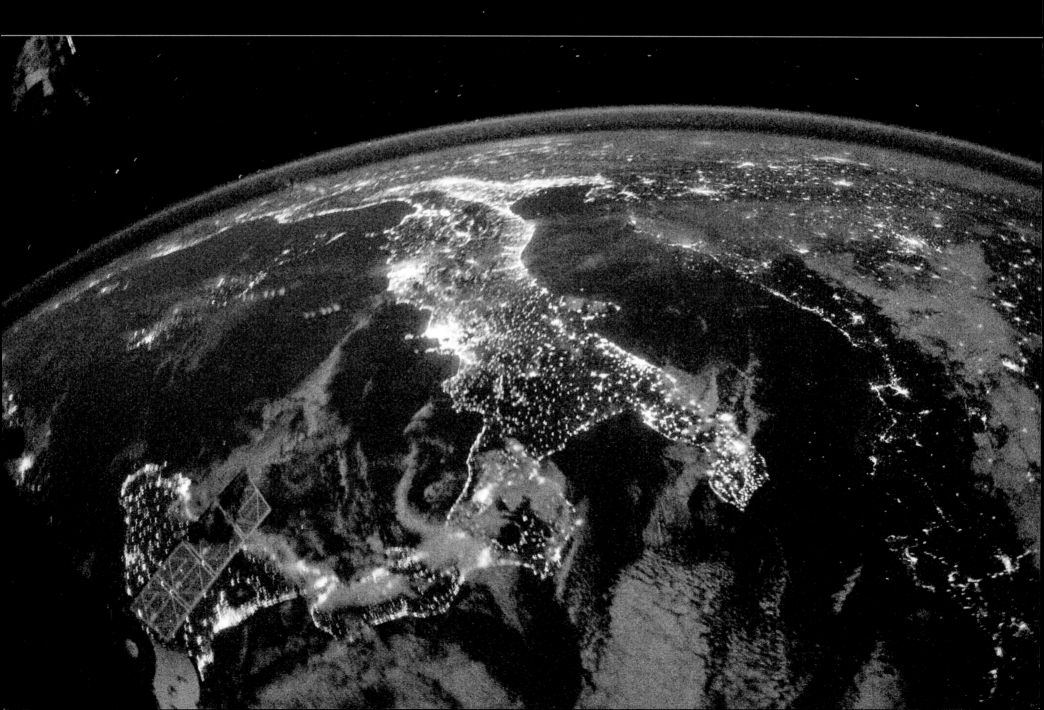

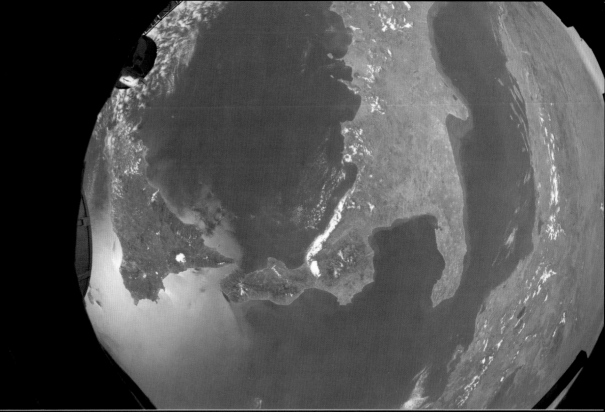

(OPPOSITE) Italy is seen in its entirety in this nine-hundred-mile-long panoramic. Airglow traces a line around the curvature of the Earth. Rome and Naples sing out their welcome to the sky. The islands in the Mediterranean just above Naples are Sardinia, Italy, and Corsica, France. Sicily is off the toe of Italy. The lights of Tunis, Tunisia, in North Africa can be seen as a bright dot to the left of Sicily. Wispy clouds drift across the bottom of the photo.

(RIGHT, TOP AND BOTTOM) Sunglint silhouettes the Strait of Messina and Sicily. Fast currents and high winds are to be found in this narrow 1.9-mile-wide passage between the mainland and Sicily.

Spain

The flowering petal of the southern Iberian Peninsula separates the Atlantic Ocean from the Mediterranean Sea with passage provided by Africa and the more densely populated towns and cities of southern Spain. Lisbon, Portugal, is on the left side of the peninsula with Seville, Spain,

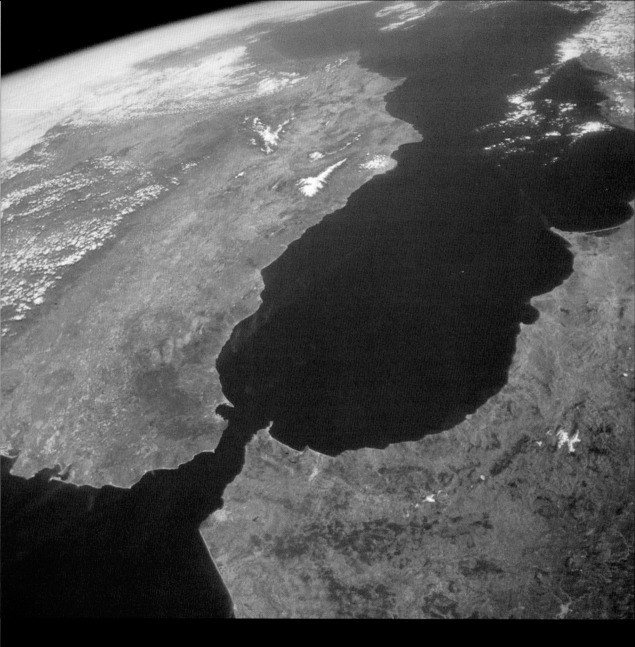

The Mediterranean Sea looking northeast from above Africa.

Spain/Madrid

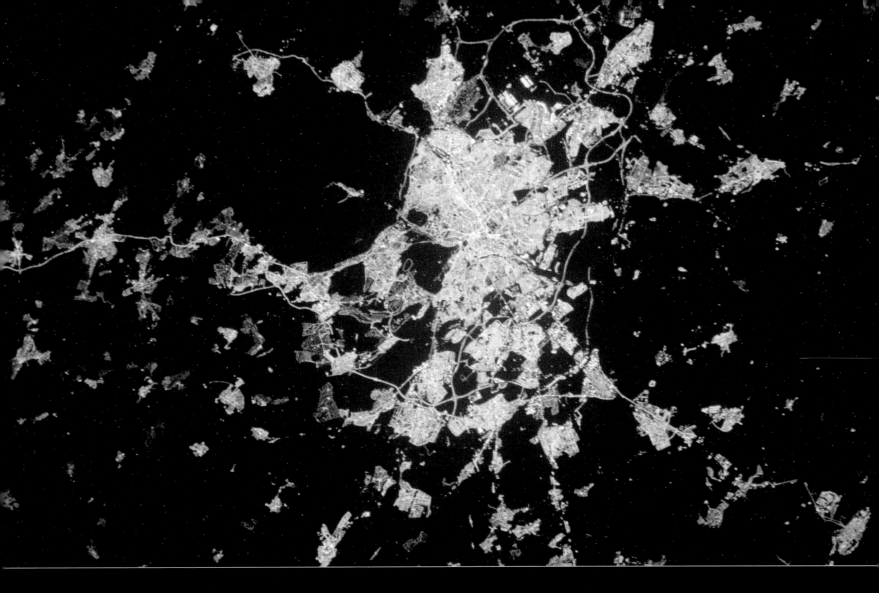

(OPPOSITE) This exquisite eight-hundred-mile oblique photo of the Iberian Peninsula clearly shows the narrowing of the peninsula's neck as it extends south from continental Europe. The dominant light in the center is Madrid. Bordeaux and Toulouse in France stitch a line across the foreground, while the outlines of Valencia are visible to the upper left.

(ABOVE) The golden tapestry that is today's Madrid traces back to the ninth century AD when the Moors established a fort on the banks of the Manzanares River. We owe the brilliance of Madrid's nighttime display of lights to the ever practical King Philip II (1527–1598), who made Madrid the seat of his colonial empire and the capital of Spain largely because it sat at the precise geographic center of the country. The 249,000-acre nature preserve called the Biosfera de la Cuenca Alta del Río Manzanares is the large dark area to the upper left of the city.

Spain/Barcelona

The gently scalloping Mediterranean coastline of Spain.

(BELOW) Barcelona is the second-largest city in Spain with a metro population of 4.2 million. It was settled as a Roman city. The city's natural harbor helped it emerge as a major trading center on the Mediterranean. Today Barcelona ranks among Europe's top-ten ports in terms of tonnage shipped. Barcelona is a dynamic blend of the old and the new with an imaginative skyline etched against the clouds by the creative whims of world-renowned architects. At night the city appears to be divided by the Llobregat River and the main transportation arteries that run alongside it. The airport is the dark area to the right of the mouth of the river.

(OPPOSITE) Barcelona is the bright, partially cloud-covered light in the foreground; Valencia is farther south. Visible offshore are the island of Ibiza and the larger island of Majorca. The bright light on Majorca is the ever popular tourist destination, Palma.

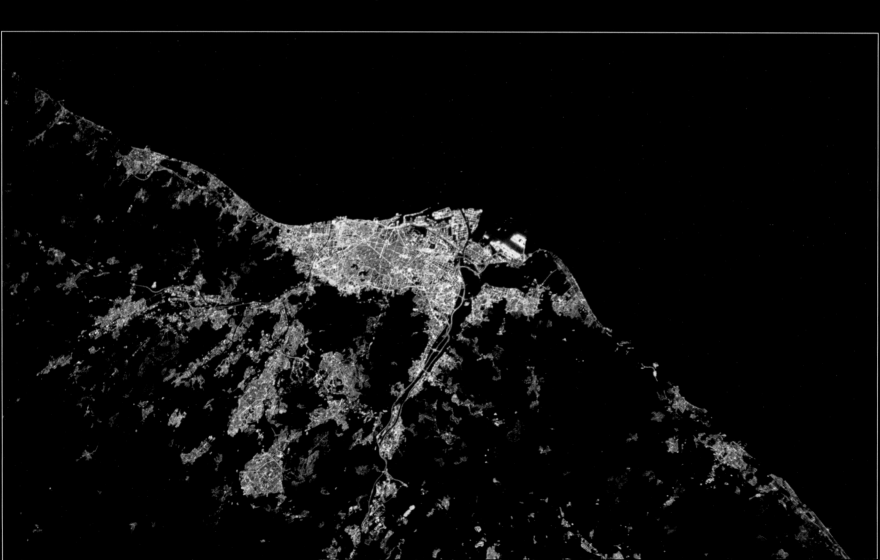

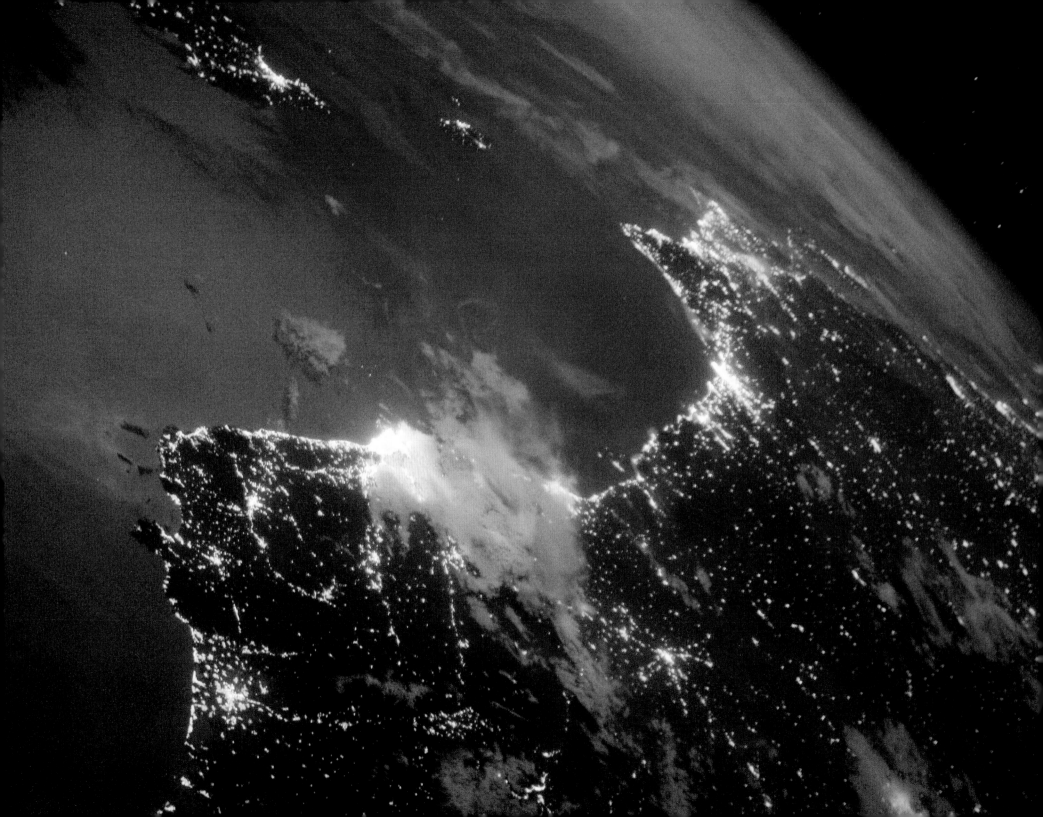

Strait of Gibraltar

Europe and Africa are separated by the nine-mile-wide Strait of Gibraltar.

(OPPOSITE) Africa is in the foreground, and the city of Tangier, Morocco, is to the left. The British territory of Gibraltar is on the right tip on the European side. Some 5.9 million years ago, the strait closed and the Mediterranean Sea evaporated.

North Africa

Following the lights across the rim of North Africa is difficult owing to length of the Mediterranean Sea, the diffused populations, and the interplay of Italy with the African lights. Tunis, Tunisia, is the bright light on a peninsula extending out toward Italy.

(OPPOSITE) The lights of Tripoli, capital of Libya. The areas photographed are indicated by the box on the daytime image.

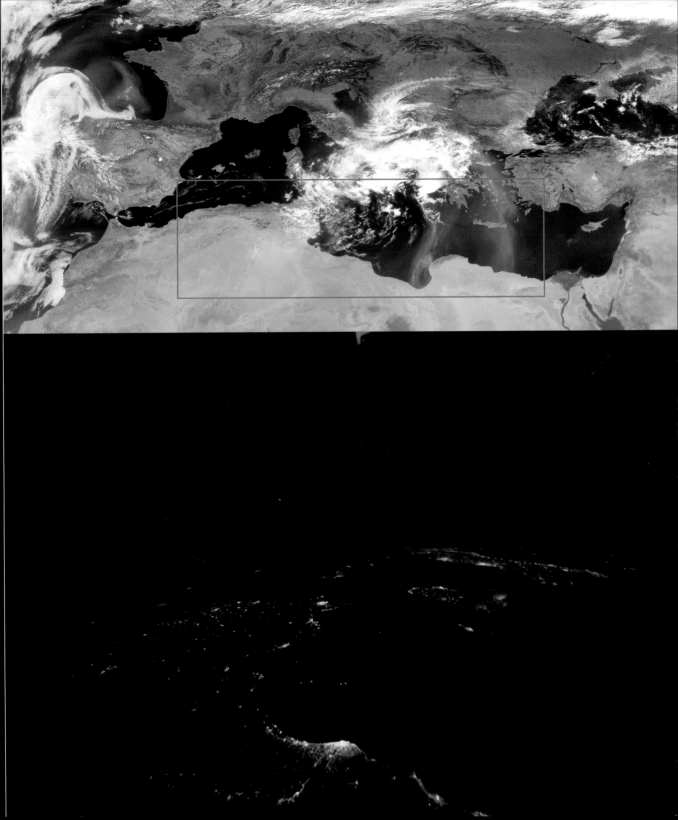

Tunisia/Tunis

We owe the gaunt, skeletal look of the ancient trading port of Tunis to a mishmash of unusual geographic features that surround this African capital. Center city is located on a land bridge between the Lake of Tunis, the dark spot directly in the middle of this photograph, and the briny wetlands called Sebkhet el Sijoumi, the dark spot behind the city. The Lake of Tunis covers more than fourteen square miles and sits just below a third dark spot, which is also wetlands. You can identify the lake by the thin orange line that bisects it. This is an expressway that parallels an ancient dam built on the lake by the early Romans. Skeletal look aside, more than 2.4 million make this Mediterranean port city their home.

(OPPOSITE) From Tunis around the peninsula east to the city of Sousse, Tunisia, bottom right. Sousse dates back to the eleventh century BC and has one of the largest olive groves in the world—twenty-five-hundred square miles.

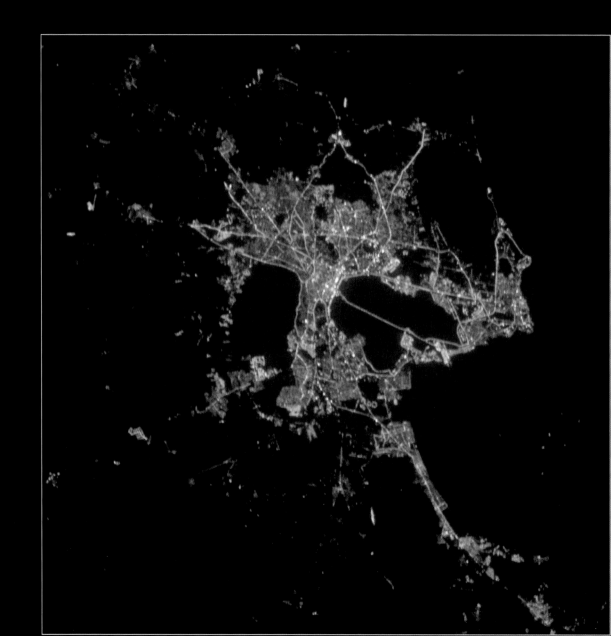

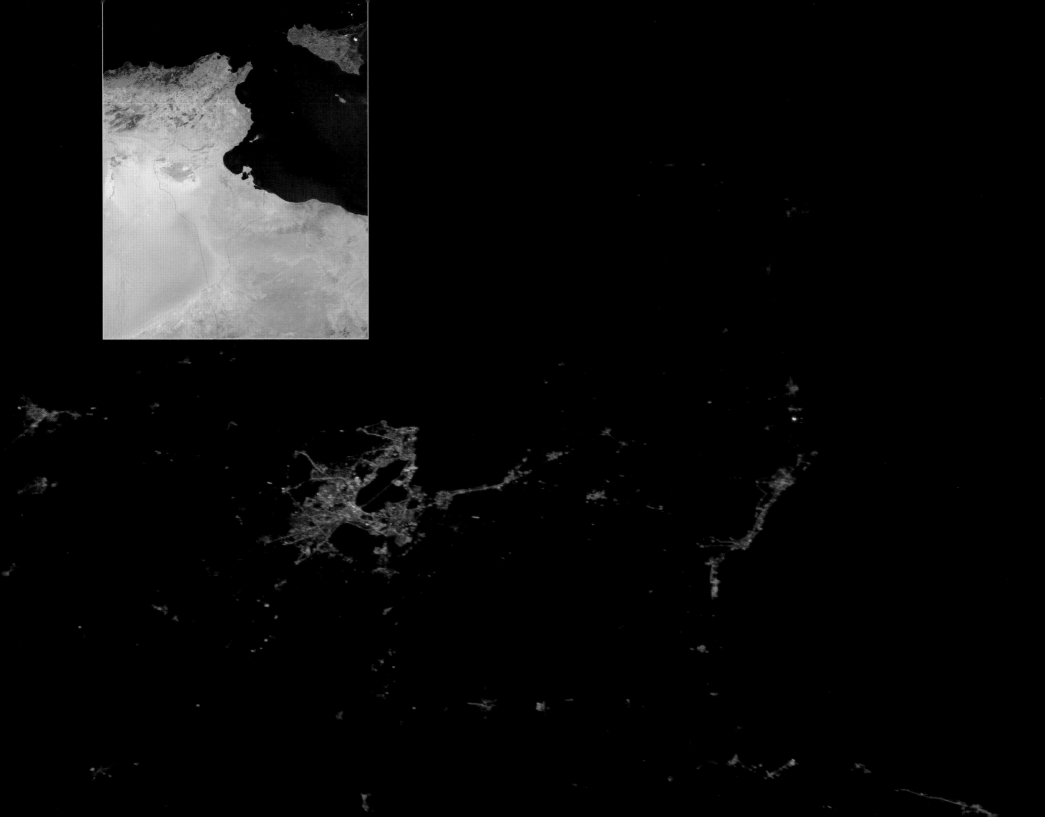

Libya

Tripoli was established as a colony in the seventh century BC by the Phoenicians and modernized under Roman control. The gently curving peninsula shelters a natural harbor to which additional breakwaters and berths have been built, giving the port a distinctly human look. The lack of urban intensification belies a capital city with a population just over one million.

At night, Benghazi speaks with a sense of urgency. Wide, well-lit highways pierce the ring road and lead into the city like the shafts of a spear. As with Tripoli, Benghazi enhanced its sheltered harbor by building breakwaters and berthing. The future of Benghazi, founded by the Greeks as a trading colony, remains as undecided now as it has been through much of its twenty-five hundred years.

ASTRONAUT SANDRA H. MAGNUS

What We See:

"Against the blackness of space you have this small, tiny, fragile-looking oasis supporting the billions of people."

I vividly remember the first time I looked out the window of the shuttle and saw Earth. The first thing that struck me was how incredibly fragile our planet looked. We know intellectually that the atmosphere is very thin—you think about these people who go up Mount Everest and how they have to use oxygen to get there—so you know the atmosphere is this thin shell of air supporting our life. But you see it from space vividly. Against the blackness of space you have this small, tiny, fragile-looking oasis supporting the billions of people on our planet, a place that looks so peaceful and serene it's hard to imagine all those people down there. But yet you know that this little fragile eggshell of air is supporting all of that life. It's really easy to take it for granted.

One of my favorite things to do was to watch the transition from day to night, crossing the terminator from day and night—and you do so in maybe five or six minutes—and you have this whole rainbow of blues spelled out underneath you. You have the bright sky blue of daylight, then the royal blues, the midnight blue, the purple-blue, the purple-black, and then you're in the nightside. That transition, that rainbow of blues, was wonderful to watch.

Another of my favorite things about the nightside were the thunderstorms, which were absolutely spectacular. I was flying during the wintertime. Across South America and across Africa, you can always find a thunderstorm several hundred miles wide. While you can see a lot of spectacular lightning from the ground, I think it's only half what you see from orbit. The lightning is jumping from cloud to cloud, multiple strings, all of the branches there to see—it's like watching a fireworks show. I never got tired of watching the lightning.

Once you get to the nightside, a few things are really apparent. Number one, you can see where all the people live. Coastlines have lots of light. Interiors, especially the interior of Asia, are very, very dark; you don't see evidence of a lot of civilization there at all. At night, the whole East Coast of America is so easy to spot. It looks almost like one big city from New York all the way down the eastern seaboard. Again the middle of the country is not so bright. It's fun to try to pick out the cities. I found St. Louis. Chicago is a little bit easier—you can clearly see the borderline where the lake is: It's almost like flicking a switch from light to black. You get a feel of cities, looking at them at night. You can see the road systems, if they were planned or not, how a city's major arteries function. You can see rivers and lakes bordering cities. You can clearly see where the people live.

You can certainly see the way geography impacts a city's spread, as in Italy, where the volcanoes and the mountains get in the way. You have some dark spots and the lights neck down and around the mountains or the bays or the volcano, Mount Vesuvius. The most striking view in the Middle East is the delta, the Nile Delta, both day and night. During the day you have this oasis of green bordered by the brown. At nighttime it's dark versus light. You can tell that there is a huge population living along the Nile, whereas farther out there is almost nothing.

There are a lot of people living on coastlines. In the United States, as you get farther south from Washington, D.C., it's not as lit up as it is in the Northeast. If you look at the West Coast, there are some splotches of dark. But as you go through the Mediterranean, you know you're over a contained body of water because it doesn't take too long to leave one shore and fly over the north side of the other shore. You get a sense of population densities.

I'm always amazed by how unpopulated so much of the planet is. The lights at night give you a feel about the population and how it's spread out in the world. That's hard to see in the day. Cities at day look like smudges; they don't stick out as much as they do at night.

Sleeping on station is probably easier than sleeping on the shuttle because you're living there long enough to adjust to it and of course the crew quarters are a lot bigger. The shuttle is a noisy place. When you're visiting on the shuttle, you're in sprint mode; you're trying to get your work done before you leave, so sleep is almost secondary. But when you're living on the space station, it is your home, you're living there for months, you develop a rhythm of life.

One of the things we astronauts enjoy doing is sharing our experiences. Our planet is such a vivid mark of color against the black drapery of space. We don't think about how fragile our planet is, but you can see it in the photography. It looks very peaceful, it looks very fragile, it looks very serene, it looks very welcoming—but fragile.

— Astronaut Sandra H. Magnus, PhD,
Flight Engineer and Science Officer Expedition 18.
Dr. Magnus was a Mission Specialist on STS 135.
STS 135 was the final flight of Atlantis and the
final shuttle flight of the space program.

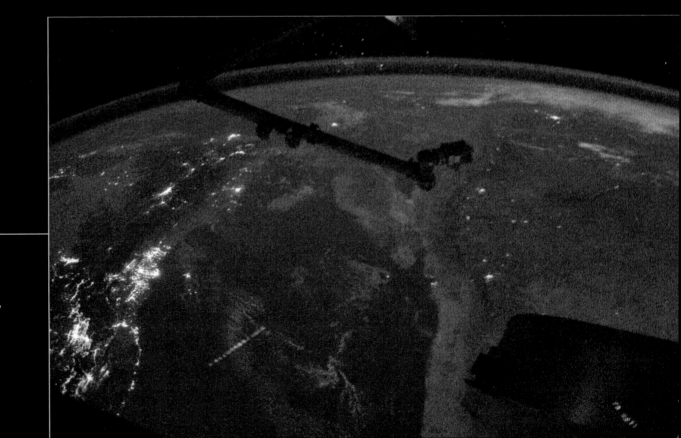

The thin, yellow-green band of light along the horizon, known as airglow, is not reflected light but rather the interaction of atmospheric molecules with solar radiation that occurs approximately sixty miles above Earth. Earth's atmosphere is held in place by gravity.

T he Middle East is neither a continent nor a country but rather a word coined in the early 1900s to describe the region between Africa and the Far East. That such a description was necessary had much to do with the climate, peoples, and resources of this region, none of which were quite Mediterranean, African, or Asian. What they were was a region in the middle, although a precise definition of the "middle," too, has been lacking. In general, today's Middle East consists of the important oil-producing countries of Saudi Arabia, Kuwait, Iraq, Bahrain, Qatar, Oman, Egypt, and the United Arab Emirates as well as Iran, Israel, Lebanon, Jordan, Syria, Turkey, and Yemen. To lessen their dependence on oil, Middle Eastern countries have undertaken some of the most ambitious economic development projects in the world, many of which have created unusual mosaics of light that are visible from space. The World Islands and the Palm Jumeirah are artificial islands in the Persian Gulf that have collectively added more than 320 miles of coastline to Dubai. These archipelagos are designed to host luxury hotels and resorts, homes and villas, and to become major tourist destinations. Similar projects dot the Persian Gulf as far north as Qatar.

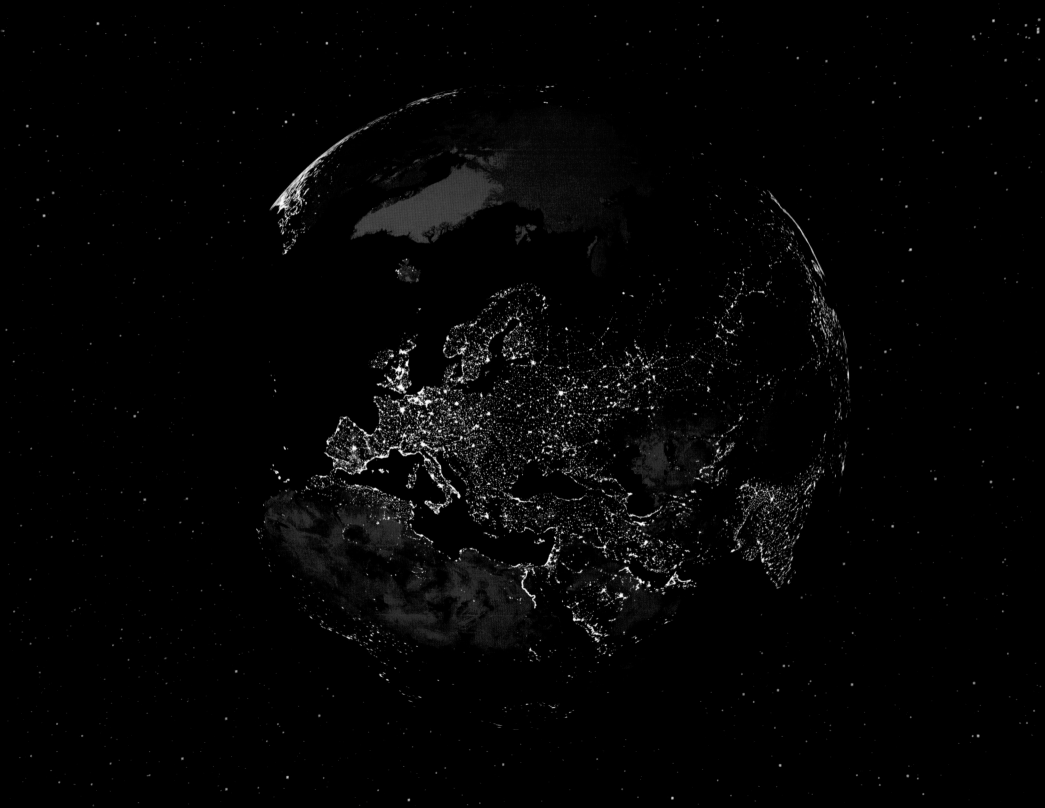

The Levant

Gaza, Israel, Lebanon, Jordan, and Syria are perched on a narrow strip of land along the eastern shore of the Mediterranean. Together they form a population bridge across the Arabian Desert that early Europeans called the Levant, meaning the "rising," as in "the point where the sun rises." It is here that some of the most important religions of mankind rose. The Levant contains the Land of Canaan, birthplace of Judaism and Christianity, and the city of Jerusalem, sacred to Jews, Christians, and Muslims.

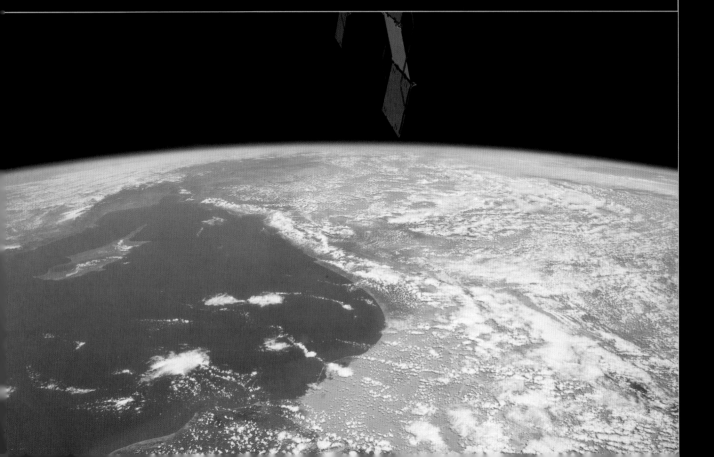

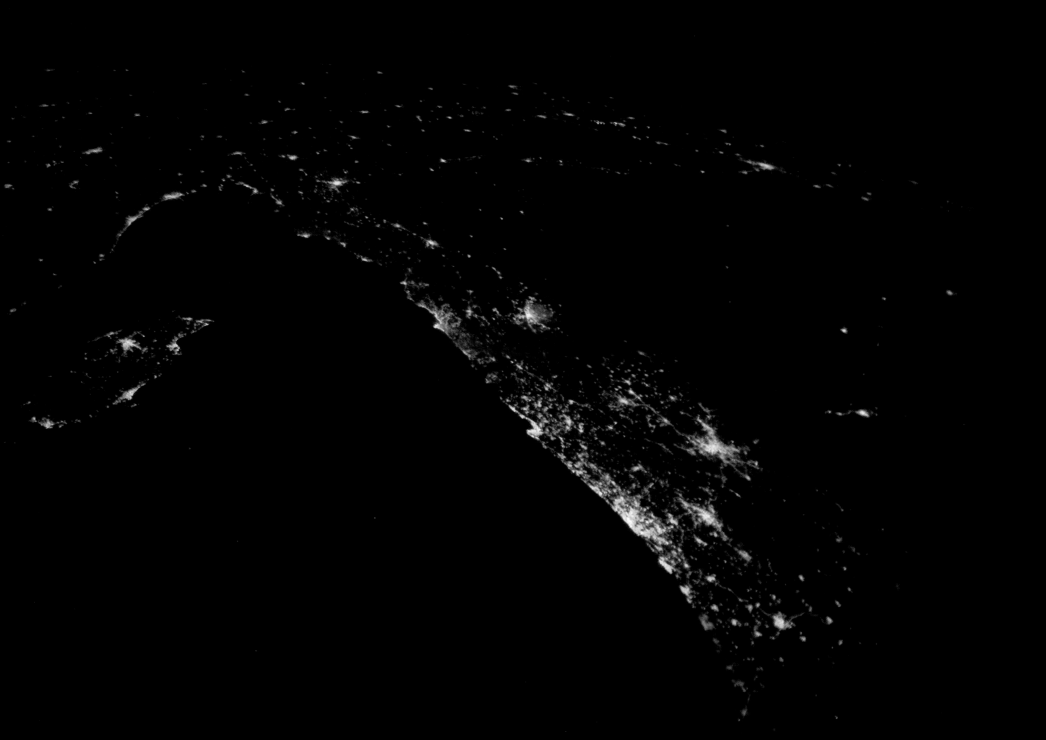

The Levant/Gaza to Israel to Lebanon

The view from space makes it seem all the more remarkable that cultures with such diverse faiths and views about humankind have coexisted in such tight confines. In an area of wars and peace, the lights of the Levant broadcast a many-layered story of ancient kingdoms and the role faith has played in shaping our human narrative.

(OPPOSITE) The lights, left to right across the eastern shore of the Mediterranean, are Gaza; Ashdod, Tel Aviv, and Haifa, Israel; and Beirut and Tripoli, Lebanon. The bright light immediately behind Tel Aviv is Jerusalem. Behind Jerusalem is Amman, Jordan, while farther north, behind Beirut, is Damascus, Syria.

(BELOW) Haifa.

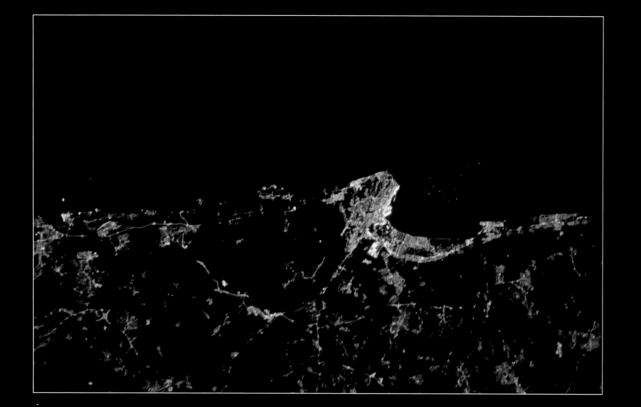

The Levant/Jordan and Israel

(BELOW) Amman is one of the oldest continuously inhabited cities in the world, with records dating back twelve thousand years. Located on the main inland trading route between the Caspian Sea and the Red Sea, and the Mediterranean Sea and the Persian Gulf, as well as the pilgrimage route to Medina, Amman has emerged as a major economic hub for the Levant. The city lights weave and dart around rugged hills and its many farms, which are seen as patches of dark. Metro Amman has a population of 2.8 million.

(OPPOSITE) This panoramic photograph captures the sprawling city of Amman, Jordan, and the lights of the Holy Lands as they cascade down to Jerusalem and Tel Aviv.

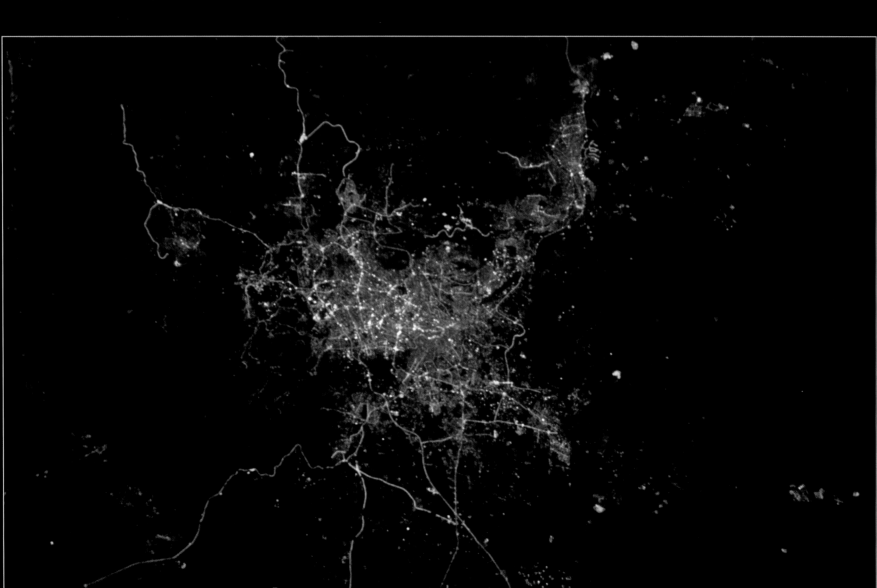

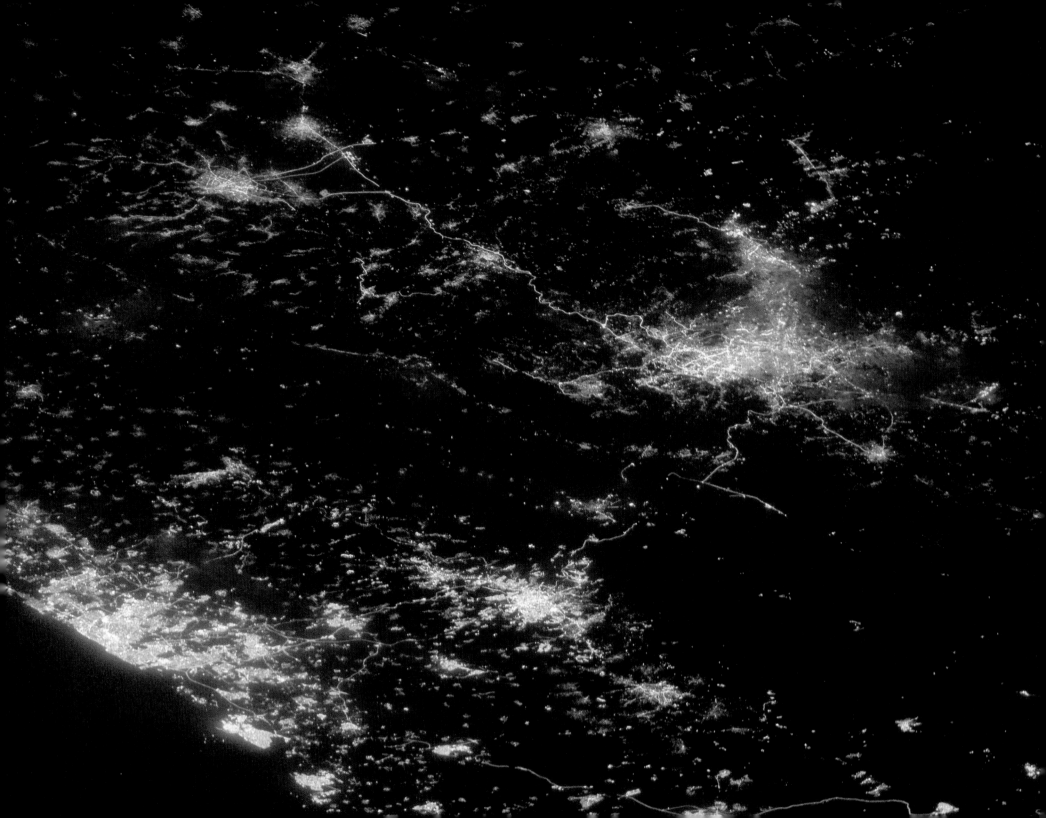

Although the precise date is subject to debate, between 1300 BC and 700 BC, Moses led the Israelites out of Egypt across the Sinai Peninsula to Mount Sinai, where he received God's covenant and the promise of the Land of Canaan. The Sinai Peninsula remains one of the most distinctive geologic features of daytime Earth—but it largely disappears at night.

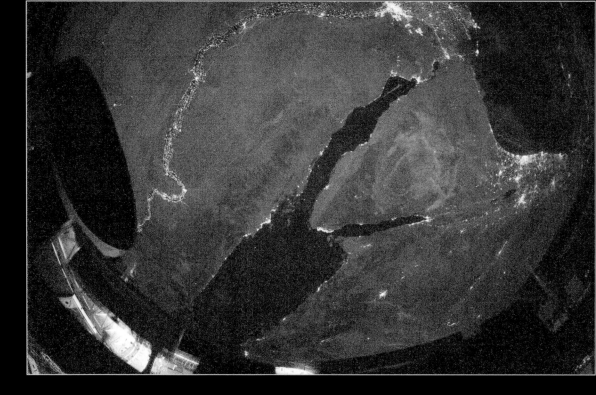

Cairo and the Levant are clearly visible as is Sharm el-Sheikh, Egypt, on the tip of the peninsula.

(OPPOSITE) The Kingdom of Saudi Arabia borders the eastern shore of the Red Sea as far south as Yemen. The Saudi cities of Jeddah and Mecca are visible as the bright white lights to the bottom right. Saudi Arabia is a nation of twenty-six million.

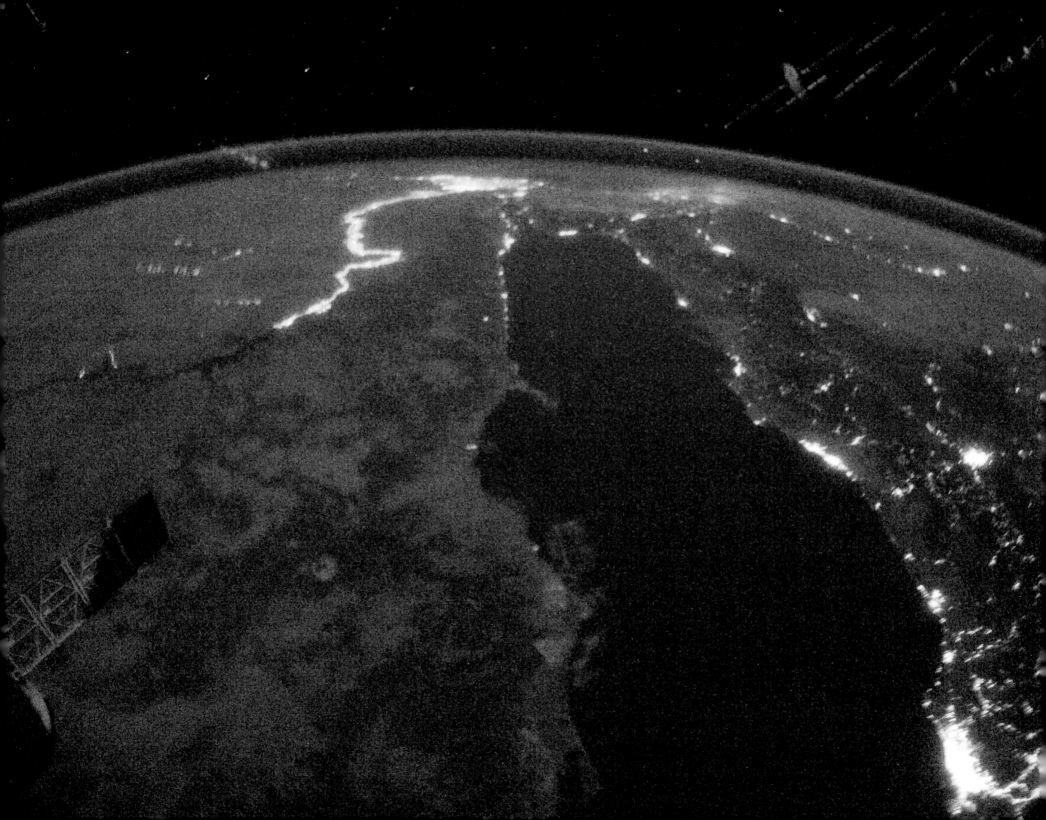

Saudi Arabia/Jeddah to Mecca

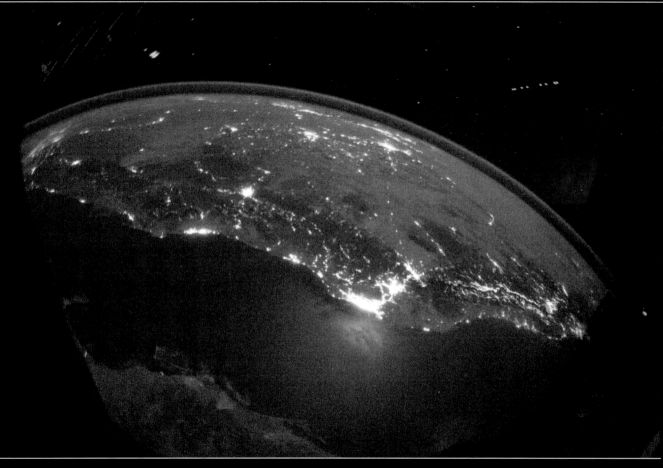

Saudi Arabia/Riyadh

Riyadh, the capital of Saudi Arabia, has a population of more than seven million. The dark area in the center of Riyadh is not the handiwork of nature but rather the Riyadh Air Base, an enormous complex owned by the Royal Saudi Air Force. The Wadi Leban Bridge soars across one of the many dry riverbeds in and around Riyadh, seen here as wedges of black in the midst of the city lights. Once a small, walled city, Riyadh is a wealthy, sprawling center of finance, telecommunications, and oil.

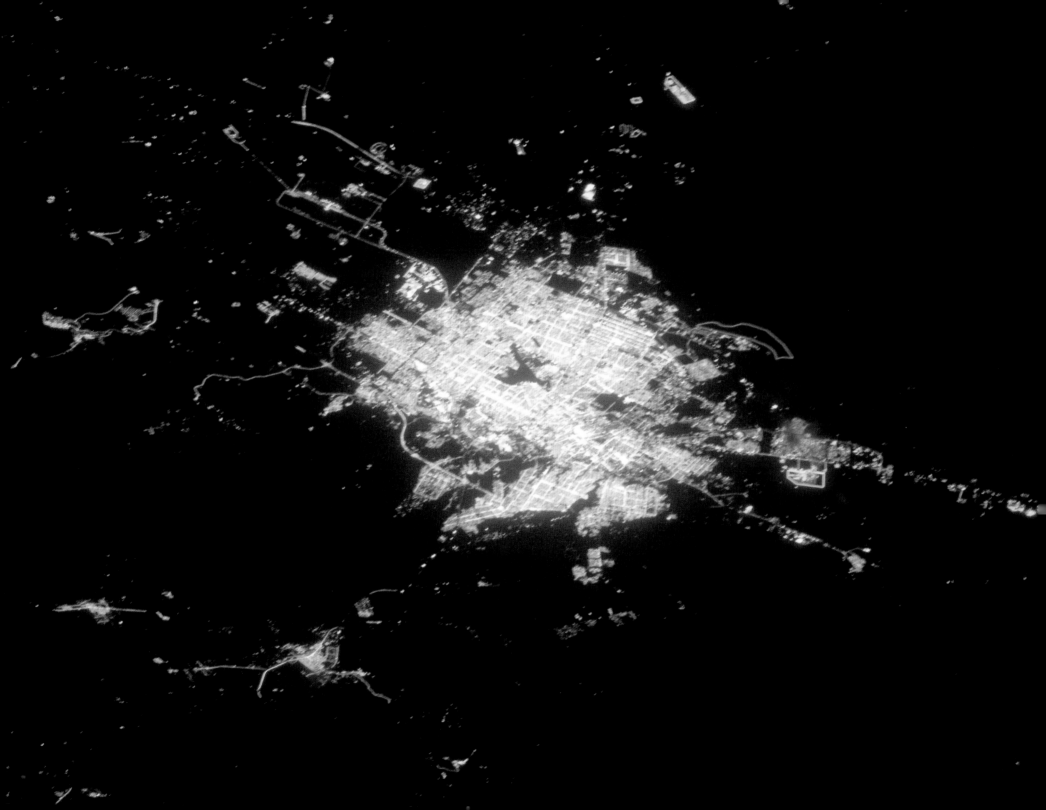

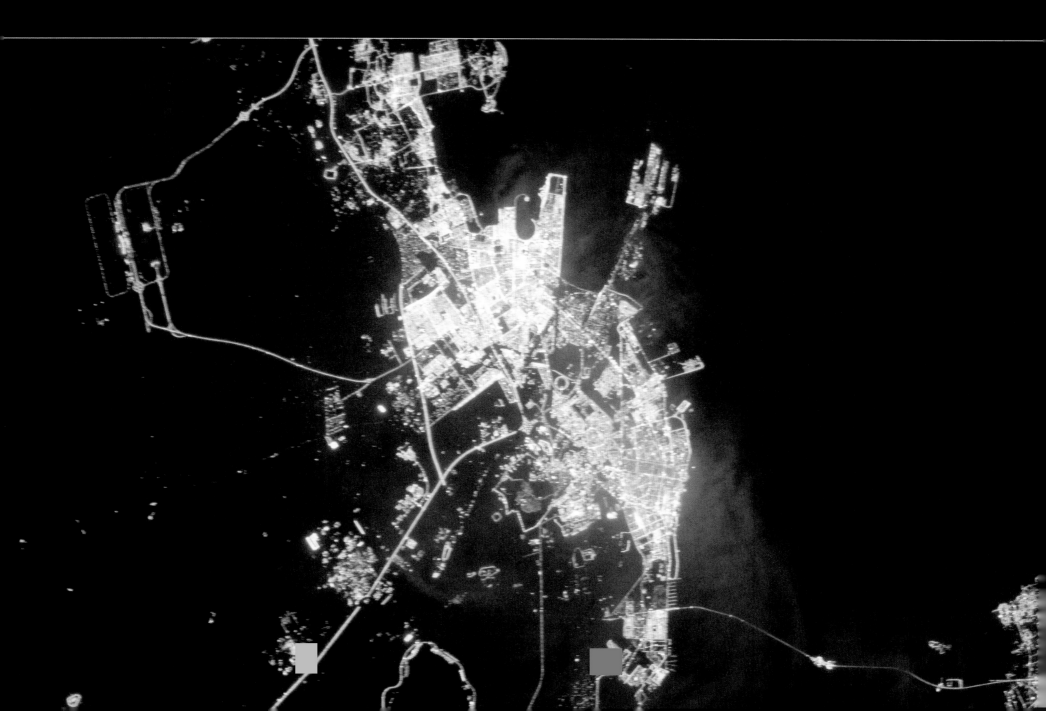

Before the discovery of oil in the late 1930s, Ad Dammam, the largest port on the Persian Gulf and the third-largest city in Saudi Arabia, was no more than a cluster of small hamlets whose residents relied on fishing to make a living. Ad Dammam is now a city of more than two million and is connected to Bahrain by the sixteen-mile-long King Fahd Causeway. You can see the distinctive lights on the bridge that are the pair of artificial islands that sits in the middle of the sea at the agreed-upon maritime boundary between Saudi Arabia and Bahrain. The terminal buildings for the international airport are the orange and green rectangles just above the city proper. Sodium vapor lights are used along the main roads and are seen as orange lines across the city.

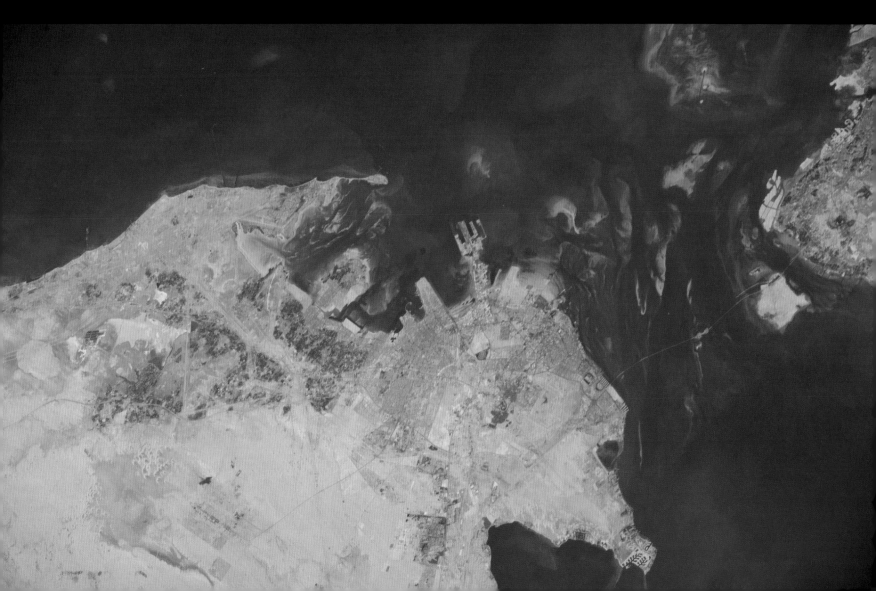

The nation of Bahrain is actually an archipelago of thirty-three islands in the Persian Gulf sandwiched between Qatar and Saudi Arabia. The country's economy is based largely on the export of oil. Al Manama is the capital city and accounts for half of the nation's population.

(OPPOSITE) Seen here, the lights of the main roads are one color while the lights of the central business district are another, imparting to the city of Manana a playful mosaic of curves and squares unmatched in the night sky. The King Fahd Causeway connecting

Bahrain to mainland Saudi Arabia is clearly visible to the left of Bahrain. The international airport is at the top right of this photograph as seen in orange. Bahrain's population is 1.2 million.

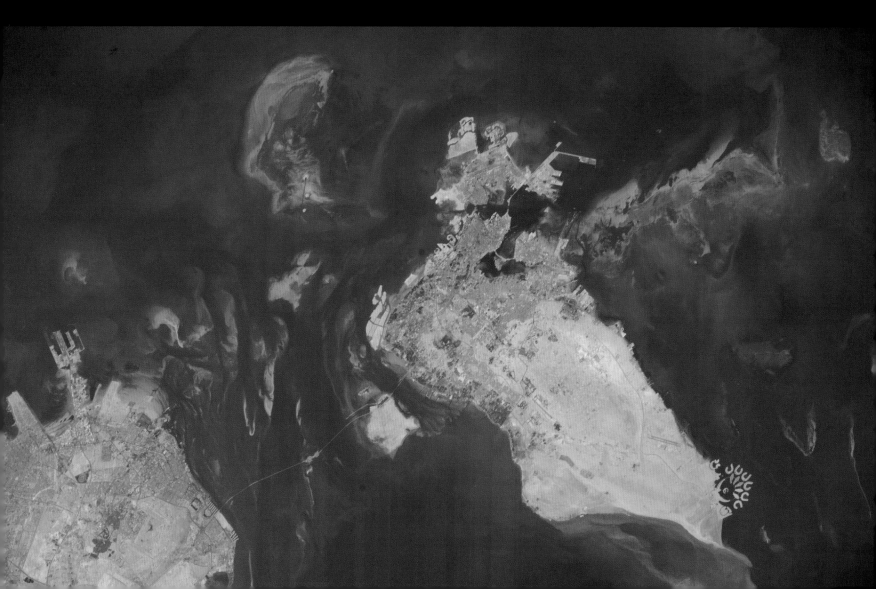

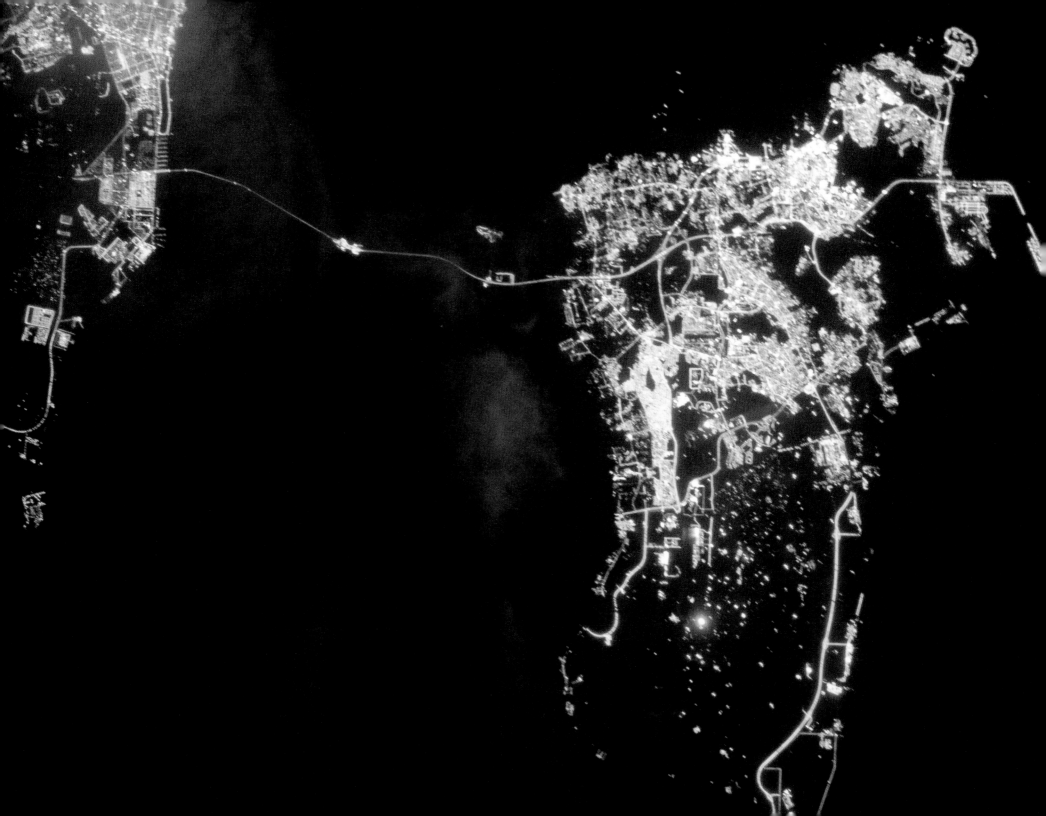

Qatar/Doha

The interplay of mercury vapor lights (bluish) with sodium vapor accents (orangey) turn Doha, Qatar, into a radiant nighttime jewel of sparkling light. Home to some of the most dramatic and at times playful skyscrapers in the world, Doha is considered to be one of the most architecturally interesting cities of the Middle East. The country traces its origins back to an original coastal village, known for the pearls harvested from the oyster beds just offshore. A new man-made island on the old pearling beds is aptly named Pearl-Qatar and can be seen as the small circular "gear" to the left of the port toward the top of the photograph. The international airport is to the right of the port, easily seen in the daytime shot but reduced at night to mysterious blocks of bluish lights.

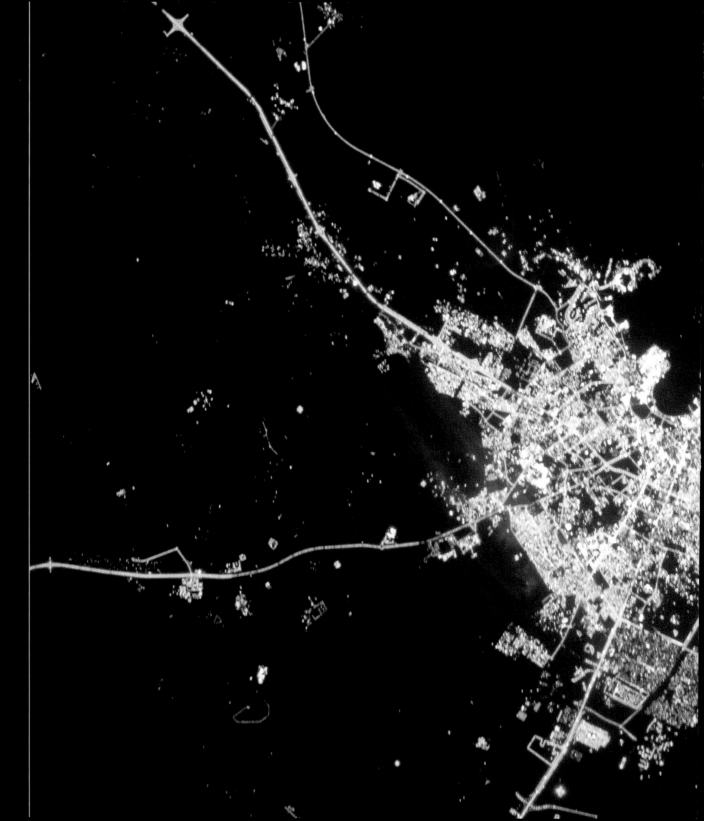

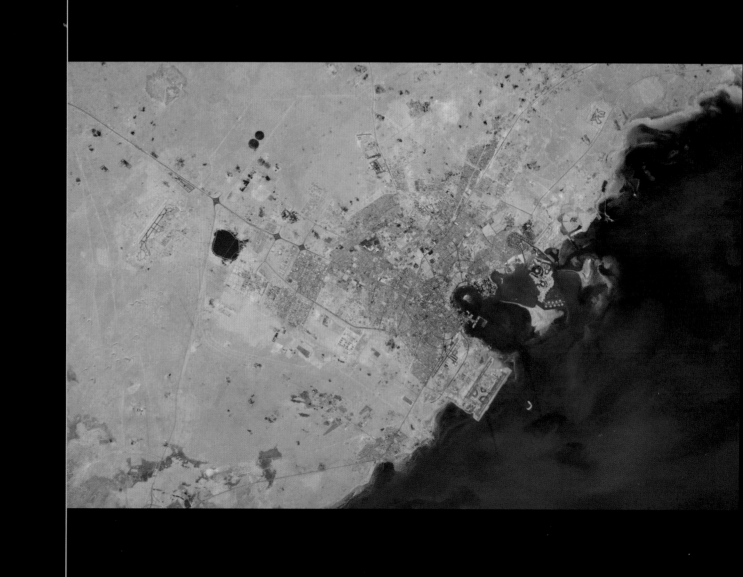

Tehran, Iran, dates back to the ninth century AD, but it wasn't until the sixteenth century, when a bazaar was built and the city was walled, that it began to grow in prominence. In the 1700s Tehran became the capital of Iran and began the surge of growth that would see it swell to a city today of thirteen million.

(BELOW) The lights on the peninsula mark the city of Baku, Azerbaijan.

(OPPOSITE) The mountains to the north form the dark ridge that brings the lights of Tehran to an abrupt halt. Just over the Protected Area, as this mountainous ridge is known, is the Caspian Sea.

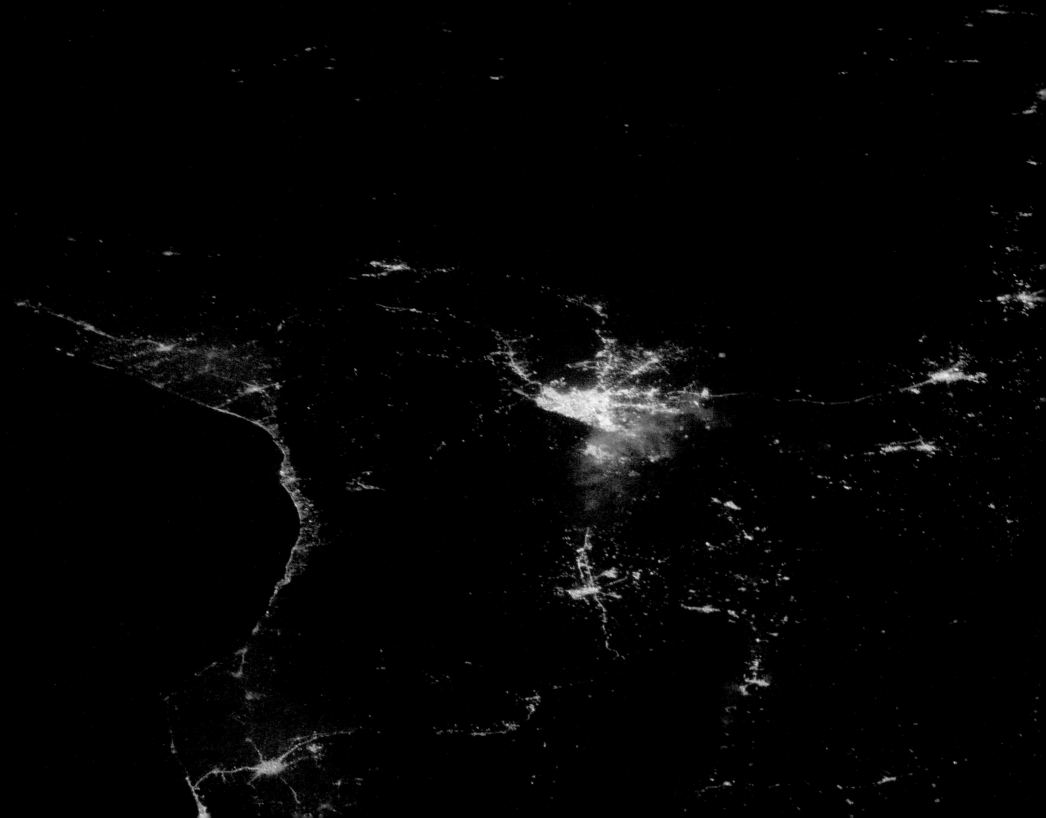

Iraq/Baghdad

The war-torn city of Baghdad dates back to the eighth century AD, when this planned city was established on a flat plain along the Tigris River. The early master plan was unique. The city was designed and built in two large semicircles of about twelve miles in diameter bracketing a circular central area that was two miles in diameter, all of which was walled. Well protected, surrounded by fresh water, blessed with a dry climate, and adjacent to the northern routes of the Silk Road, Baghdad was all but assured to grow. The Tigris can be seen curving through the city.

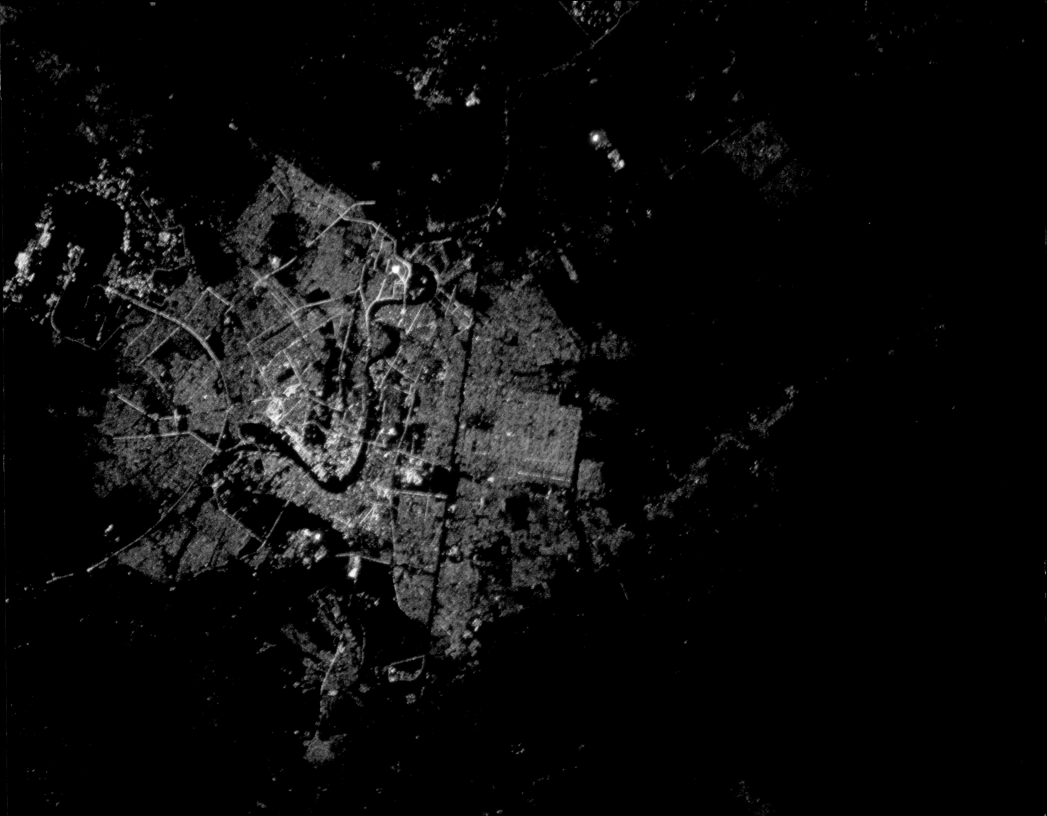

Kuwait/Kuwait City

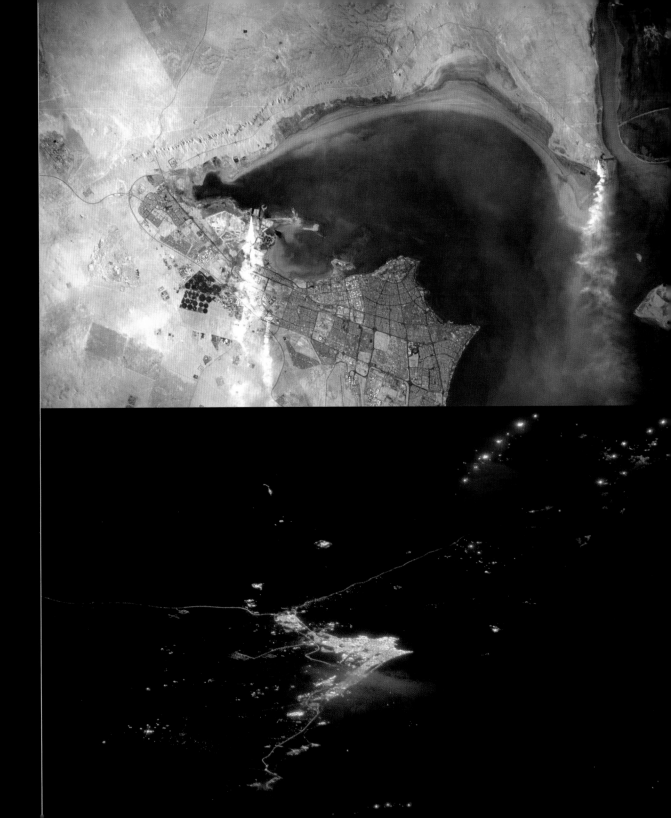

Kuwait City was a fishing village settled in the mid-1700s and walled in 1760. With the finest harbor in the northernmost part of the Persian Gulf, it was only natural that trade from Baghdad, Amman, and Damascus would funnel through it and onto the fleet of Doha sailboats based there. Today more than 2.3 million people live here. In these images, the peninsula of Kuwait City seems to be leaping out toward Az-Zawr on Failaka Island.

The Persian Gulf bends around the Musandam Peninsula and empties into the Gulf of Oman. The Musandam is a rugged, mountainous extension of the Arabian Peninsula. The narrows are called the Strait of Hormuz, a hazardous water passage twenty-nine miles wide with rocky outcroppings and rugged mountain walls on either side. In these three views, the brightest lights on the Persian Gulf side and are Ajman, Dubai, and Abu Dhabi. Muscat, Oman, is on the opposite side. The lights in the center of the peninsula are those of Al Ain, a desert city built around a thriving oasis that has grown to be the second-largest city in Abu Dhabi.

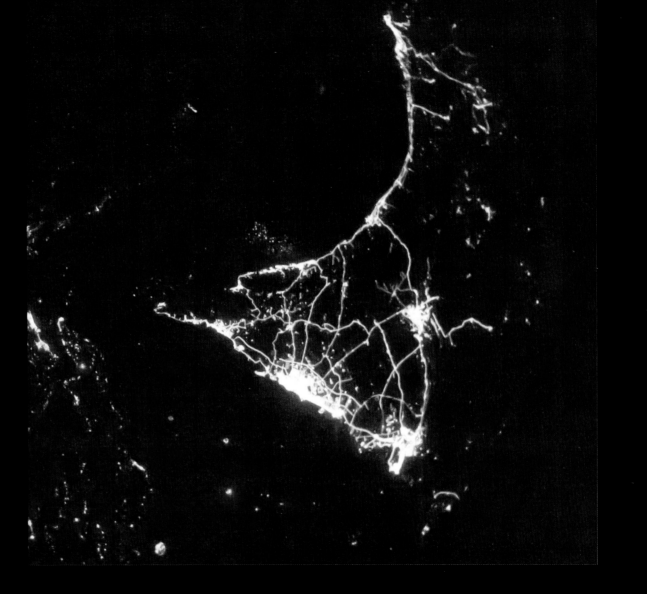

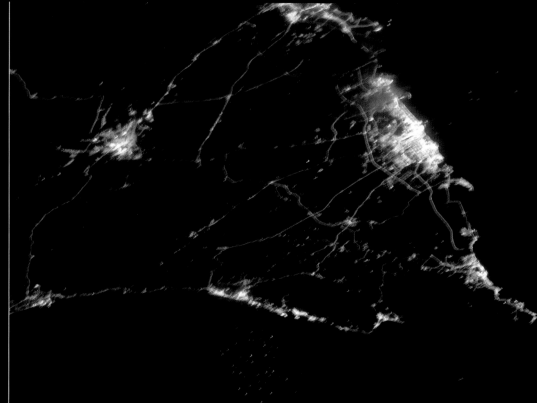
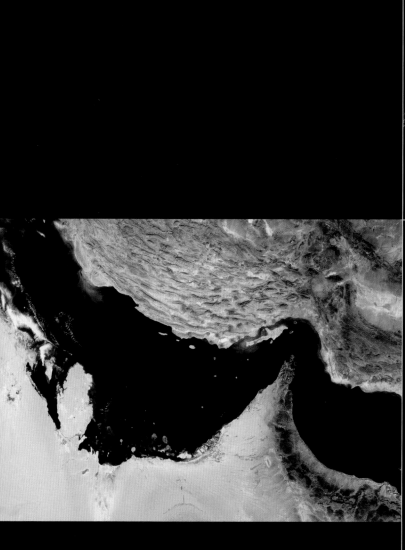

United Arab Emirates/Dubai

The blending of mercury vapor and sodium vapor lighting creates a colorful portrait of Dubai, one of the seven emirates of the United Arab Emirates (UAE).

(OPPOSITE) Dubai dates back to 1799 when it was settled as a modest fishing village. Spurred by steady growth in the region, by the late 1800s it boasted one of the largest port facilities on the Persian Gulf. The discovery of oil in 1966 nearly tripled its population and made it a city of international importance. Today Dubai is a major oil-producing nation with a population of more than three million and with imaginative construction projects including the two Palm Islands and the World Islands. Palm Jumeirah was the first of the Palms to open. It was built from more than fifty million cubic meters of sand. It is visible in the upper left of this photograph.

(RIGHT) Looking down the Arabian Peninsula. Abu Dhabi is in the foreground, Dubai is just beyond. Dubai and Abu Dhabi were two of the founding members of the UAE.

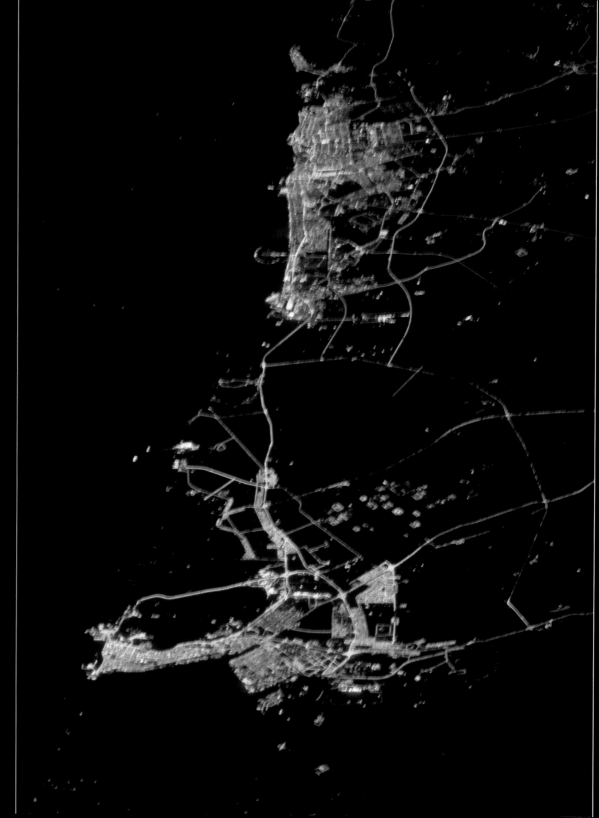

UAE/Oman and Abu Dhabi

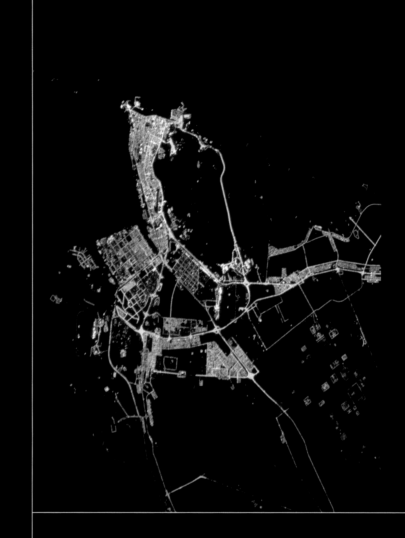

(OPPOSITE) The Sultanate of Oman, not part of the UAE, has strong trading links to India and Africa and has used its oil profits to build its tourism, mining, and manufacturing industries. Oman has a population of 2.8 million. Muscat, the capital and pictured here, has a population of one million.

(ABOVE) Abu Dhabi's center city sits on a squat, T-shaped island in the northeastern Persian Gulf. It is connected to the mainland by a series of bridges and bracketed by large sandbars on either side. These features give Abu Dhabi its unusual appearance at night. Major roads are lit by orange sodium vapor lights. Abu Dhabi has a population of just under nine hundred thousand.

What We See:

"Nighttime
is very cool
because people
get a totally
different
perspective.
It allows you
to think in
a different
realm."

Earth at night is absolutely spectacular—you can see things that you can't see in the daylight, like thunderstorms and lightning; the cities at night. One of the neatest things for me was to fly over the United States and see the tremendous amount of lights along the eastern seaboard from Maine all the way down to Florida—it was almost like looking at a map of the United States that had been painted neon orange. It's just so dense. But then the other cool part was getting over Australia or Africa and seeing the lack of lights until you come to cities. It's really cool to think how spread out those less-developed countries are.

I found it fascinating how the presence of light would draw the outline of the maps of countries. To be up there and to be able to see the shape of Europe and the boot of Italy because of the light was kind of cool. But then you'd fly over Australia, where there's less light, and you had to imagine how the continent was shaped if you did have light everywhere. We'd try to find London and Paris and Tokyo, but it was so cloudy so often. Typically at night when you see the clouds over a real populated area there's a haze the lights of the city create. And if you throw that in with a storm front, as you come upon that city you see those gauzy clouds get thicker and thicker until you lose the city lights and pick up lightning.

Nighttime is very cool because people get a totally different perspective. It allows you to think in a different realm. Of the population densities. Or the development of a city. Or a village in India that you can barely see but know is there because you can see the lit highway that goes out of the city to the northeast and then it just stops. Because that's where civilization ends.

When I flew, we didn't have cameras capable of taking good pictures at night. I tried a few night

shots with the cameras we had, and you simply couldn't do it; today they have the new Nikon D3S cameras that can do at night what we could do at daylight. But when I flew, my time in the window at night was looking in awe and marveling at how beautiful it was.

I didn't know what to expect on my first flight. When I got to orbit, I adapted almost instantaneously; I didn't get sick, I didn't have vertigo. The station has a din to it. When you first come in, you'll hear it. When we do a reboost to raise the station's orbit, you hear the engines fire and feel the thrust and the acceleration. When I slept at night, I sensed the vibration of the solar arrays turning through my module where I slept, which was kind of neat to me.

(OPPOSITE) The Black Sea as seen east of Bucharest, Romania, near Constanta.

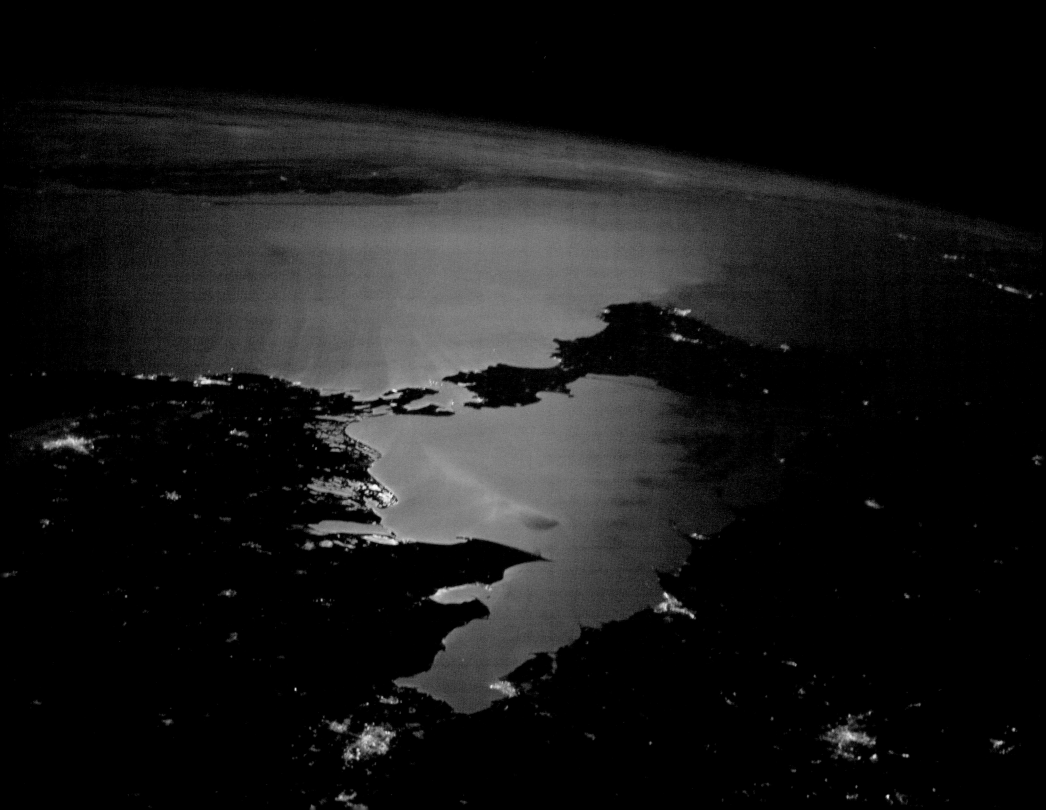

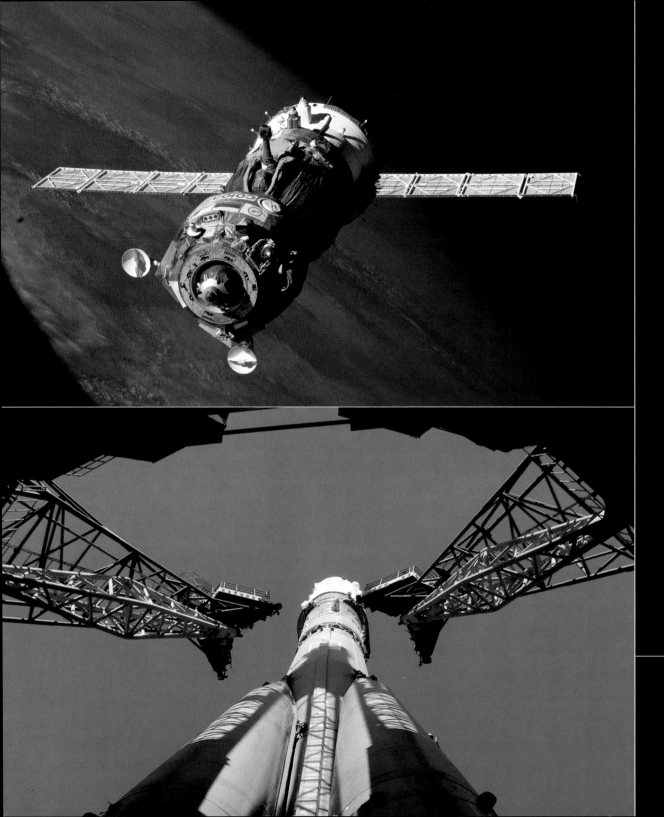

The history of the astronaut corps has been grounded in short-duration missions. Now, with the ISS, it's all about long duration, six months in space heading up on a Soyuz rocket and coming home on a Soyuz capsule. It's a huge paradigm shift in the way we work, this shift to long-duration space flight.

Why six months in space? After about six months the Soyuz capsule needs to come back down. Originally we in America talked about four to six months, and the feeling was that four months was ideal. You weren't there too short of a time or too long of a time. The problem now is that you need the Russian spaceship to get you up there and Soyuz capsules have about 180 days of lifetime on orbit, which is kind of where the six months come from. And of course the Russians have been doing six months for quite some time and we gravitated towards that simply because we're using their vehicles to get up and down.

Why are night images resonating? People have never seen these pictures before. The fact that we're able to tweet them is huge. We need to engage people on the importance of space flight, and social networks let us instantaneously show people what we're doing. The users of social media are young, they're the future; we need more people to be pumped by science and math and doing cool things in space—especially in America. If I can tweet a picture every day or two and fire up new kids, new people about the space program, then I am getting something done.

— Astronaut Clayton C. Anderson, Flight Engineer and Science Officer on Expedition 15. Mr. Anderson was also on STS-131, a resupply mission to the space station flown on the shuttle *Discovery*.

(TOP, LEFT) A Soyuz capsule separates from the space station for the journey back home.

(BOTTOM, LEFT) The Soyuz launcher on the pad.

(OPPOSITE) A crowded space station.

Docked on the station is an unmanned Progress resupply vehicle, an unmanned Japanese HTV-2 resupply vehicle, and two Soyuz capsules.

SOUTH AMERICA AND MEXICO

Like in Australia and Africa, the lights that mark our presence on the continent of South America show only a shell of the actual land mass. Owing to its topography and thick jungle growth, the interior of this continent is largely uninhabited or lightly populated and thus disappears at night. Considering the extremes in terrain this is hardly surprising. Forty percent of South America is covered by rain forests, one of the driest deserts in the world is in Chile, the Andes trace the length of western South America, and vast grasslands account for much of the interiors of Argentina and Venezuela. Little wonder that 75 percent of the 388 million South Americans live in cities, many of which are on the coast. By the 1500s, South America, Central America, and most of Mexico were either entirely or largely under Spanish control, and rich natural resources flowed back to the Old World, including precious metals and stones. Over time, Incas along western South America, the Aztecs in Mexico, and the Mayas in Central America would be decimated by diseases brought to the New World by the conquistadores. The night lights in this section extend from Mexico City to Cancún and down to São Paulo and Rio de Janiero. Many world-class South American cities have yet to be successfully photographed from space.

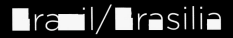 Brazil/Brasilia

Geography—and rigid urban planning—gives a delightful nighttime shape to Brasilia, the capital city of Brazil. Brasilia was conceived in 1956 as a way to shift population away from the crowded coastal cities to the interior by building a new capital city well inland. From the very beginning, Brasilia was a success. Tightly controlled by a master plan, Brasilia opened in 1960 and has blossomed into a city of some 3.6 million. As viewed from space, the metro area presents itself as a magnificent hunter dressed in gold with a bold breastplate speckled with dots of white that are the city center. Others describe the city center as the "airplane" of Brasilia with golden wings curving back from the fuselage. The dark waters of Lake Paranoá form the "shoulders" of this beautiful city while the scattered dark spots here and there are tropical savannas. Brasilia National Park is the large dark area to the bottom.

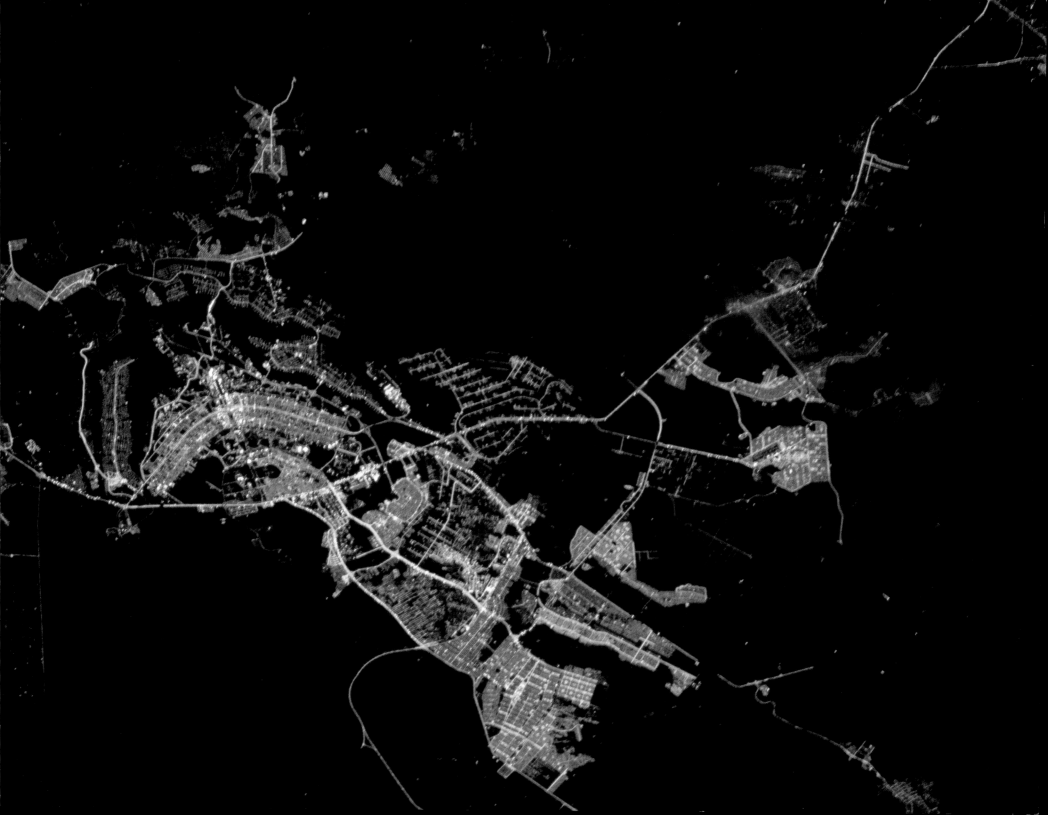

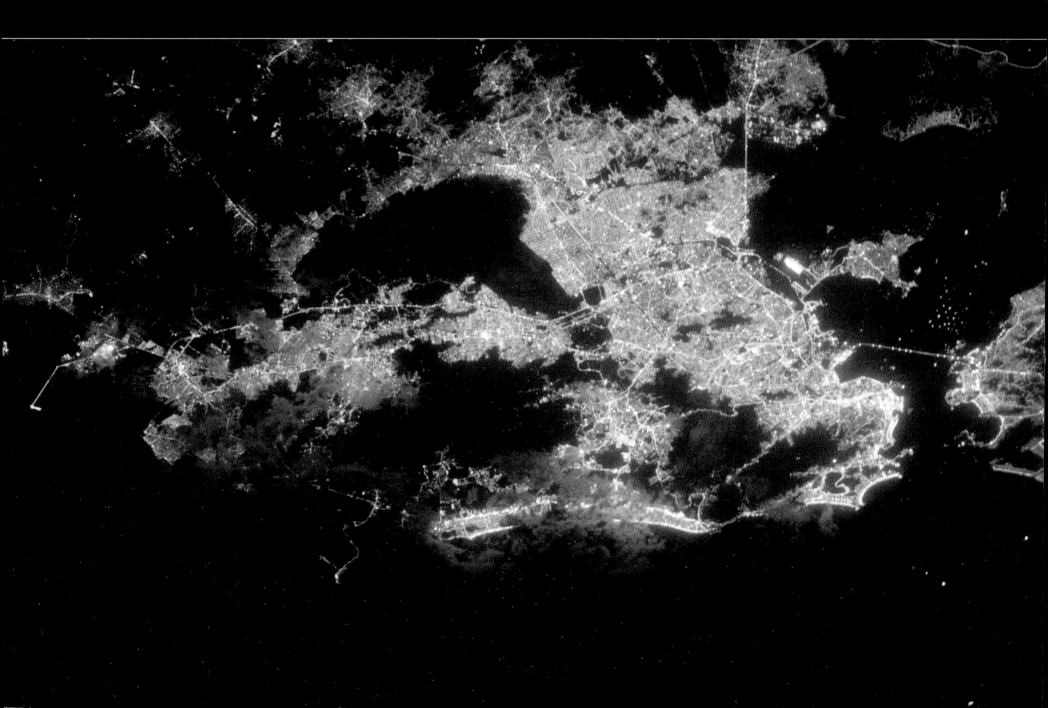

Portuguese explorers discovered Rio in January 1502, and thinking that it was the mouth of a river, unimaginatively named it Rio de Janeiro, or "River of January." The Portuguese formally colonized Rio some years later, but it wasn't until the early 1600s, when Portuguese Bandeirantes, originally colonial scouts and slave hunters, discovered gold and diamonds, that the city began to grow. Rio soon became a major port for the export of precious metals and stones, as well as cash crops from the area such as sugarcane. The geographically challenged city muscles its way around Guanabara Bay, in and around the mountainous terrain of Tijuca National Park, and down to the ocean. Copacabana Beach is the first scallop on the bottom right and is outlined in bluish-white lights as is Ipanema Beach to its left. More than six million live in the city, with more than fourteen million in the metro area.

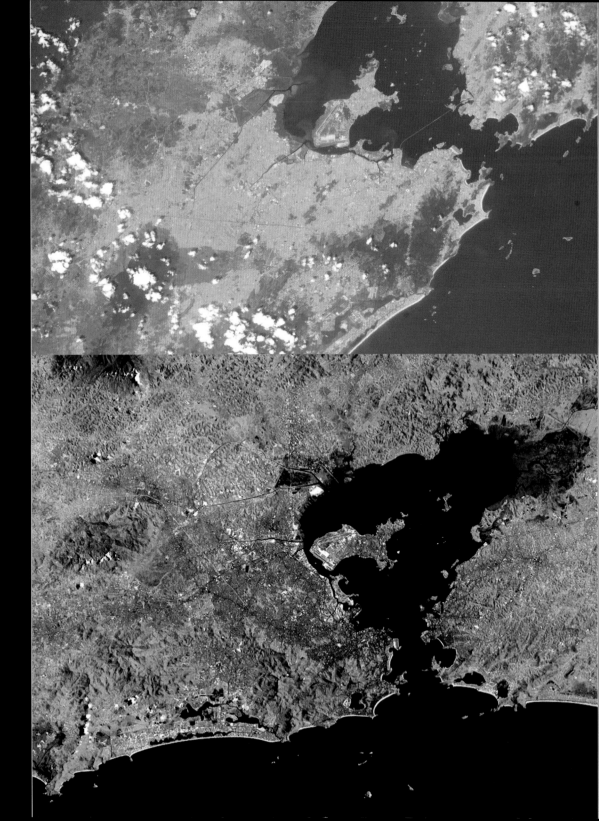

Brazil/São Paulo and Cabo Frio

(LEFT) Settled by the Portuguese in 1532, São Paulo is the largest city in Brazil and a major financial center of South America. Coffee exports propelled its early growth, and by the 1700s it was a thriving cosmopolitan area. Emigration to São Paulo was encouraged much the way it was in colonial America—land grants were promised to Europeans who would settle in the area. São Paulo drops down twenty-five hundred feet across mountainous terrain to the port city of Santos on the coast. The metro area has a population of 19 million.

(OPPOSITE) The seaside town of Cabo Frio is home to nine popular beaches and is a major vacation spot for Brazilians. Cabo Frio is the bright blue area in the bottom right facing the ocean and backing up to the bay.

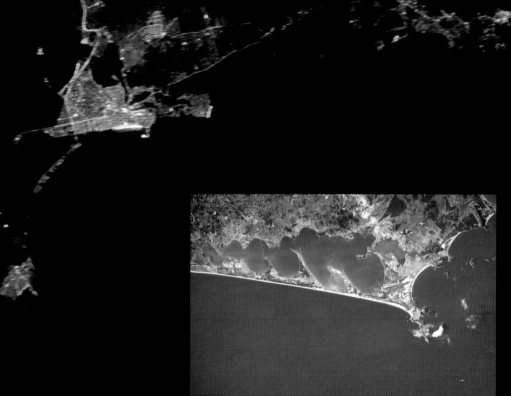

Guadalajara and Mexico City

The proud Mexican cities of Guadalajara, this page, and Mexico City, opposite, embrace unusual geographic features that shape their nighttime signatures. The lights of Guadalajara come up to the edge and partially hug the magnificent seventy-five-thousand-acre nature preserve called the Bosque de la Primavera, seen as the dark area to the left of the city. Guadalajara is home to four million people.

(OPPOSITE) Mexico City, a metro area of twenty-one million people spread over more than 570 square miles, is interrupted by the beautiful Bosque de Chapultepec, a sixteen-hundred-acre nature preserve called the "lungs of the city." Rugged foot-hills, ravines, and mountains account for the second dark spot seen to the right of the Bosque.

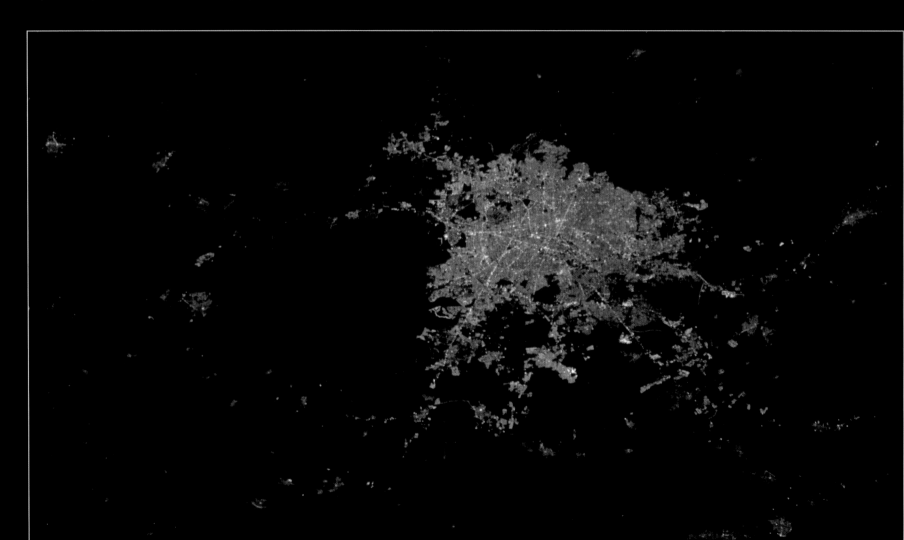

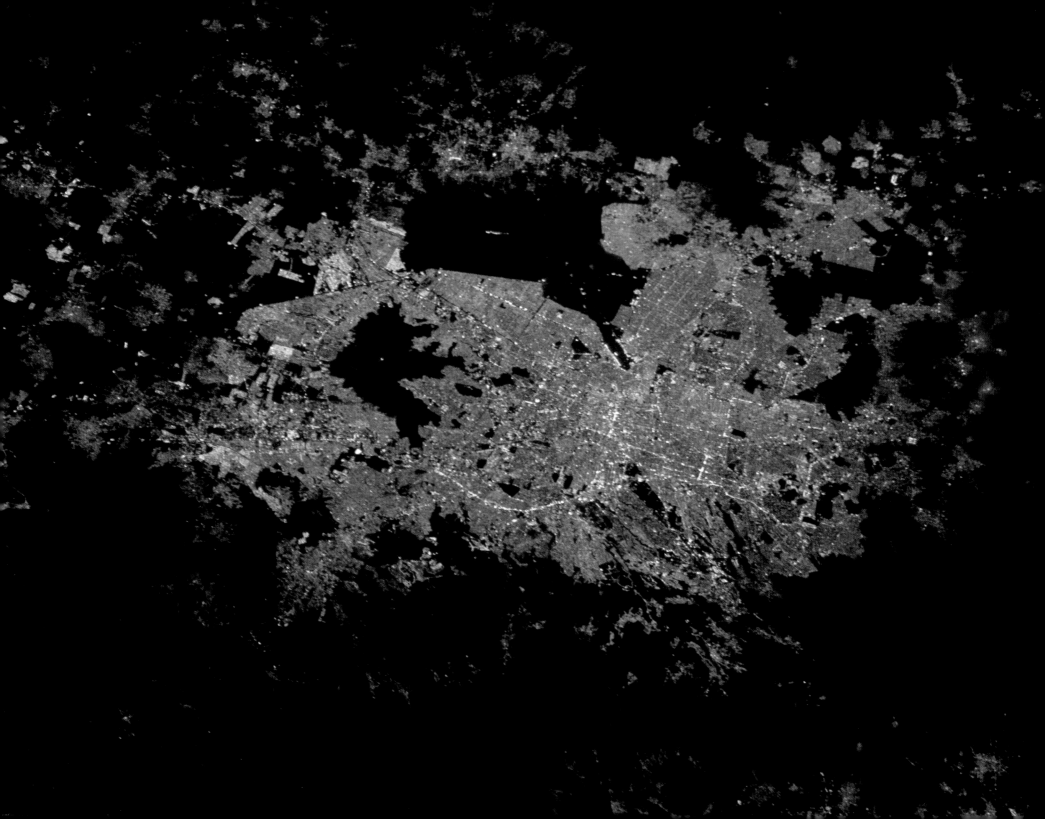

Cancún and Mérida

Although they both sit on the Yucatán Peninsula, no two cities could be further apart than Cancún and Mérida. Sandy beaches, luxury hotels, and piña coladas are among the things that come to mind when one mentions Cancún, right. In this exceptionally clear nighttime photograph, the city's famous beaches curve inward along the Caribbean while to the north is Isla Mujeres. The inland city of Mérida, shown opposite, is better known for its nearby Mayan ruins and its historic city center but it has no beaches, although the federal highway makes a beeline across the short twenty-two miles to the beach town of Progreso, Mexico.

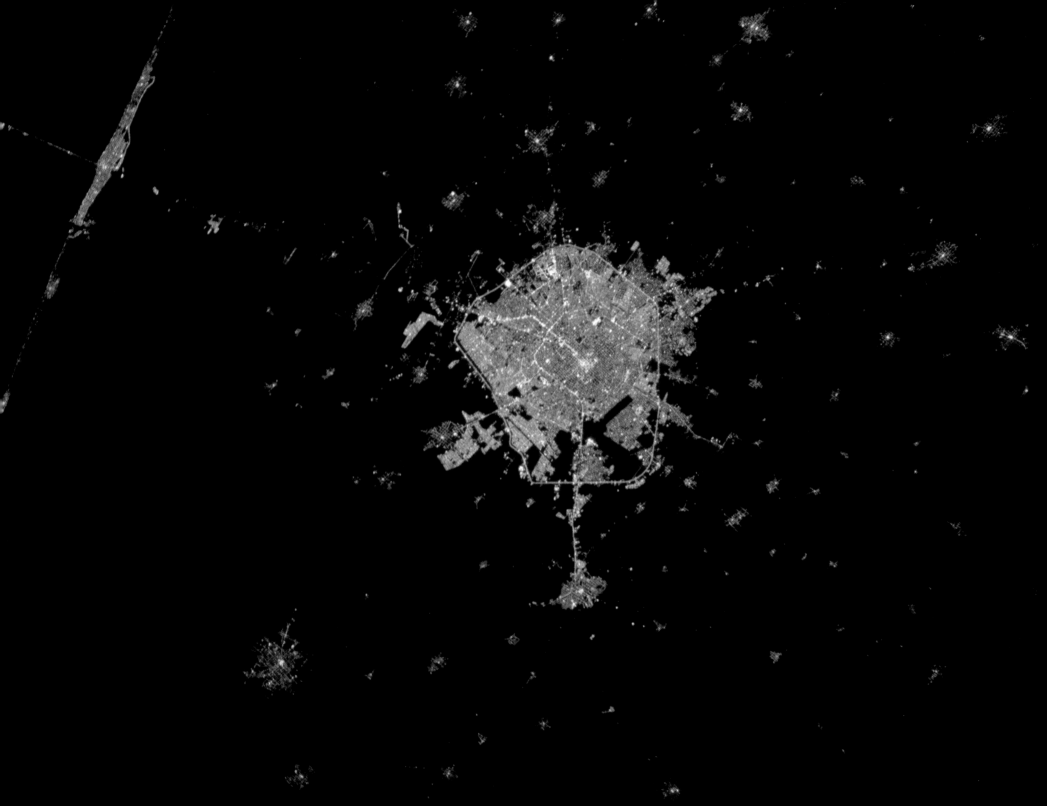

ASTRONAUT DONALD R. PETTIT

What We See:

"Earth at night is a jewel that nobody has been able to capture on film before and share with the public."

You see Earth from space and you want to record this beauty so you can share it with other people. Earth at night is a jewel that nobody has been able to capture on film before and share with the public. We see all kinds of daytime astronaut photography, and it looks pretty close to what you see with your eye. But we haven't had the equipment capable of recording anything near what nighttime Earth is like until recently. The nighttime imagery we're able to do now is so much better than even a year ago, and for the first time, it gives people on Earth a chance to experience something close to what an astronaut can see.

We have a very defined orbit, and we go up to 51° latitude. So if you wanted to have a nadir view, which is a straight-down view, you can't see anything above 51°. Now you can look obliquely to see farther than that. Just as an example, Moscow is about 55°, so there are no nadir-looking views taken from the space station of Moscow, but you can get oblique views. Obliques are more like what you see with your eye.

Most people, when they get on station, want to use the 400 and 800 mm telephoto lenses to take a picture of their hometowns. They take telephoto images and zoom in and get marvelous images, the Eiffel Tower, the pyramids, etc., and go "wow." But why take a picture that a machine like Google Earth is already doing? There are no satellites that give you oblique images. That is a unique perspective from the space station. Human beings can make compositions that satellites can't. There are all kinds of fascinating human-derived patterns—whether it's cities or agriculture patterns in fields—that are visible from space, and some of these images can be composed using the human eye and made into spectacular imagery. Satellites can't do that.

Why has it taken so long to photograph Earth at night? Partly because of crew time and partly because of the cameras. The cameras we have now are so superior to anything we've had in the past. The other thing is that crews now have the time. Shuttle missions were typically eight to ten days, but when you live and work on the space station you have off-duty time, and this is when a lot of people take pictures of Earth. On station in 2003, I put together this tracker that for the first time compensated for orbital motion and allowed you to take one- to two-second exposures that were nearly free from any kind of orbital motion effects. Today, the cameras are so much better than anything we've had before. The stuff that is coming down is really amazing. And at night, everything shows up.

Things happen really fast on orbit. Earth's diameter is twenty-four thousand miles. We make one orbit every ninety minutes. Specific

sites come up so quickly that unless you get to the window early and have your camera all set up to go, you'll miss it. If you want nadir views of something—straight down—you're only on target for maybe ten seconds and then you've missed your window; it's gone. Say you went over Kennedy Space Center and you shot a whole lot of pictures of the launchpad area. Almost before you can get your memory card changed out and a new one put in, you're over Cuba. If you don't have a second camera body or something ready to go, you're going to miss it.

How far can we see? Looking along your flight path, your horizon is about two thousand kilometers in either direction. I did an experiment; when I was over the central part of Australia, I could see both the east coast and the west coast at the same time.

Everybody who's in space sees something different. Earth from space is such a different perspective from what we're used to. It's an amazing sight. I find the experience reaffirms what your existing philosophies and beliefs are. Some look at Earth from space and say human beings are ruining it, and others say, "Wow, it's unadulterated, it's beautiful," and some look at Earth from space and are convinced that it proves there is God. If you're atheist, you'll look at Earth and you'll say this proves there is no God. If you think that human beings are trashing the planet, you'll look at it and say human beings are trashing the planet. If you think that we're working well with nature, you'll look at it and say, "Wow, look at this; it's a big planet."

How can two people have such diametrically opposed views? If you look at the Los Angeles area with your eye at daytime, it's a gray smudge; you cannot see any effect of man unless you already know that man is there. Another person can look at that and say that gray smudge down there, that's Los Angeles, isn't it awful? And all of these perspectives are fine.

— ASTRONAUT DONALD R. PETTIT, PHD. DR. PETTIT PIONEERED NIGHT PHOTOGRAPHY OF EARTH IN 2003 BY INVENTING A SIMPLE DEVICE TO COMPENSATE FOR THE FLIGHT OF THE INTERNATIONAL SPACE STATION AS IT TRAVELED AROUND THE PLANET.

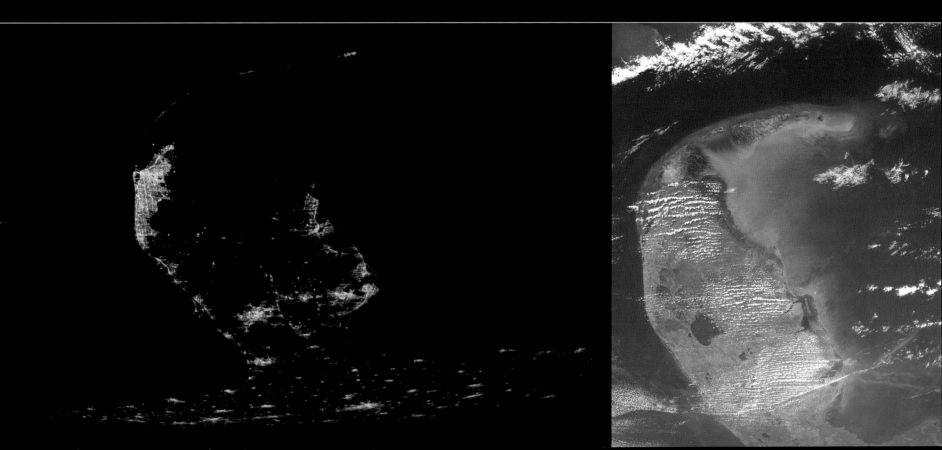

THE FAR EAST

Exotic cultures with histories painted in the delicate sheens of translucent porcelains and exquisite silks live side by side with crowded, bustling cities that have breathtaking skyscrapers soaring to ever higher heights. The old and the new, that's Asia, but what exactly is it? The term *Asia* was coined by early Western civilizations to describe disparate landmasses populated by Chinese, Japanese, Persians, Indians, Russians, Indonesians, and more. Asia is thus a definition rather than a geologic formation with obvious borders such as the continent of Australia. Today, most people agree that Asia is the landmass separated from Europe by a line drawn from the Urals down to the Bosphorus and separated from Africa by the Red Sea, thus incorporating Saudi Arabia and other "Middle Eastern" countries on one continent, although even these boundaries remain subject to some academic debate. That said, across this vast and varied land, contrasts abound. The world's highest peaks, the Himalayas, are found in Asia, but Asia also has the largest desert, too. So vast is this land that the Caspian Sea is actually considered a lake, but so intimate is it that a single day visiting a Buddhist temple can be transforming. The post-World War II economic boom propelled the great cities of Asia to the prominence they enjoy today. Bustling ports ship fish, rice, tin, pearls, palm oil, rubber, petroleum, electronics, cars, and countless other natural and manufactured goods to the rest of the world. Almost four billion people live in Asia, and some of Earth's brightest lights can be seen here. Cities with metro populations between ten and twenty million people are routinely found on the Asian continent.

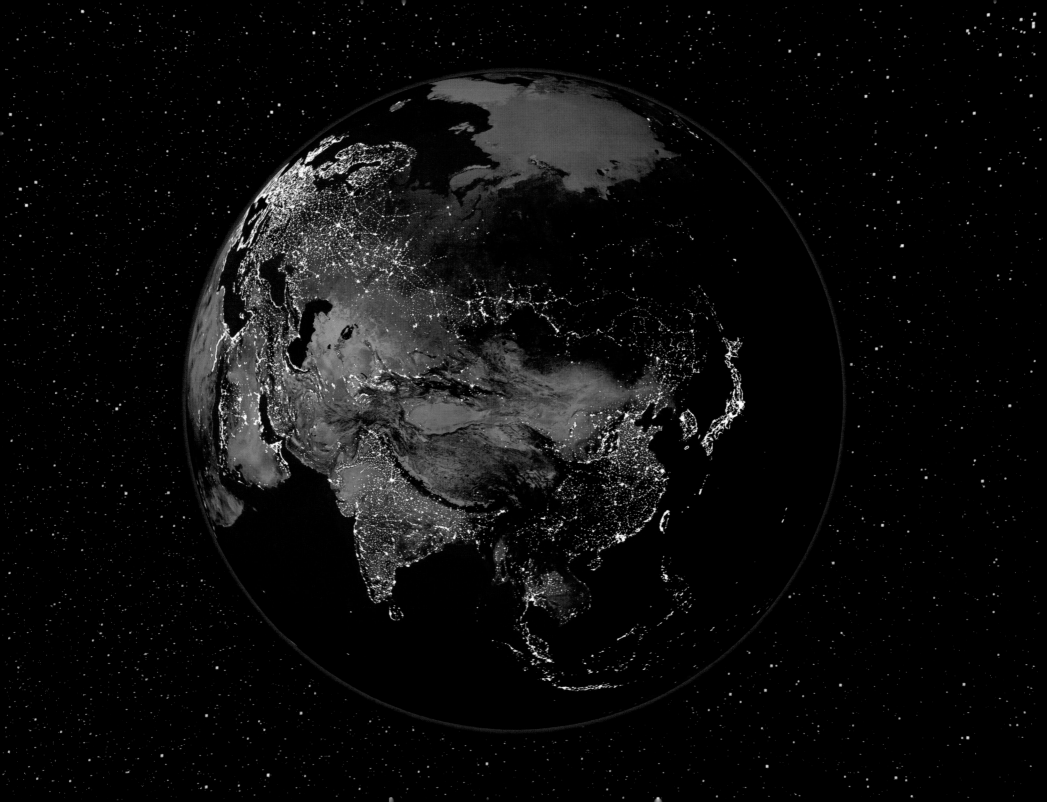

Vietnam/Ho Chi Minh City

Ho Chi Minh City, Vietnam. A swirl of soft clouds masks a vibrant city of nine million. After two millennia of divide, a newly unified Vietnam has arrived on the world scene as a major force in manufacturing and agricultural exports. Ho Chi Minh City sits on the edge of the fertile Mekong Delta and has both superb port facilities on the Saigon River and access to the South China Sea. Ho Chi Minh City has become one of the economic hubs of the Far East. The dark triangle in the center of the city is Tan Son Nhat Airport. The lights of fishing vessels can be seen at the bottom right.

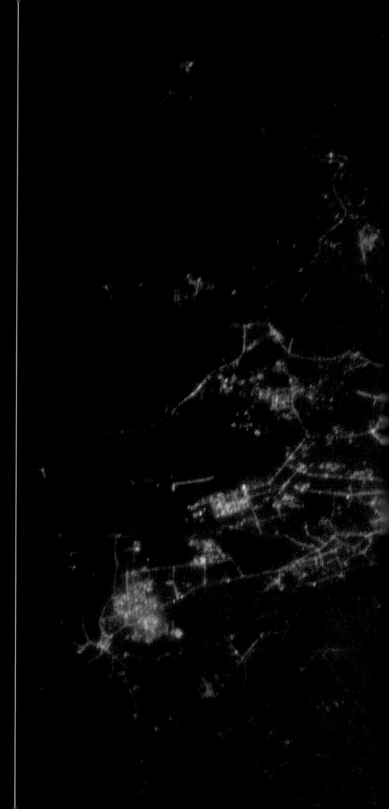

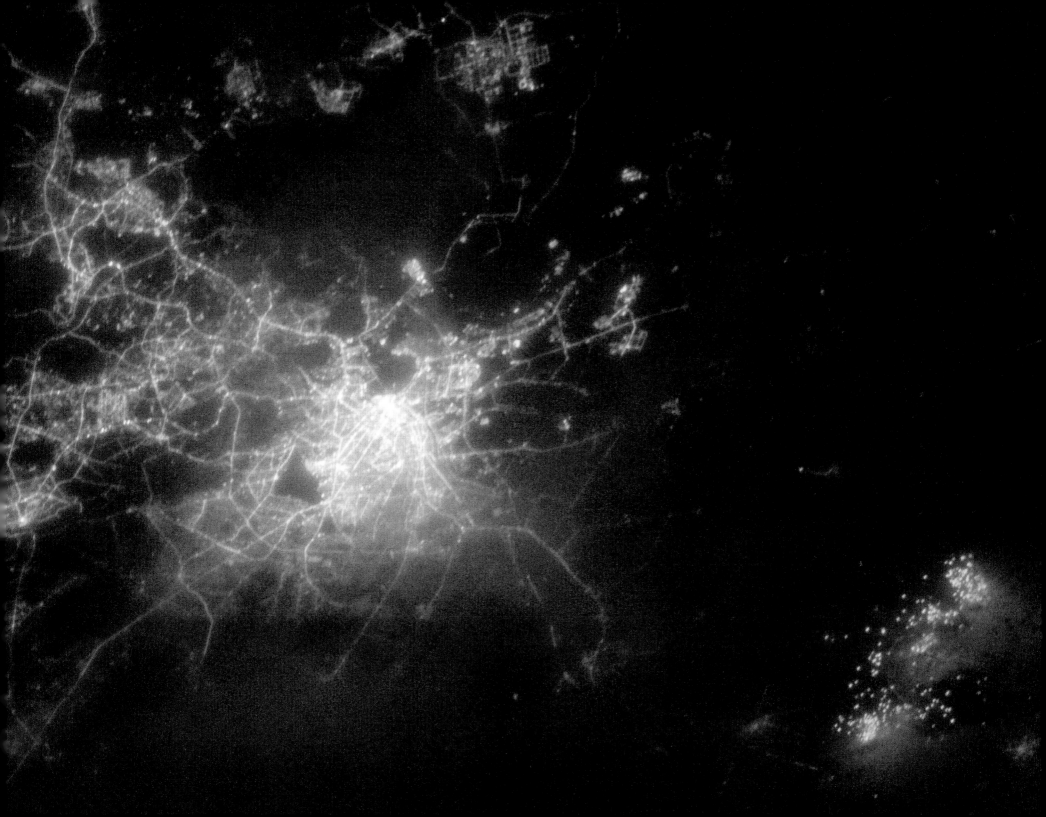

Thailand/Bangkok

Thailand is unique among countries in the Far East in that it is the only nation never to have been ruled by a Western power. Thailand exports tobacco, rubber, rice, sugarcane, silk, soybeans, electronics, and other products. The capital city of Bangkok sits at the mouth of the Chao Phraya River and wraps its arms around the Bay of Bangkok. The dark spot in the center is Lumphini Park. The population of Bangkok is eleven million.

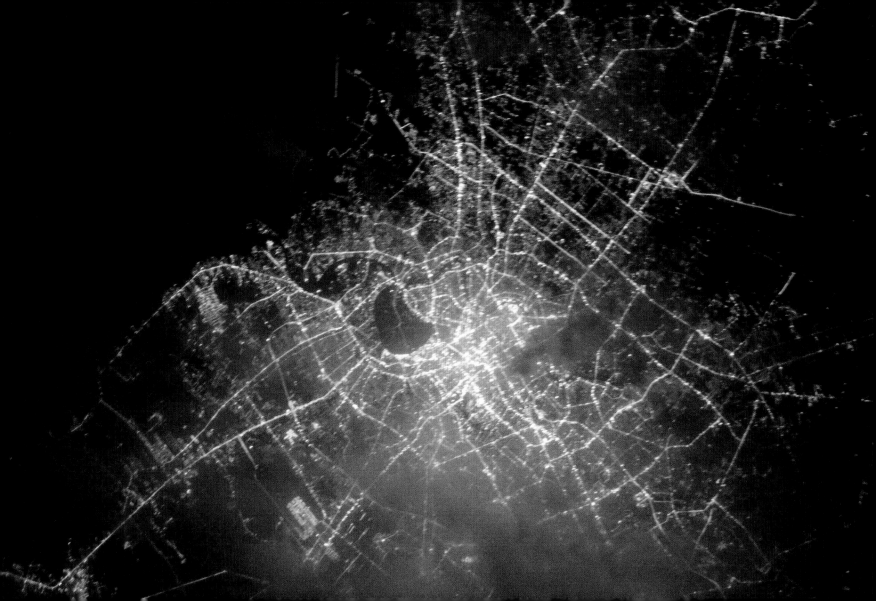

Kuala Lumpur, Malaysia, and Manila, Philippines

The nation of Malaysia consists of two landmasses separated by four hundred miles of the South China Sea. Peninsular Malaysia extends down from Thailand south into the South China Sea. In this panoramic view, the capital city of Kuala Lumpur is at the top left, while the island nation of the Republic of Singapore is seen at the bottom. Although oil has become the nation's primary export, Malaysia is or has been the world's leading producer of rubber, tin, bauxite, and palm oil.

(OPPOSITE) More than seven thousand islands make up the Republic of the Philippines, although fewer than one thousand are inhabited. The Philippines were colonized by Spain in the 1500s and named after King Philip II. Spain ceded the Philippines to the United States at the end of the Spanish-American War. Japan invaded the Philippines in 1942.

The capital city of Manila is seen on the upper right-hand side of the land bridge between Manila Bay on one side and Laguna de Bay, a freshwater lake, on the other side. Some sixteen million people call metro Manila their home.

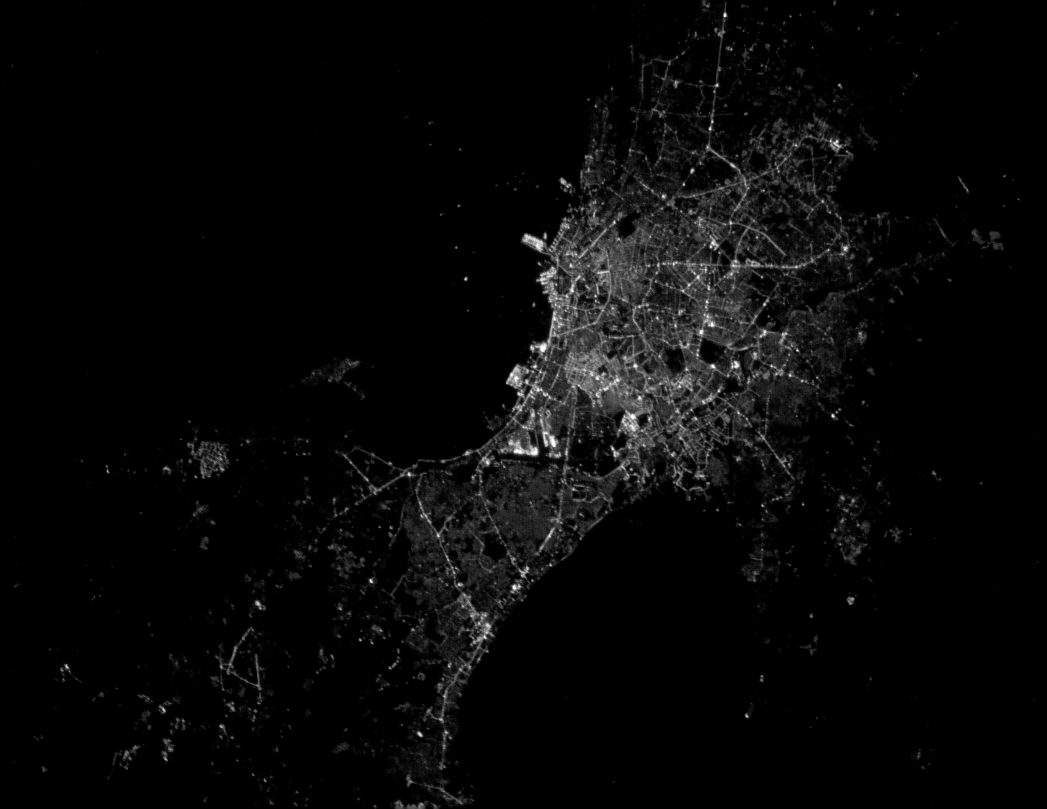

Singapore

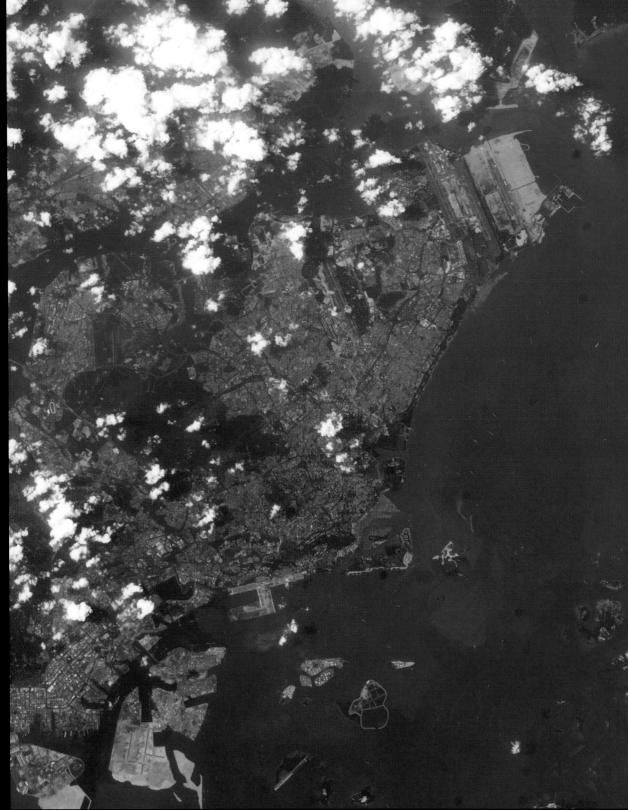

(OPPOSITE) The island nation of the Republic of Singapore is separated from Malaysia by the Johor Strait, which is the dark, curving line around the top of the island. The Johor-Singapore Causeway connects mainland Malaysia with Singapore and is visible as a short thread of light in the center. The port and naval installations are to the front of the island, as is the international airport. The lights of fishing vessels speckle the waters just offshore.

Taiwan/Taipei and Kaohsiung

(OPPOSITE) Taipei, seen in the middle, top, is the largest city on this island nation of twenty-two million. Taipei sparkles with soaring skyscrapers and luxury hotels but is also rich with period architecture and museums. Originally named Formosa ("beautiful island") by the Portuguese, Taiwan has a balanced economy based on agriculture and manufacturing.

(BELOW) Soft clouds partially obscure the center of Kaohsiung, Taiwan, one of the largest ports in the world. From the interior of Taiwan and from fleets of fishing vessels, fruits, vegetables, fish, and more flow into the enormous processing plants that ring Kaohsiung harbor. Container ships take these staples to the rest of the Far East. The Love River bisects the city.

Twenty-one million people occupy the seven islands that make up the city of Mumbai, India. A large harbor and its strategic location along the sea routes that link Africa, Europe, and the Middle East gave rise to its prominence as one of the major trading and distribution centers of the Far East. In the late 1500s, the region fell to the Portuguese, who named the city Bom Bahia or "beautiful bay." When the British took control of India, they re-named it Bombay, but in recent years the city has reverted to its original name, Mumbai.

Land reclamation projects have connected some of the seven islands, giving Mumbai its distinctive nighttime appearance. The "eye" of Mumbai is Mahim Bay. Mumbai embraces the Back Bay at the top, left. The terminals of the international airport are seen just below the city as a rectilinear cluster of orange lights.

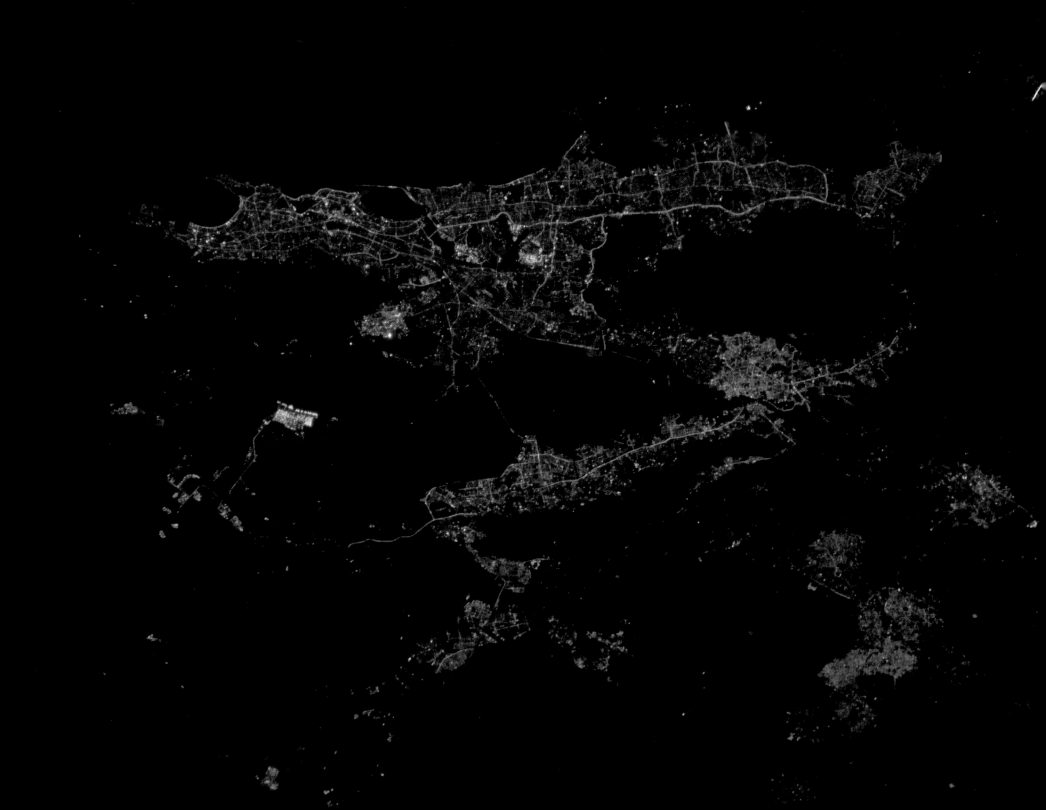

China/Beijing to Tianjin

(OPPOSITE) Lights abound as Beijing and Tianjin, China, are captured in this panoramic image taken from the space station. The dark areas in and around the cities are farms and fields of wheat or corn. Beijing is one of the oldest capitals in the world and is the economic, cultural, and government center of China. It is laid out in neat grids with major roadways surrounding it in concentric rings. Twenty-two million people live here.

(BELOW) Tianjin is a major trade center on the South China Sea and is linked to Beijing and the vast interior via the South China Sea through the Hai River and to the Yangtze and Yellow Rivers via the Grand Canal of China. The Grand Canal of China is the longest canal in the world and a major waterway connecting two dozen interior cities. Its construction started in 486 BC. It begins in Beijing and goes south eleven hundred miles to Hangzhou near Shanghai. In this nighttime photo Tianjin is seen connected to the port city of Binhai Xinqu. The Hai River valley and floodplains are seen as the dark slash between Tianjin and Binhai Xinqu.

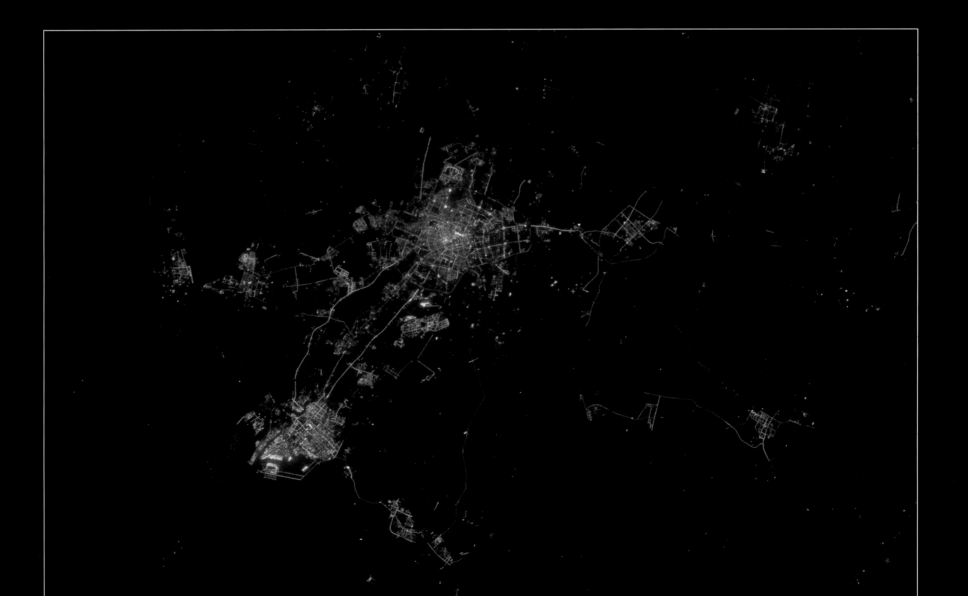

China/Beijing and Xian

(OPPOSITE) The ring roads that circle Beijing are clearly visible in this night photo. At the very center of Beijing is the Forbidden City, seen as a darkened rectangle. The international airport can be seen in the upper right-hand corner as a cluster of golden orange rectangles.

(BELOW) The eastern end of the Silk Road terminated at Xi'an, now simply called Xian.

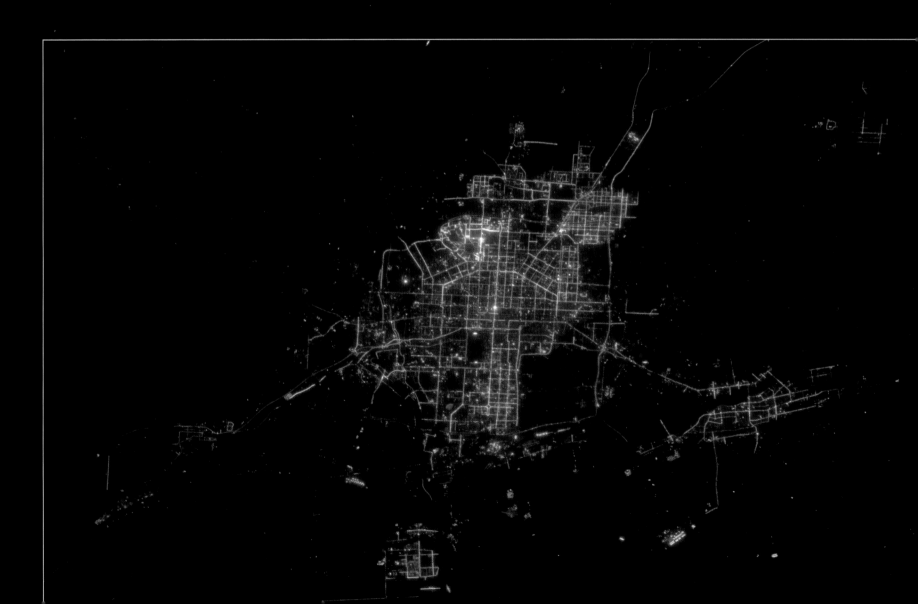

China/Shanghai

For generations Shanghai was a small trading town notable for a good harbor strategically located at the mouth of the Yangtze River. Foreign trade with China, however, was a one-way affair. China willingly sold goods but rarely allowed imports, essentially a closed nation. This trade imbalance led to novel solutions including importing opium, which foreign traders sold to Chinese smugglers, thereby equalizing the monetary flow. China clamped down on the practice, the British sent in ships, a war was fought, which China lost, and in 1842 Britain was granted a most favored nation status allowing trade to and from China through the port of Shanghai. Shanghai's population exploded as the port grew in stature. Trade with the United States and other nations soon followed, and the concept of "most favored nations" flourished in diplomatic circles through the 1970s.

(OPPOSITE) Fishing vessels can be seen off the coast of Shanghai. Taiwan is the island beyond the fishing vessels. Today the lights of Shanghai reveal a population of 22.1 million, narrowly passing Beijing as China's most populous city.

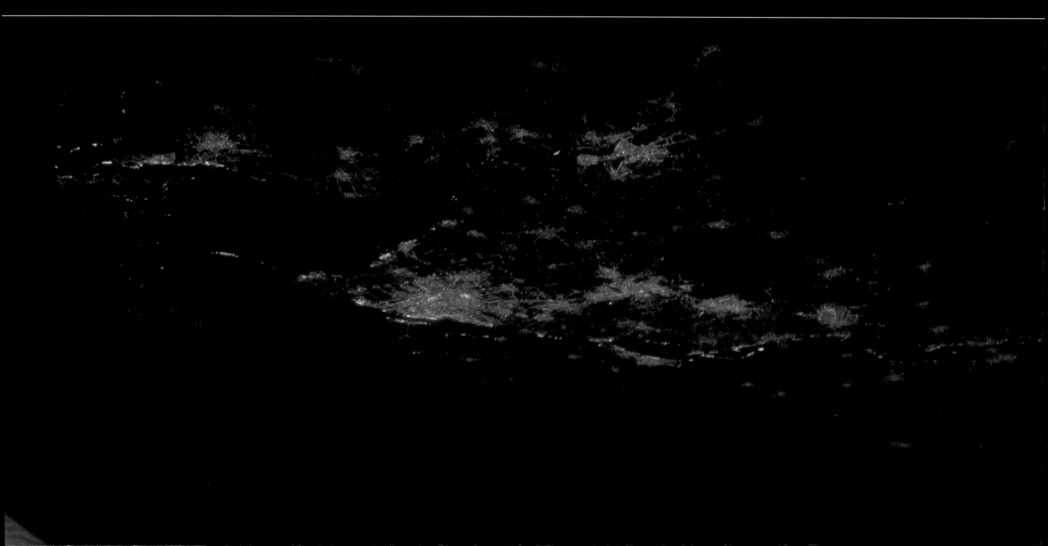

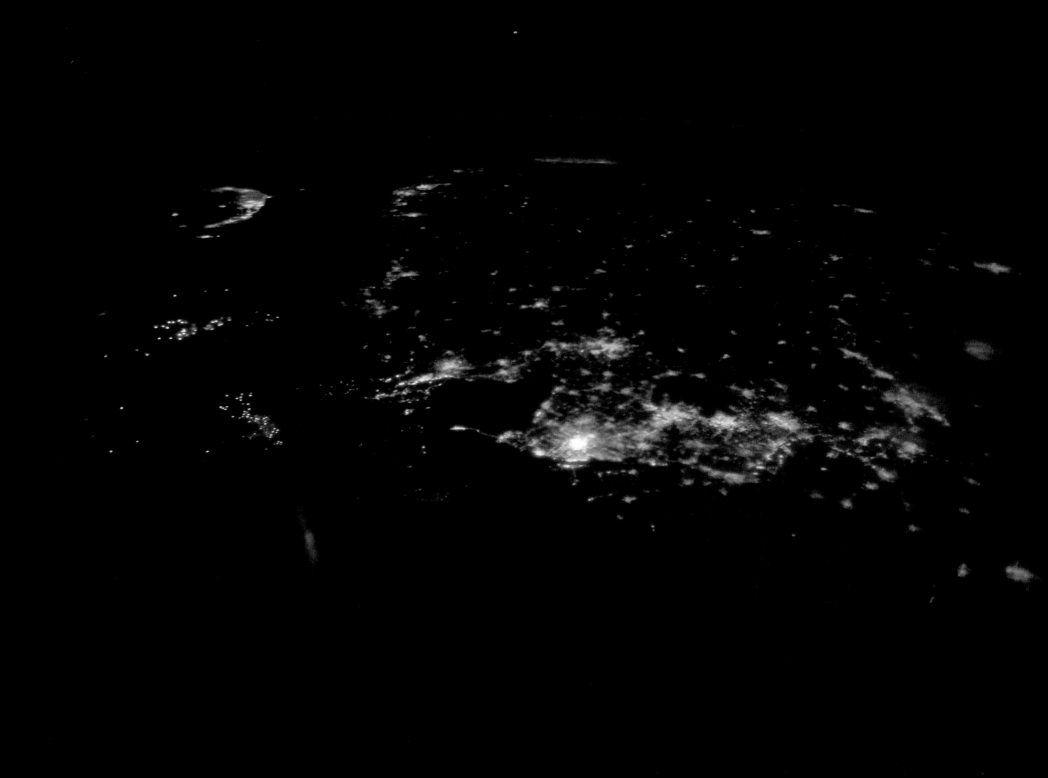

China/Hong Kong

In 1842, Hong Kong was lost to the British (under the same treaty that opened Shanghai), who made it part of what would be known as the British Empire. The British developed the city, with its deep, natural harbor, into a world-class trading center. Hong Kong reverted to the Chinese in the 1990s and has flourished as part of the explosive growth of the Far East. The population is now more than seven million.

Hong Kong is in the foreground. Night lights snake around the many rugged mountain peaks that dot the harbor landscape. The block of orange lights off Victoria Harbour are the piers and container facilities of Rambler Channel.

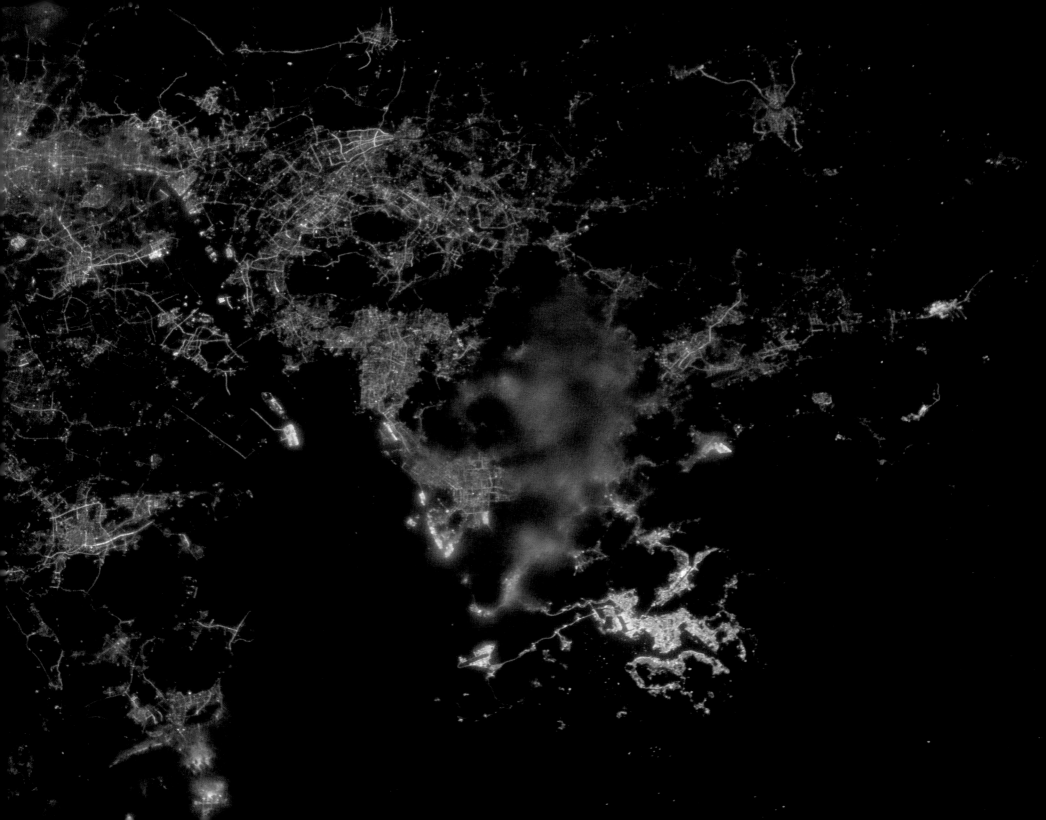

The Korean Peninsula

The Korean Peninsula is a portrait of human oppression. To the south, the lights of Seoul swirl and sparkle in a collision of democracy and capitalism, while to the north light disappears into the dark emptiness of totalitarian rule and human subjugation. Democracy to the left, a military state to the right. The seeds for this divide were planted at the end of World War II when the United States agreed with the Soviet Union to divide the nation into two zones of occupation—the U.S. Zone in what is today's South Korea and the Soviet Zone, which is today's North Korea. Unlike a similar occupation arrangement that left Germany divided (East Germany and West Germany), the two Koreas have never reunited and remain, technically, at war.

The Korean Peninsula/Seoul and Pyongyang

(OPPOSITE) The pinpoint dots of bluish lights seen to the far left are fishing boats off the tip of South Korea. Seoul is a modern city with a population of ten million and a metro area, including Inchon, of twenty-four million. It is neatly bisected by the Han River. The line of golden lights marks the Demilitarized Zone (DMZ), which is the border between South Korea and North Korea.

(RIGHT) The city of Seoul radiates across the Korean Pennisula. Such a contrast to the North. The only light seen in North Korea is a point of light between South Korea and the first faint lights of China. This is the North Korean tower of self-reliance, the Juche Tower, located in the capital city of Pyongyang.

The Korean Peninsula

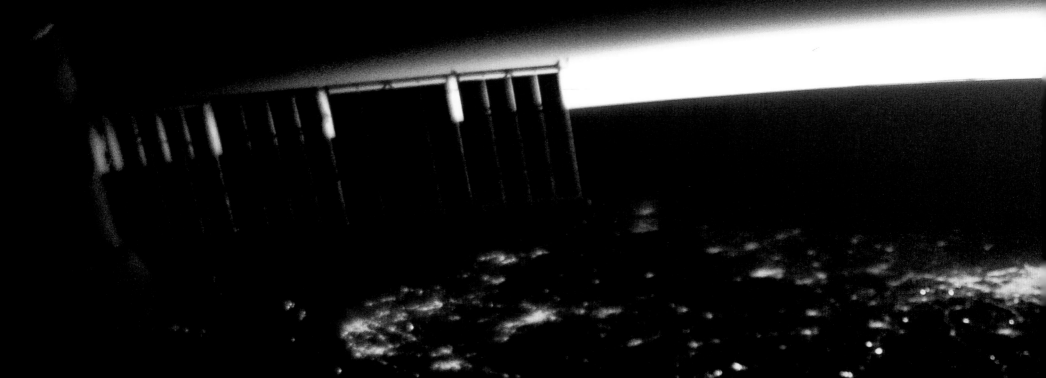

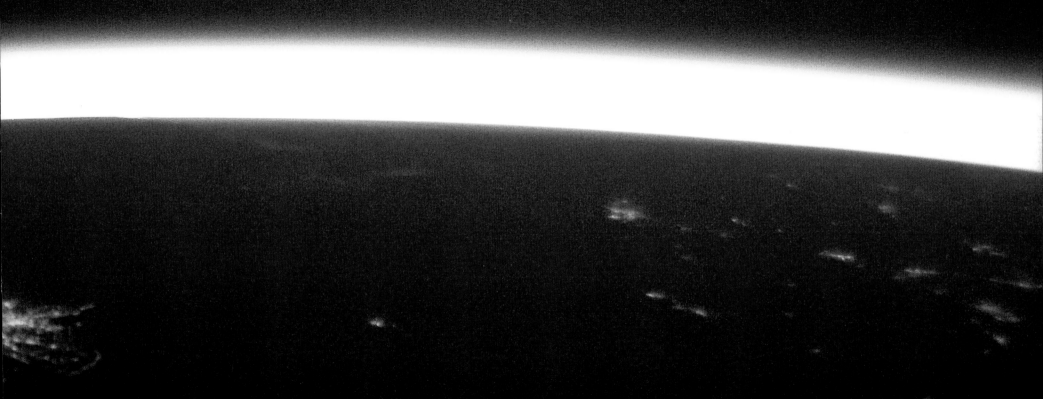

Japan

Light explodes across the face of the planet as the
space station passes over Japan and its brilliantly lit
coastal cities. Japan lives, works, and manufactures
by the sea. Seventy percent of Japan is covered by
mountains and forests, leaving the other 30 percent
for farming and living. Japan's 127 million people
thus crowd into its coastal cities, creating the
distinctive serpentine lines of light as seen at night.

Japan/Tokyo

The Tokugawa Shogunate established its military government in Tokyo, originally called Edo, in 1603, and by the eighteenth century, more than one million people made the city their home. In the 1860s the shogunate collapsed, and Edo was renamed Tokyo. Shortly thereafter, the emperor moved from Kyoto to Tokyo, thus making Tokyo the ceremonial center, and capital, of Japan.

(RIGHT) The Imperial Palace can be seen as the circular dark spot in the center of the city. Narita International Airport is in the bay forward of the palace and can be seen as a small cluster of orange rectangles.

(OPPOSITE) Mercury vapor lighting gives Tokyo a bluish-green color. The blunt "teeth" around Tokyo Bay are natural and artificial islands, including one island built for a cluster of universities. Tokyo's thirteen million residents blend in with those of Yokohama and Chiba for a regional population of thirty-five million.

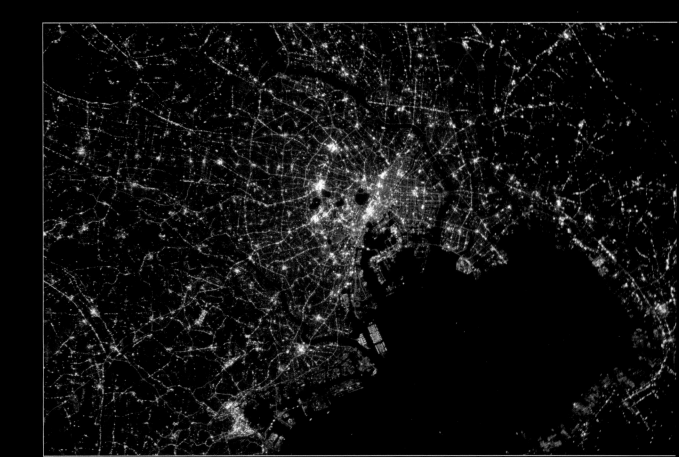

Japan/Nagoya

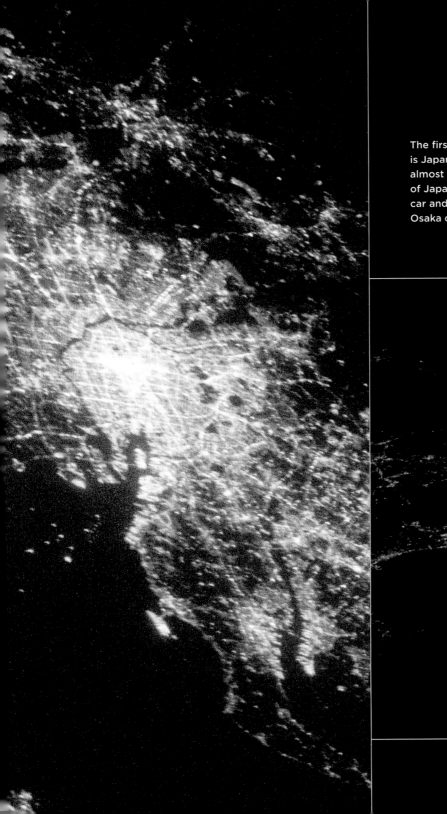

The first major port city southeast of Tokyo, Nagoya is Japan's third-largest metropolitan area, with almost nine million residents. It is the home of many of Japan's largest heavy manufacturers including car and airframe makers. Nagoya sits on Ise Bay. Osaka can be seen at the far left.

Japan/Osaka

Osaka is Japan's second-largest metro area, with a population of eighteen million. Osaka channels most of Japan's rice exports to the world and is a major center for the manufacture and export of electronics, toys, textiles, and appliances. Laced by canals, Osaka is sometimes called the "Venice of Japan." It is bisected by the Yodo River, as can be seen in the photograph opposite.

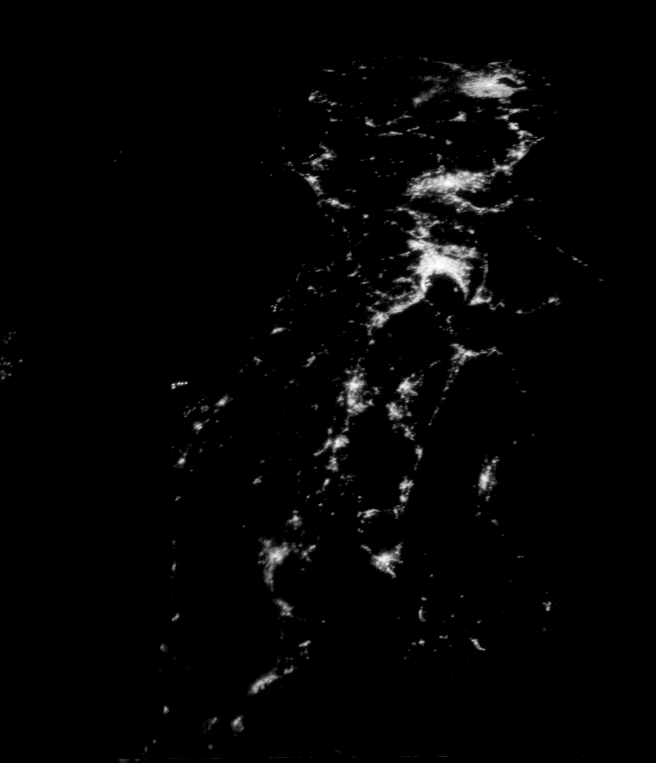

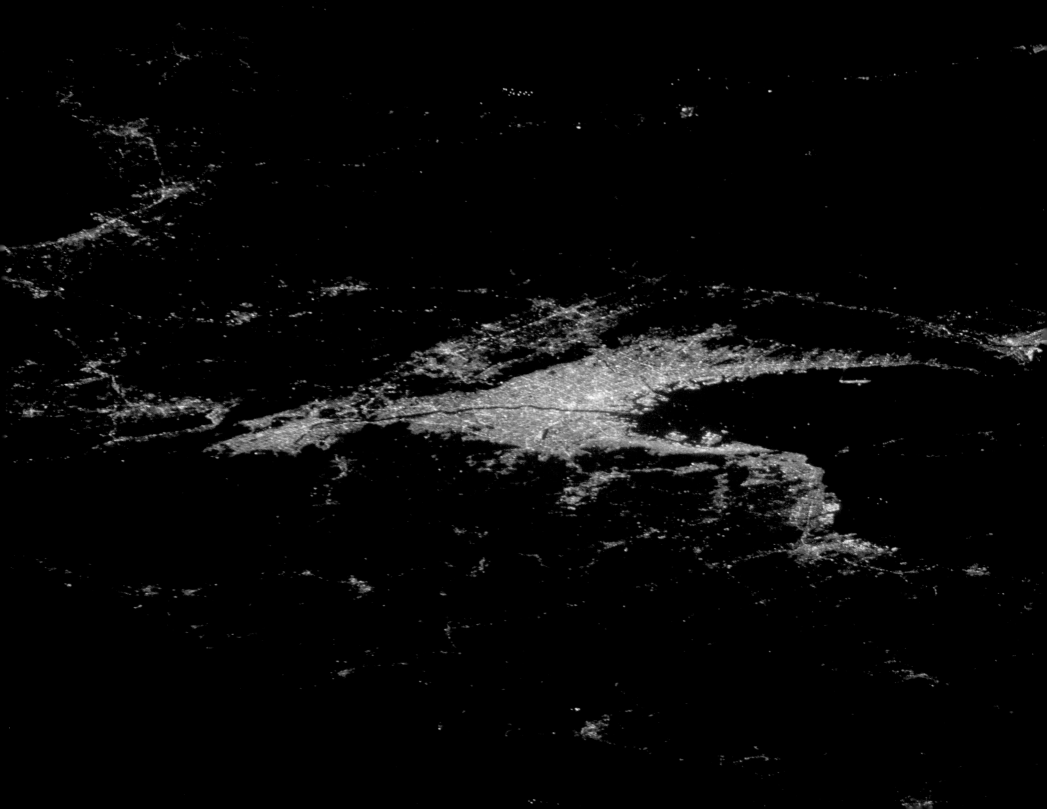

Sendai Earthquake and Northern Japan

The port city of Sendai was established in the 1600s on the footpath to Tokyo as a capital in the northern region. Today Sendai has a metro population of just under one million. The Sendai earthquake of 2011 was one of the five most powerful earthquakes in recorded history and the most powerful ever to strike Japan. The lights of Sendai and Miyagi Prefecture are seen here and mark the last major urban areas in Northern Japan. The damage from the tsunami that followed the earthquake is still visible in the photograph opposite.

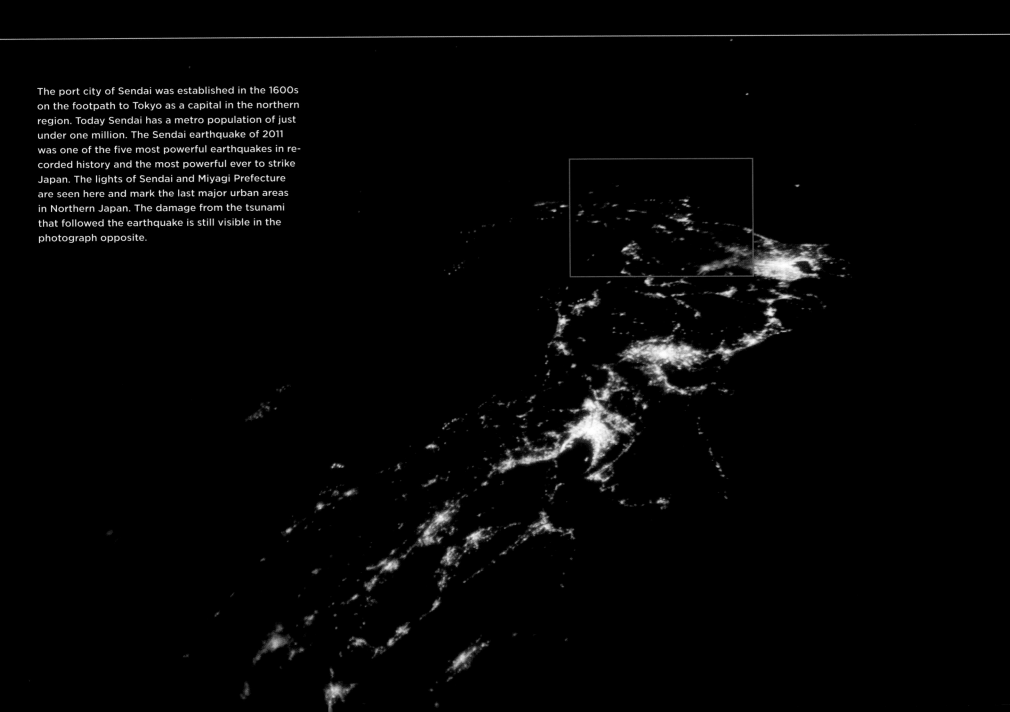

There is a divide between day and night, between the illuminated and the unilluminated part of a planet, a place that marks the end of day and the onset of night. The terminator is that divide. This is the moment in the rotation of Earth when the sun is at its lowest point on the horizon; this is the moment when objects on Earth cast their longest shadows, when we pass from daylight photography to nighttime photography. On the International Space Station, it takes about six minutes to completely cross the terminator. In this photograph, the moon has risen, and the first lights of Earth at night have appeared below.

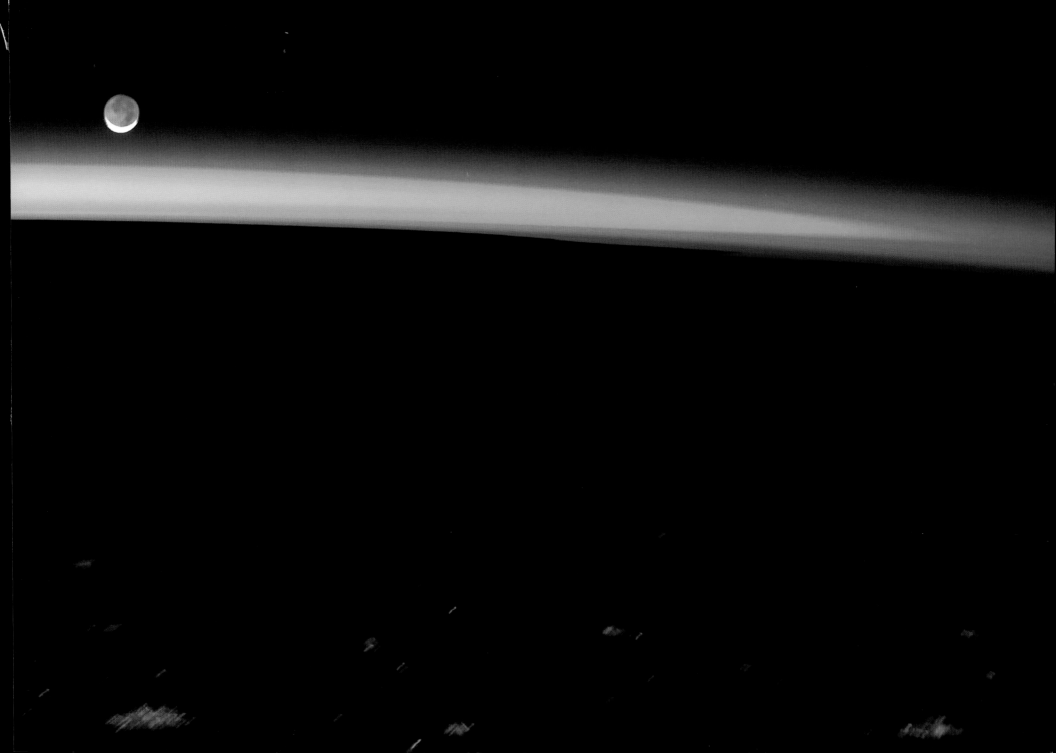

AUSTRALIA

Quirky, defiant, proudly individualistic, ruggedly handsome, and in no small part the great frontier. All of this and more is Australia, the last of the habitable continents to be settled. Though the early Romans had no idea if such a place even existed, Australia was apparent to them as Terra Australis Incognita, meaning "the unknown land of the south." To the Romans there was a certain imbalance to planet Earth and that imbalance was the absence of the as yet undiscovered landmass called Australis. It wasn't until the early 1600s that the Dutch would prove the Romans correct—and it wasn't until the late 1700s that the English established a penal colony in New

at night. Arable land accounts for less than 10 percent of its landmass, and the interior is lightly inhabited. Almost all of Australia's major cities are on the coast. Except for the stretch of coastline between Melbourne and Sydney, strings of interconnected city lights such as we see on other countries are largely absent here. Australian cities stand alone—from space they are well defined, urbanized, and distinctly shaped by their geography. As the space station flies over them, they appear to pop up out of the darkness and then just as quickly fall away.

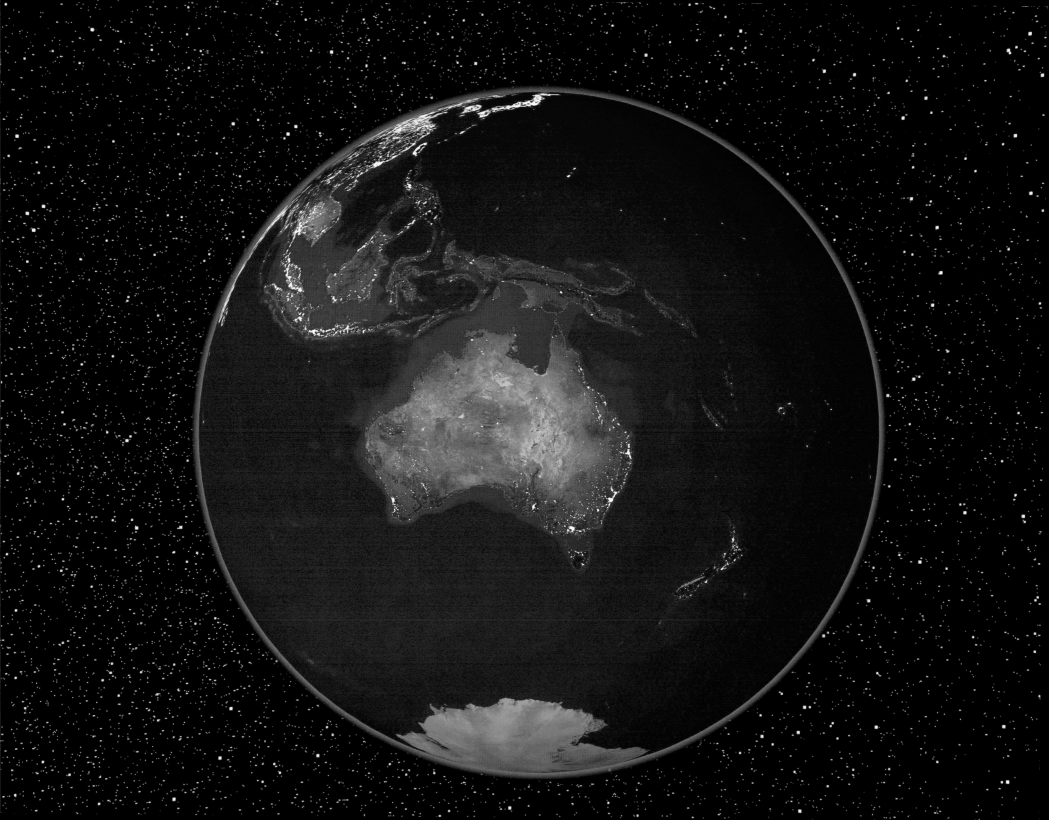

Sydney

Sydney was first visited by the Old World when English Captain James Cook landed there in 1770. What Cook found was a sea captain's dream—two splendid harbors separated by a small peninsula of land, Botany Bay to the south and Sydney Harbor to the north. Sydney was settled as a penal colony eighteen years later when eleven ships packed with some one thousand passengers arrived. The introduction of Merino sheep in 1800 was the accelerant Sydney needed to grow, a trajectory magnified by the gold rush of the 1850s. By the turn of the century Sydney was a city of nearly one million people. At night, Botany Bay attracts our eye but that brilliant spot of white light seen to the left— Sydney—is on the other side, on Sydney Harbor. Sydney has a population of 4.5 million people.

In this photograph opposite, left, the view is straight up the eastern seaboard of Australia. Melbourne is in the foreground, with the lights of Canberra and Sydney in the background. Melbourne's history differs somewhat from other Australian cities in that it was settled locally. In 1835, John Batman, the son of an English immigrant, was the managing director for a group of Tasmanian farmers who bought six hundred thousand acres from the aborigines to establish a village where Melbourne is today. The venture was a success, and in 1847 Britain's Queen Victoria declared Melbourne a city and it was incorporated. Melbourne's population surged, and today it is home to four million.

The lights of Melbourne surround Port Phillip Bay. Inside the bay is a small hook of land that creates Hobson's Bay, also visible at night, which further shelters the piers of Port Melbourne. Fluffy clouds can be seen just offshore, heavy clouds in the background.

Perth and Adelaide

Perth at night is a brilliant display of lights and angles. Perth was settled by the British on the Swan River in 1829 upriver from the coastal port of Fremantle. In the photograph below, the Swan River is the dark line that makes its way toward the ocean, widening dramatically after it passes Perth, then narrowing again as it enters Fremantle, which is seen as the bright triangular tip pointing towards the ocean. Rottnest Island is the wedge of light just offshore to the left.

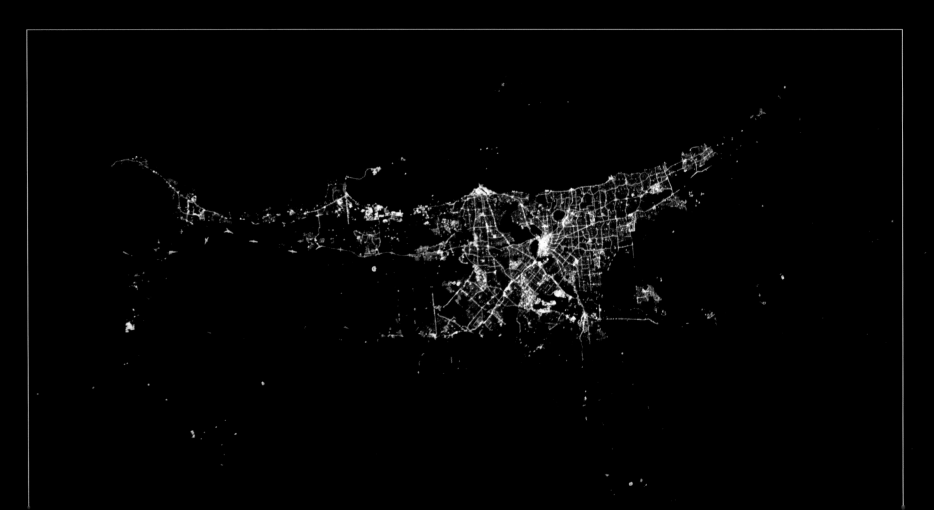

Perched alongside Gulf St. Vincent, and slightly indented by Barker Inlet, is Adelaide. Colonized by the British in the 1830s, the city was a commercial venture planned from the start to attract free immigrants by offering good quality land to settle on and religious freedom. The city was laid out in grids with wide boulevards and large public squares. Land sold well, sheep were imported, wheat fields were planted, churches rose, and Adelaide was up and running as one of the few settlements in Australia not established as a penal colony.

(BELOW, RIGHT) The nighttime arrowhead shape of Adelaide is the result of coastal mountain ranges as they angle down to the sea.

ASTRONAUT MARIO RUNCO JR.

What We See:

"I thought to myself, why would I ever want to watch TV when I could be looking out the window?"

Structural engineers look at windows as holes in their structures. In the design of a space vehicle, you still have to fight to get windows, let alone windows that are useful beyond just viewing. Think of the scene in *The Right Stuff* when the Mercury astronauts were telling the engineers that they wanted a window and a hatch on the capsule. Even today it's just more holes and weight to the engineers and more money to the managers. Odd considering they all want the photos and have needed to use the windows to solve many external engineering problems.

For photography and scientific use, you want glass that's essentially invisible to light. If the glass of a window is not on par with the quality of the lens of the camera, it's going to degrade the image. So what's the point of having lenses that are worth thousands of dollars if the window you shoot through makes them no better than the lenses on disposable cameras? You want light to pass through that window unadulterated, as if the glass were not there. You don't want any imperfections; you want the transmittance of the glass to be as high as possible. We've all seen our reflections in a pane of glass. That's reflected light. We don't want that. We want 100 percent of the light to come through. The transmittance of the space shuttle windows is about 85 percent, pretty good but very limiting. The transmittance of the Cupola and Lab windows are almost 95 percent across the visible spectrum—the blues, the reds, the yellows, the greens; 95 percent of the light comes through. You also want the surfaces of the glass to be perfectly flat. Polishing glass to near perfection is a major component in making the glass optically viable. This is accomplished pretty easily and inexpensively today, yet the perception is otherwise, which I suspect is part of the reason that quality windows are still not a given on spacecraft.

When you first get up there as a rookie, the windows are human magnets. Throughout the workday you're sneaking peeks and taking pictures as often as you can. Over the course of several orbits, as you become more experienced, the Earth becomes your backyard and you know it with the same sense of familiarity. With that experience you can look out the window and know those mountains are the Andes, not the Himalayas, and the continents become recognizable without seeing coastlines or looking at the GPS.

When I look down at Earth amid the infinite blackness of space, I see magnificence. It is absolutely mesmerizing to be in orbit, to go over our planet and look down and see the oceans and the clouds go by. It's spellbinding, and if you're not careful, you'll be by the window all day. I was once asked by a young student if we had TV in space. I thought to myself, why would I ever want to watch TV when I could be looking out the window?

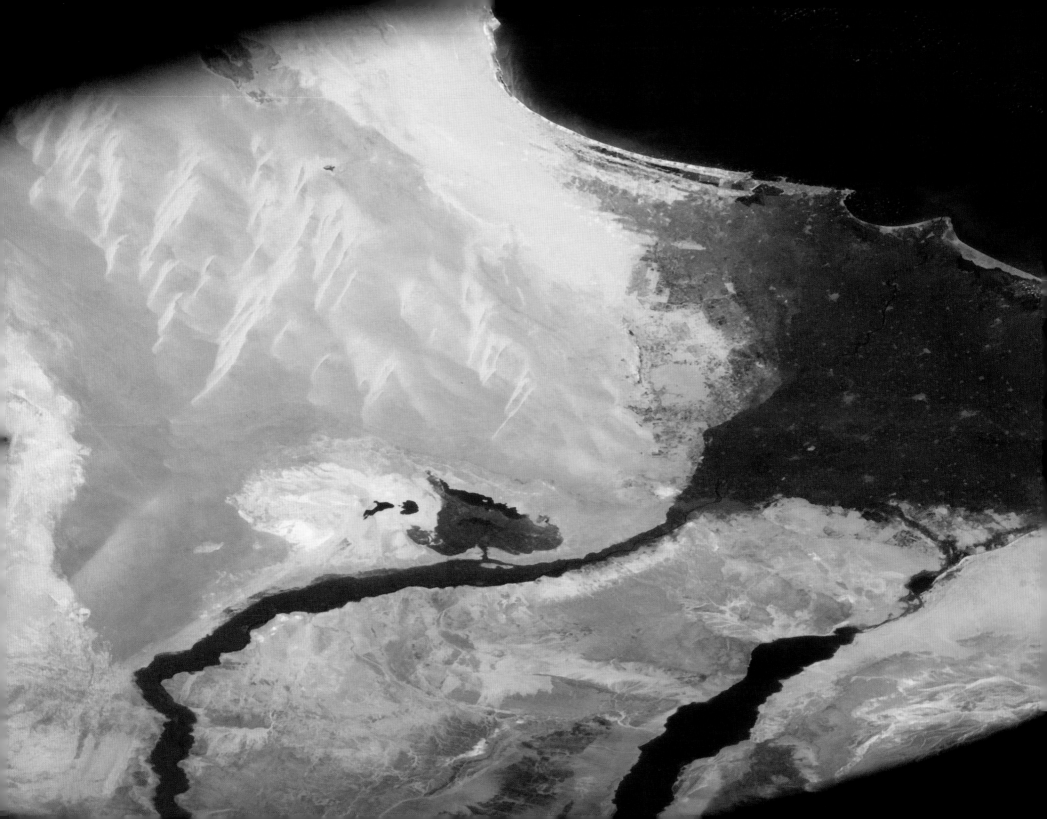

When you look at London at night, you can see the highways radiating out from the center of the city like the spokes of a wheel, with the concentric rings of the loop roads around the city. I thought, here I am in space with all this incredible technology in the middle of the twentieth century and I'm looking down at our planet and I am reminded of the Roman Empire's "All roads lead to Rome." London was originally built by the Romans. The Romans used a hub-and-spoke system in building their cities, unlike the grid system of many modern cities. At night, up there in space, you're seeing the influence of the Romans two thousand years after the fact.

All of these thoughts flood my mind just from looking out the window. And if you look past the Earth into the blackness of space, you are confronted with the reality of infinity. It is an amazing confluence of science, art, history, philosophy, and religion.

— MARIO RUNCO JR.; MISSION SPECIALIST AND EARTH SCIENTIST, NASA-JSC ASTROMATERIALS RESEARCH AND EXPLORATION SCIENCE DIRECTORATE. MARIO WAS ON THE TEAM THAT DEVELOPED THE WINDOW OBSERVATIONAL RESEARCH FACILITY (WORF) AND THE OPTICAL QUALITY GLASS FOR BOTH THE CUPOLA AND THE NADIR POINTING SCIENCE WINDOW IN THE U.S. LABORATORY MODULE NAMED DESTINY. THESE WINDOWS ON THE WORLD HAVE ENABLED THE ISS TO BE USED AS AN EARTH-SCIENCE REMOTE SENSING AND IMAGING PLATFORM. MARIO'S CRYSTAL-CLEAR WINDOWS ARE A FAVORITE PLACE FOR ASTRONAUTS TO SPEND THEIR OFF-DUTY HOURS.

You've heard people say that when you look down at the planet, you don't see borders, you don't see nations; you see one planet, but that's not exactly true. Land use patterns are climatically driven and very cultural. If you're flying over Poland, you can see its long, skinny farm fields. In the United States they're square and larger. There is no natural boundary like a river between San Diego and Tijuana or between Egypt and Israel, but by the land use patterns, by the coloration of the ground, you can clearly see the lines between the countries.

At night, when you're not familiar with a locality, you might ask yourself—why are there no lights there, is that Mount Vesuvius or is it a large lake or sea? You see these holes in the lights, and you try to come up with an explanation. Sometimes you'll see an odd string of lights across a dark area and you discern it's a bridge over water. Being an Earth scientist I could understand and interpret the whys and wheres of what I was seeing: cold fronts, cloud formations, ocean patterns, the geology, and the geography.

Take, for instance, Cairo, Egypt. Your focus is not so much on the city as the river delta on which it sits. Why is it called a delta? Well, the first cartographers in the area were the Greeks. The Greeks had their alphabet. What is the shape of the Greek letter delta? A triangle. When you look at the mouth of the Nile River, what is its shape? A triangle. It becomes clear then that the reason that we refer to that and all such features as deltas is because of the ancient Greek cartographers and their encounter with the Nile River delta.

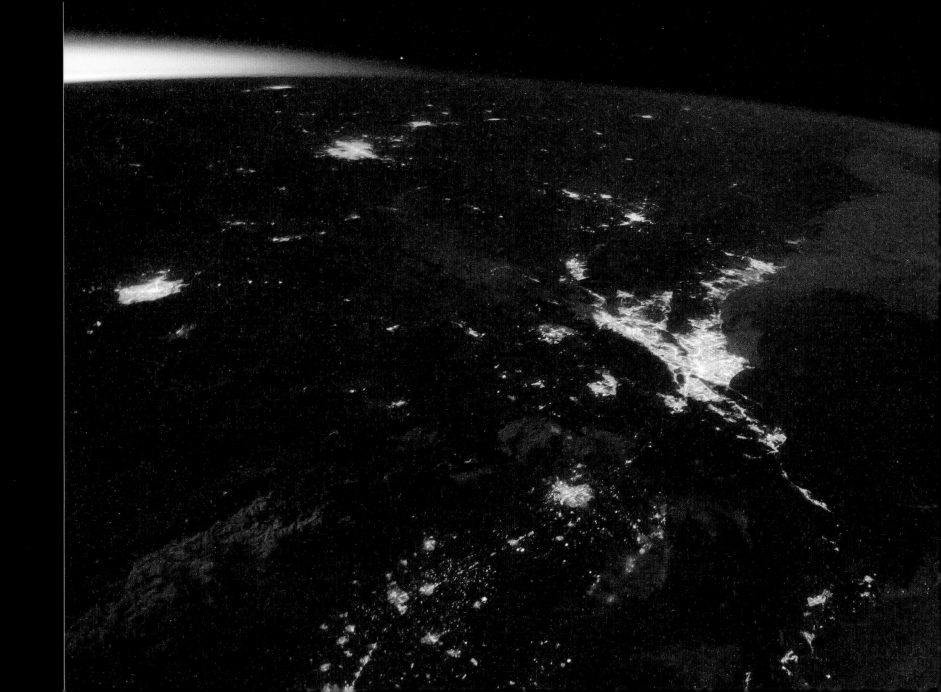

The lasting treasures of Mozart, Michelangelo, Dostoyevsky, Socrates, and Shakespeare are but five of Europe's splendid gifts to humankind—and yet such a list barely scratches the surface of the influence Europe has had on the world at night. Europe was and is the touchstone through which many trace a common heritage, something we see in the densely layered lights of this magnificent continent. On and off between the 1600s and the early 1900s, Europeans colonized or controlled the United States, Canada, much of South America, Australia, and New Zealand as well as a number of countries in the Far East and Africa. Profits from these ventures came back to London, Paris, Amsterdam, Brussels, and Lisbon, accelerating their growth as cities, swelling their exchequers, and supporting grand public projects in architecture, monuments, and the arts. Europe's gains from its early and ambitious colonial exploits are but one of the reasons Europe so boldly lights up the sky; the other is Europe's relatively small landmass. The European continent is second only to Australia for being the smallest continent in the world, but second only to Asia as the most densely populated. Indeed, while an eight-hundred-mile panoramic of the United States might barely connect Chicago to New York City, the same composition would find packed into one image the cities of London, Paris, Brussels, Amsterdam, and Milan, to name but a few. Europe has a population of 730 million.

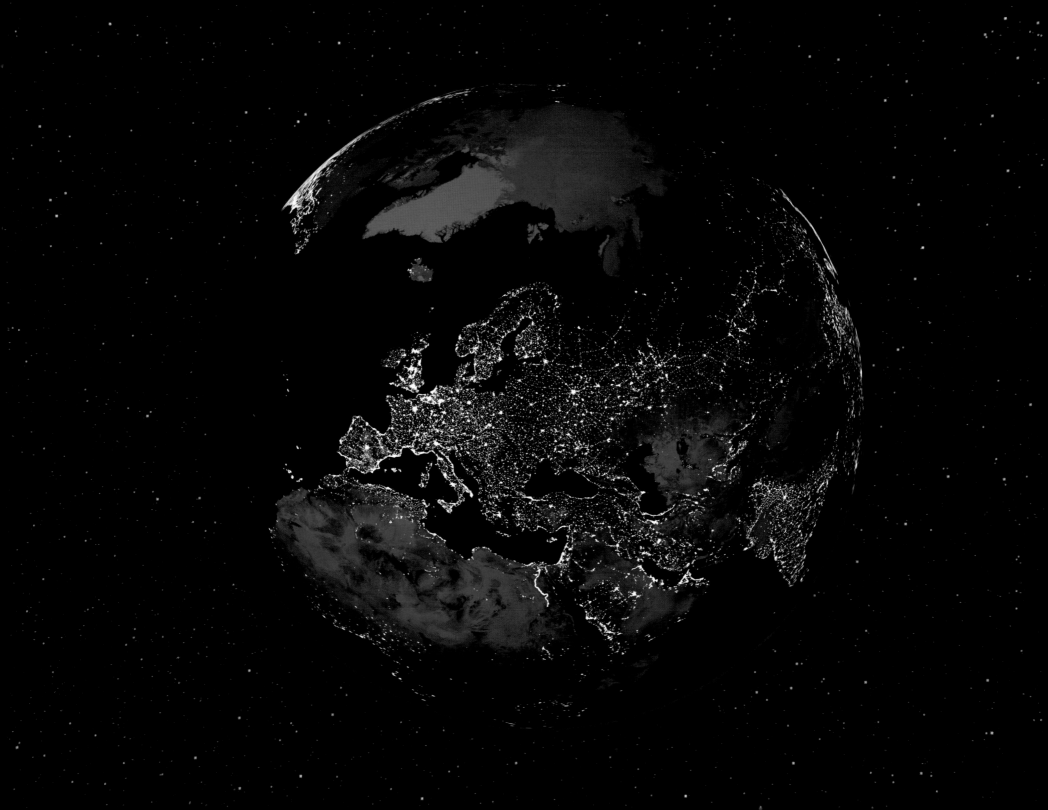

EUROPE

(BELOW) The city of London looks over the English Channel toward France and the Low Countries.

(OPPOSITE) The distance from Antwerp, Belgium, to Naples, Italy, is 856 miles. From Antwerp to Barcelona, Spain, is 687 miles. All of which—and more—we see in this magnificent panoramic of the European continent. The coastal wedge of orange sodium vapor lights to the left is Belgium. To the left and above Belgium are the white lights of the Netherlands; the bright points of light are Brussels, Rotterdam, and Amsterdam. Paris is center foreground, Lyon is to the right. The bright lights of Milan and northern Italy are near the top of this photograph. The last point of light to the extreme right is Barcelona. The very faint lights of Norway are seen in the upper left-hand corner near the horizon.

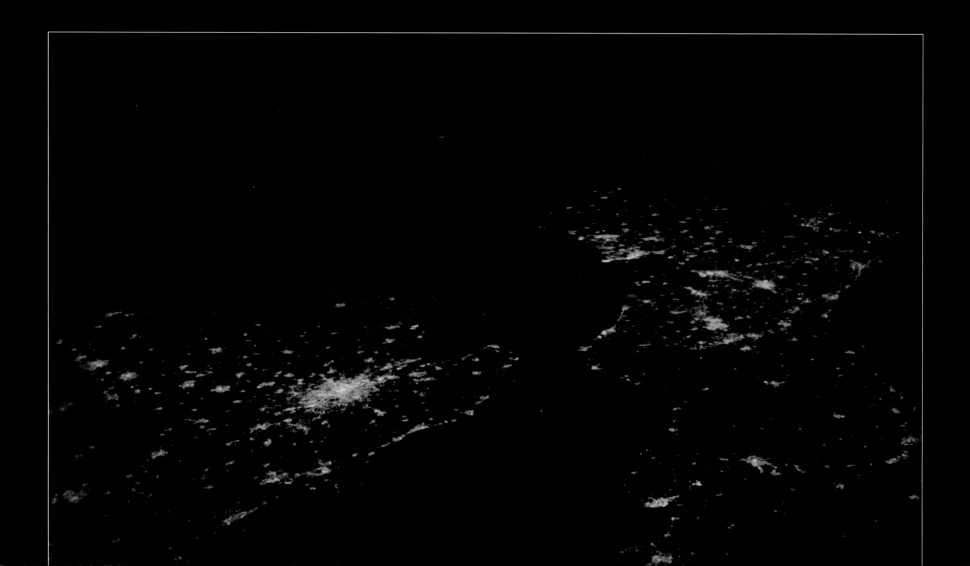

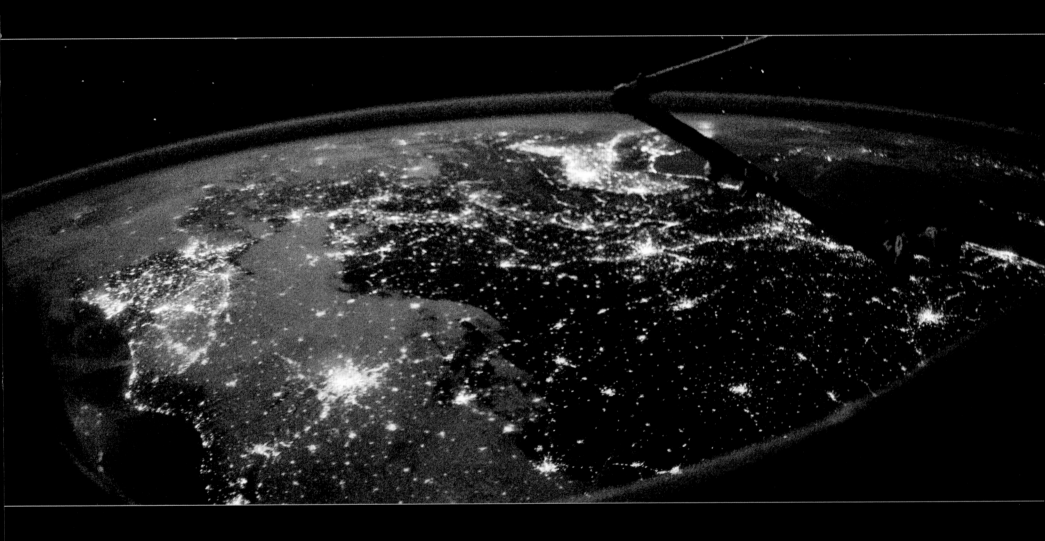

England

This unusual camera angle combines with moonglint and scattered clouds to give the United Kingdom a decidedly medieval look. The view below is from Ireland northeast over Belfast and Dublin toward Liverpool and Manchester while the photo, page opposite, is the reverse view, looking up from London over Birmingham toward Glasgow and Edinburgh.

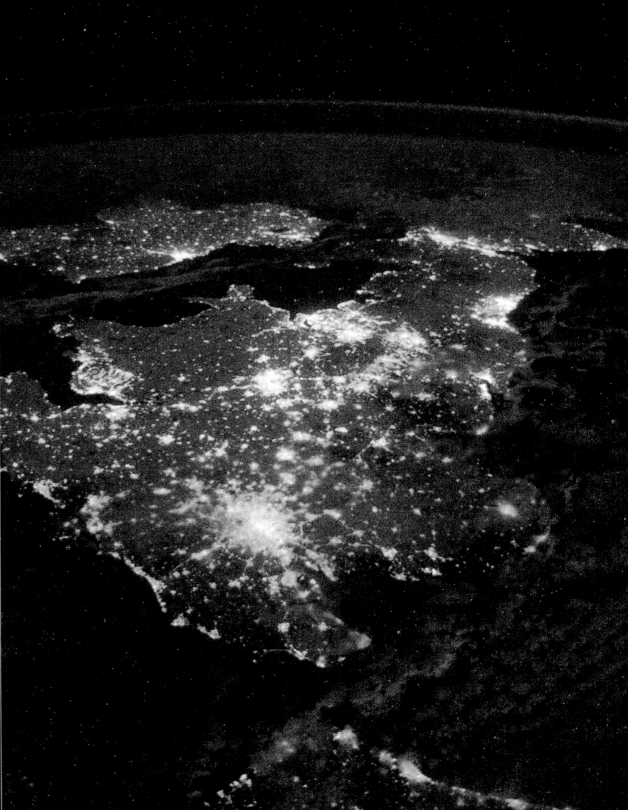

England/London

As much as we love the British for their afternoon tea and the comings and goings of the royal family, London actually traces back to the Romans, who founded the city in AD 43 as a trading post on the Thames. The city was laid out in perfect grids across an area representing one square mile, and it was walled. Today this is the City of London. The City of Westminster was founded around 1040 as a residence for England's rulers. The two cities merged, and by 1100 London was a bustling, noisy city of one hundred thousand. It was under Queen Elizabeth I (1533–1603) that London developed into a world trading center. British colonies were established in America, Canada, and the Caribbean. Merchants' ships sailed the world over. Trading profits flowed in, and new territories were annexed or conquered until by 1922 Great Britain had some one-quarter of the world's population under the British flag. The Thames weaves through central London and is visible in both of these images. Attesting to the magnitude of its lights, London has a city population of 8.7 million and a metro area of some twelve million.

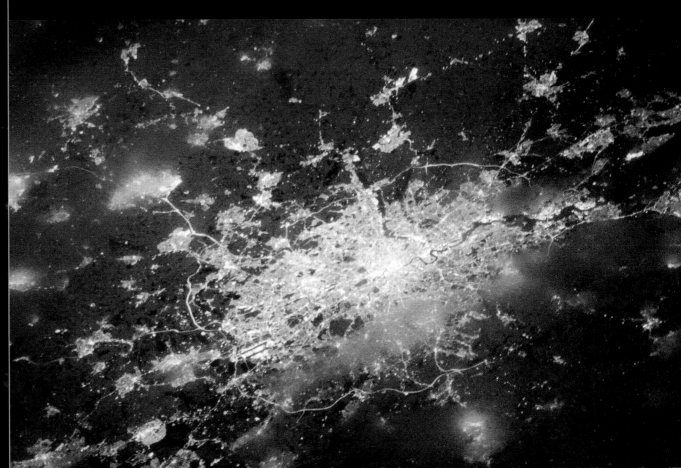

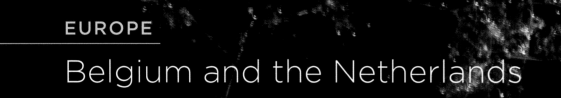

Belgium and the Netherlands

The orange lights of Belgium and the white lights of the Netherlands speak through a slightly obscured sky. Both Belgium and the Netherlands were conquered by the Romans but were largely ignored until Dutch ships—and Dutch-made ships—started to appear with increasing regularity at ports around the world. By 1600, more than half of the world's trade sailed on Dutch ships, and Amsterdam and Antwerp were major hubs of commerce. The Dutch colonized New York City, much of Indonesia, and South Africa and until the mid-1800s the Netherlands was the only nation Japan allowed as a trading partner.

(OPPOSITE) Brussels is the light in the middle with Lille and Brugge closer to the coast.

(RIGHT) The scale of this photograph is deceptive. Amsterdam is the small, concentrated point of light at the top while The Hague and Rotterdam are the middle center. The bright lights on the coast are coming from the industrialized shipping channel and are warehouses and port facilities. Rotterdam and Antwerp rank among the fifteen largest ports in the world and are the principal gateways for trade to the continent of Europe. Amsterdam, Rotterdam, and Antwerp have metro populations of 2 million, 1.3 million, and 1.1 million respectively.

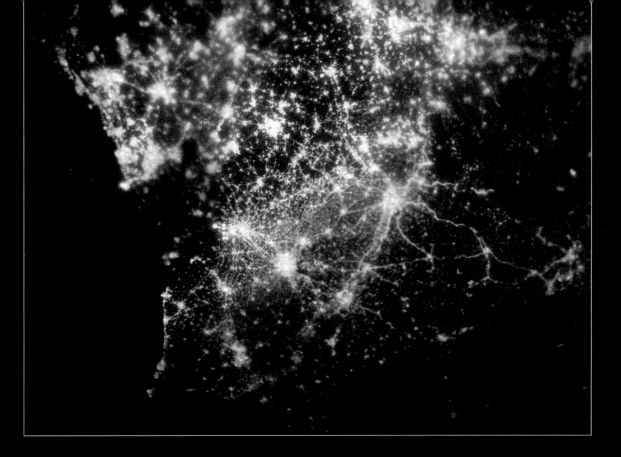

France/Paris and Lyon

France is the largest country in Western Europe and one of the most influential nations in the world. France has been ruled by emperors, kings, queens, generals, and peasants. Its natural resources include oil, coal, and natural gas, and it has some of the most productive farmlands in the world. Paris and Lyon are France's two brightest cities, the former established on the Seine River and the latter at the confluence of the Rhône and the Saône Rivers.

(OPPOSITE) Paris, France. Seen in this photograph to the upper right of the city is a small wedge of dark farmland that extends out from Paris to Charles de Gaulle International Airport, seen in orange surrounded by black. Immediately below the center of Paris is the Bois de Vincennes, a twenty-four-hundred-acre park, and above Paris is the square-shaped Forêt Domaniale de Montmorency, a fifty-four-hundred-acre preserve. Orly Airport is to the middle left, and to its right is the Forêt Domaniale de Notre Dame. Paris has a population of eleven million.

(BELOW) Lyon is shaped by the convergence of the Rhône and Saône Rivers, which weave their way through the city and converge to the south. The dark triangle is Parc de la Tête d'Or, a 290-acre park in center city. To the right and running down from the park is the university campus and then a widening dark area, which is a length of lakes, parks, and lands between the Saône and the Rhône, including the Lac de Miribel Jonage. The edge of a cloud partially obscures the surrounding area. Metro Lyon is home to 2.9 million people.

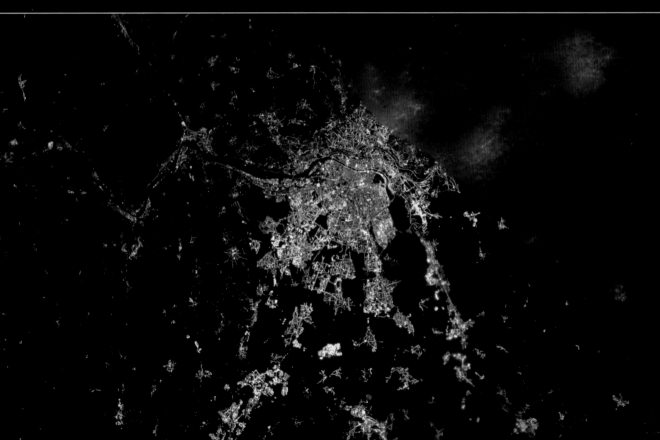

Switzerland/Zurich and Geneva

The Swiss passion for independence and neutrality is perhaps why we see the cities of Switzerland at night at all. In the 1500s, Switzerland established a policy of not taking sides in the wars that routinely ravaged the continent of Europe and declared a policy of neutrality. This in turn helped legitimize a banking system offered by the Swiss that guaranteed an absolutely safe and absolutely secret haven for gold, diamonds, cash, and other assets. Of course it didn't hurt that the Swiss banks were figuratively and literally protected by the Alps, but in any event the results were immediate and the Swiss prospered as they became a world banking power. Zurich and Geneva both sit on beautiful lakes by the same names. They are the largest cities in Switzerland with populations of 2 million and 1.2 million, respectively.

(ABOVE) From the left, Bern, Lucerne, and Zurich.

(OPPOSITE, TOP) Zurich at the tip of Lake Zurich.

(OPPOSITE, BOTTOM) Geneva is on the left end of Lake Geneva and is slightly obscured by clouds.

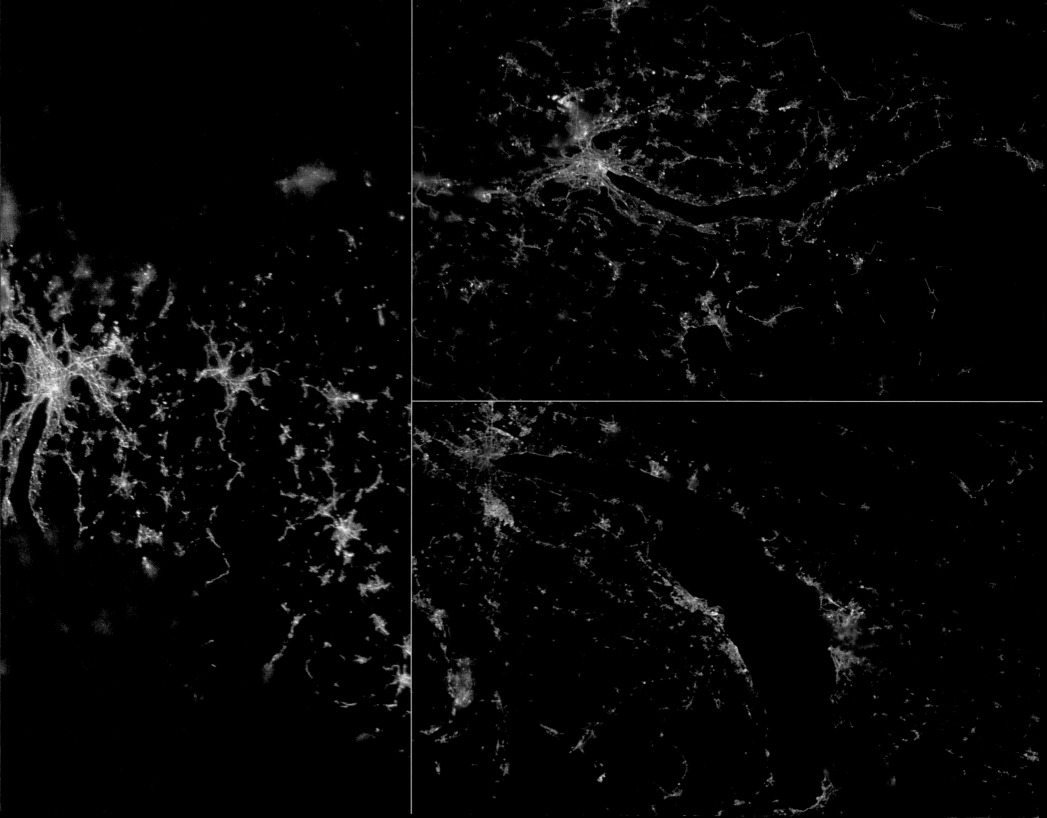

Germany and Austria

The post-World War II history of Germany is a story of reconstruction, democracy, prosperity, and commerce that has given rise to the lights we see today. A battered nation nearly destroyed by the war began a reconstruction program that saw the rebuilding of bomb-damaged cities from Munich to Berlin. The results were swift and in 1990, the East and the West reunited. Germany is the world's fourth largest economy and a nation of eighty-one million.

(OPPOSITE) Munich is the bright light in the center of this photograph. It was settled on the River Isar at the edge of the Bavarian Alps. An early Roman city, Munich today is a center for publishing, finance, movie production, and of course, beer. Beyond Munich is Ingolstadt, Germany. Munich has a population of 2.6 million people. Salzburg, Austria, is in the foreground at the bottom of this picture. It lies on the banks of the Salzach River and curves

around Hohensalzurg Castle, on top of Festungs-burg Mountain, and is visible in this photograph as a round dark spot in the center of the lights. Metro Salzburg has a population of 529,000.

(BELOW) The world seems at peace in this panoramic photograph of the snow-covered Alps at night. Village lights dot the valleys between the ridges and the mountain ranges.

Central Europe

Three priceless European capitals were each a major trading center of the ancient world. Today, each is a thriving city of more than two million with a river that gives shape to its night lights.

(OPPOSITE) Budapest, Hungary, sits on the Danube River and has been a trade and distribution center for central Europe for more than four hundred years. Today, Budapest is the site of one of the main rail hubs for Europe and for years was a much anticipated stop on the legendary train of luxury, the Orient Express. Budapest has a population of 3.2 million. The Danube widens as it sweeps around Margitsziget to the left of the city.

(RIGHT, TOP) Warsaw, Poland, is on the Vistula River, which connects to the Baltic Sea. Warsaw was almost entirely destroyed during World War II. The dim lights mask a city of 2.6 million.

(RIGHT, BOTTOM) Bucharest, Romania, is on the Dambovita River. It has a population of two million.

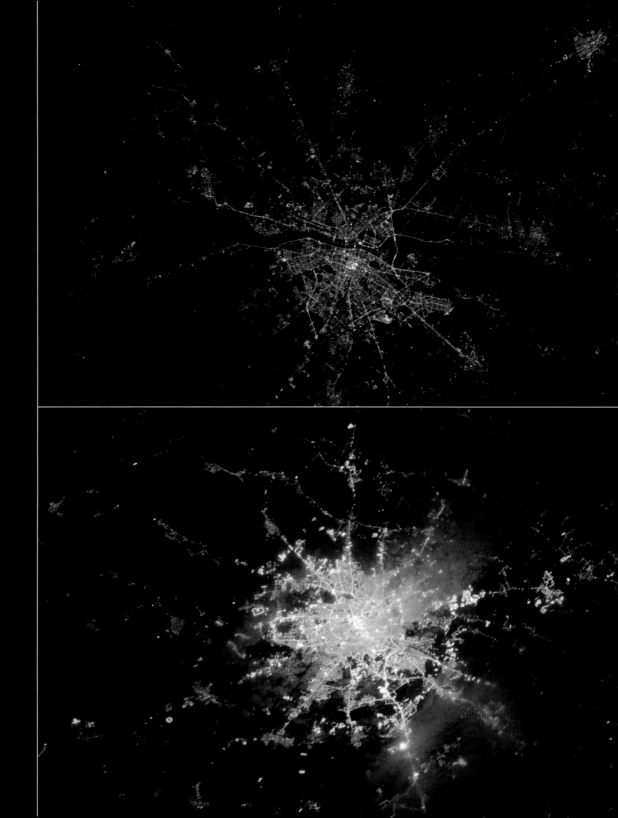

Russian Federation/Moscow

Moscow was settled as a trading post on the
Moscow River, but it was so ideally located on the
footpaths to the interior that in the fifteenth century
Ivan III declared it the capital of Russia. Moscow
is laid out in a series of ever enlarging concentric
circles or ring roads that connect the main arter-
ies radiating out from the city. The dark triangular
slash into the city from the right is the twenty-eight-
thousand-acre Losiny Ostrov National Park. Moscow,
home to the Kremlin, has a population of eleven
million.

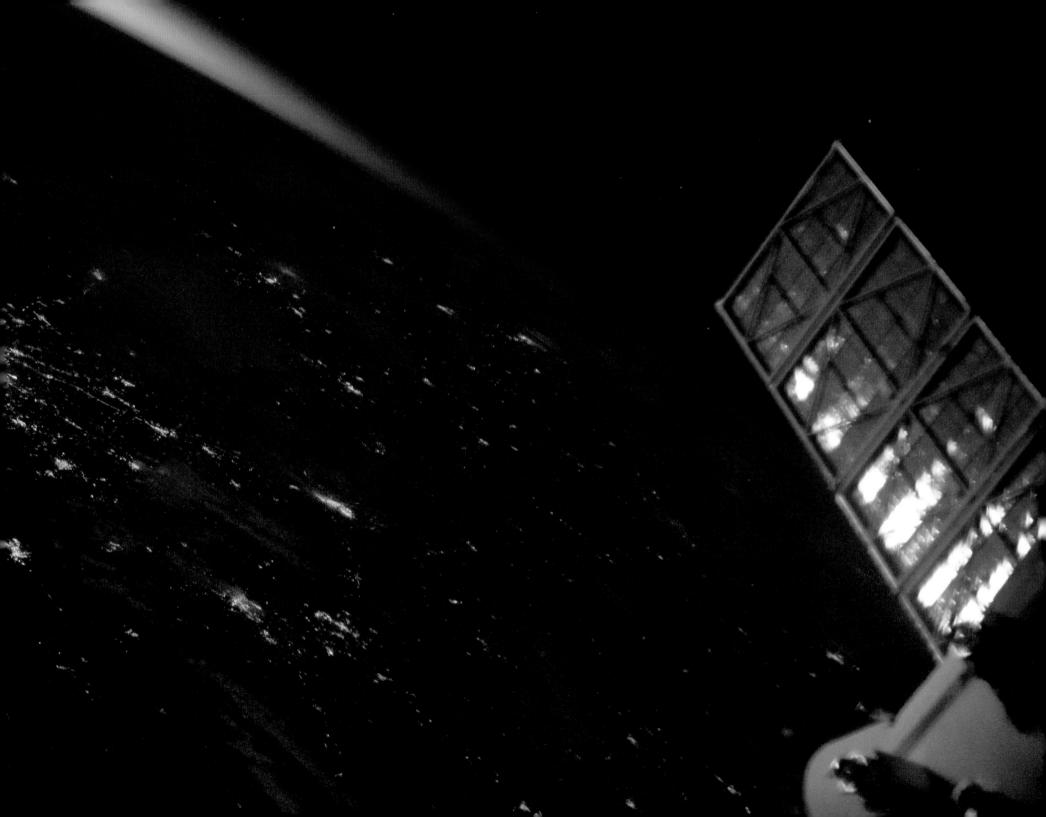

What We See:

"The crew originated night photography. It was purely the crew's desire to share what they're seeing with the people."

Our main job is to train the astronauts, make them familiar with what's of interest at the moment, features, dynamic events—and then send a message to them each day that will point out places with the right lighting and so on, so that when they have time, they can get to the window and take a picture of it. We'll explain the types of phenomena they'll be looking at. Volcanoes. Impact craters. Deltas. Reefs. Cities and city changes. And then they downlink their imagery and we post it on the Gateway to Astronaut Photography of Earth. They send us 250 to 300 images a day of the Earth alone. We have to keep up.

People have tried night photography in the past, but because of the equipment and the lack of time, it wasn't until Don Pettit developed his tracker that we started getting cities at night. He was the first. The new D3S that we have up there now is the best camera we've had for night photography.

The crew originated night photography. It was purely the crew's desire to share what they're seeing with the people. The images are just gorgeous. They're just beautiful. The oblique views of, say, Italy or Sicily—just gorgeous. You can see why they want to share it. It was so hard to get good images before.

We give the astronauts the sites we want photographed, and they choose the window. They'll take the picture, downlink it, and then we catalog them. We assign a center point to the image, add a degree of cloud cover, add a few features that we see such as a lake or a river or a peninsula or the name of a bay. You hesitate to say an image is out of focus because it could be haze or motion or several things that make an image look soft. We give them feedback once a week. If

Sue Runco is in the back row in the black shirt. Her monitor is being fed images from the space station of the space shuttle Discovery's wings. Her team will give Discovery a green light before it will be released for the return to Earth.

we see a consistent problem with the softness of an image, we'll let the astronauts know.

When they can't sleep, they go to the windows and look out. They really enjoy seeing Earth. It's a favorite pastime. Our requests for photography give them an excuse to go to the window. Plus their photographs provide a real connection to the public—to see what the astronauts are seeing, and they enjoy the responses they're getting from their Twitpics. Not only are people seeing the Earth from the astronaut's point of view, but they're also participating, connecting with an astronaut.

In the past, we never requested night images because we felt the equipment wasn't good enough;

it would just result in a bunch of smeared pictures. When Scott Kelly got onboard, he knew we had the D3S up there and he and Doug Wheelock started taking night city lights. We now feel comfortable asking for night lights because of that camera and because of the confidence that the crew has that they can be successful taking those pictures.

The city outlines at night generally dovetail with what you see on the map but not always, and that raises questions. Sometimes the city outlines are bigger than what we see with the lights. It happens in different countries, so that's something we're exploring. It may be that some countries have a specific number of lights per square feet or blocks versus a densely populated area where you have more lights. Is it an economic factor—streetlights aren't installed? There are several theories, so many variables. The types of lighting used? The planning in that city? Is it a phenomenon associated with a specific country? We're interested in all of this.

— Susan K. Runco, Principal Investigator, International Space Station Crew Earth Observation Payload. Ms. Runco has been training astronauts in the science of Earth observation for twenty-three years.

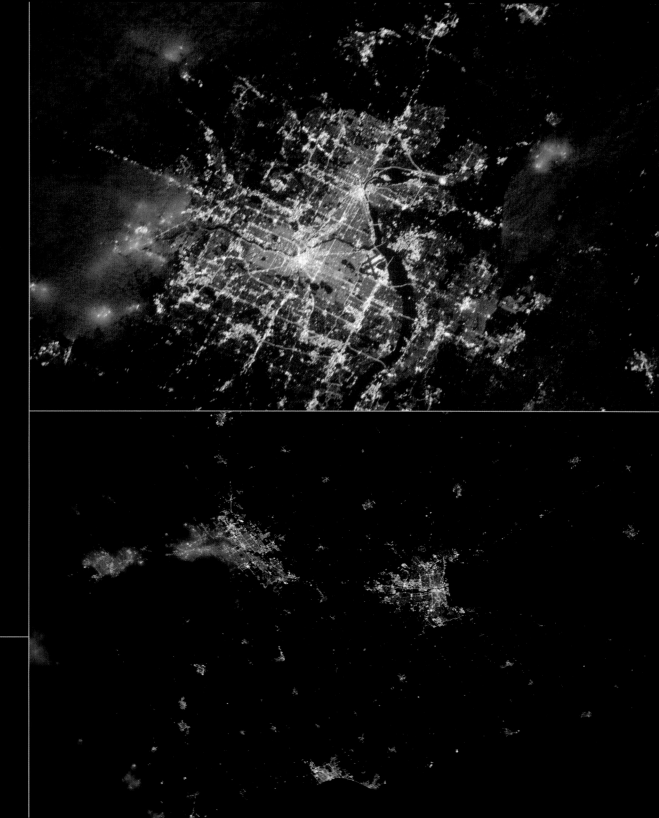

(TOP) Minneapolis-St. Paul is bisected by the Mississippi River.

(BOTTOM) Green Bay, Wisconsin, gives a crablike embrace to Green Bay, an extension of Lake Michigan.

he unexpected land found between Europe and the Far East was North America. As the discovery unfolded and the outline of a new continent took shape, the simple dream of a new route to China and India was replaced by far grander ambitions of profits and plunder and land conquests writ boldly across the planet's third-largest landmass. Within three hundred years of its discovery, colonists, conquistadores, and missionaries had populated all of the coastal areas now seen so brilliantly at night, including many of the major inland ports and trailheads. North America includes Greenland, Canada, the Caribbean, Mexico, and Central America. It boasts the largest freshwater lake in the world (Lake Superior) and the largest island (Greenland) and has the most diverse biogeography of any

continent. With few exceptions, all of the world's large mammals, all of the major crops, and all four climate zones can be found across North America. The lights, however, are concentrated in the middle—the United States and Canada. South of Mexico City and Guadalajara the continent goes progressively dark with most of Central America scarcely visible at night. Named for the Italian explorer Amerigo Vespucci, who was the first to suggest that North America was not the leading edge of the Far East but rather a new unknown landmass, North America today has 529 million people.

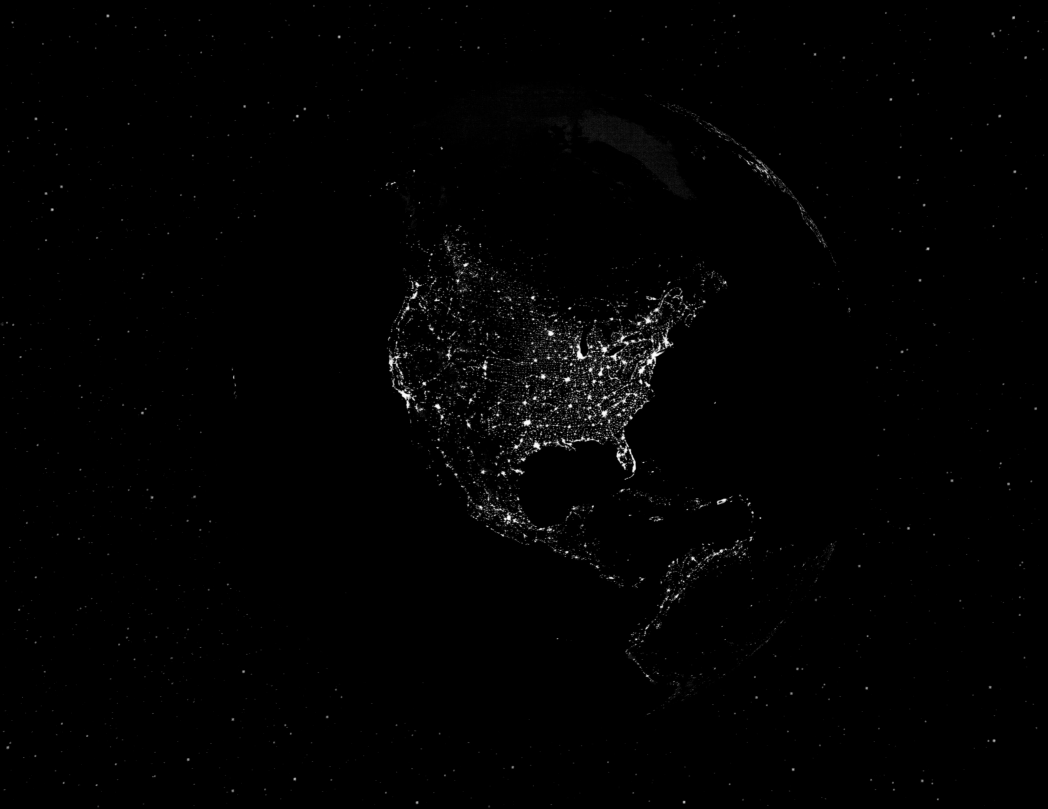

The United States of America

America is a complex, interconnected network of cities and towns that speaks to the universe in points of lights that are as nearly uncountable as the stars. From the ports of Boston, New York, Philadelphia, Baltimore, and Charleston, colonists moved inland on footpaths that became trails that became roads—and on those roads grew new points of light: Detroit, Cleveland, Chicago, Kansas City, St. Louis, Houston, Dallas, Denver, Atlanta, Nashville, Louisville, and Indianapolis.

Today, America moves to the beat of a $14 trillion economy, yet the stories behind these lights are intensely local. The auto industry spurred the growth of Detroit, oil, and space spurred Houston, while aviation, oil, and movies were the propellants for Los Angeles. Chicago made itself indispensible to the Southwest by building railheads at the end of cattle drives and then canals that linked the interior rivers to the Great Lakes. New York built the Erie Canal to link the Hudson River to the Great Lakes, which linked New York City to the network of rivers downstream of Chicago. Freight rates

plummeted from $100 a ton overland to $10 a ton over waterways. By the 1900s all of the navigable inland rivers were thick with cargo boats, and the Oregon Trail, the Santa Fe Trail, the Cumberland Road, the Pony Express, the Overland Stagecoach Trail, the Mission Trail, and the National Road were clogged with wagon trains that connected some eight hundred towns and some seventy-five cities that had populations of more than fifty thousand. Railroads soon paralleled the roads, and the interstate highway system laid grids over much of the United States, grids that become visible at night.

Can you make out the cities in this fish-eye view? Here's a hint: Dallas is the bright light on the left, and St. Louis is clearly visible to the right.

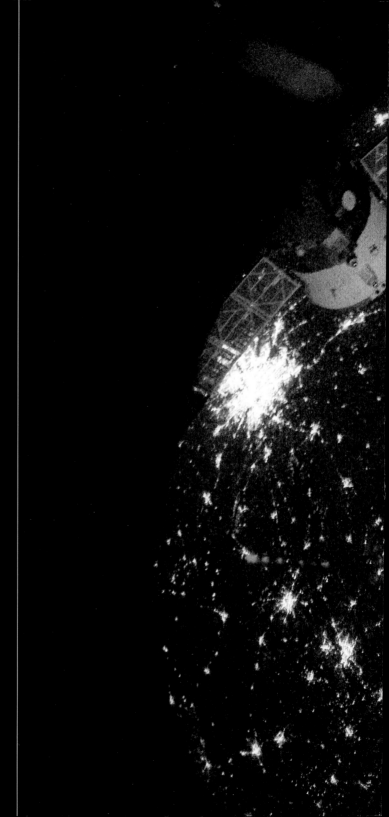

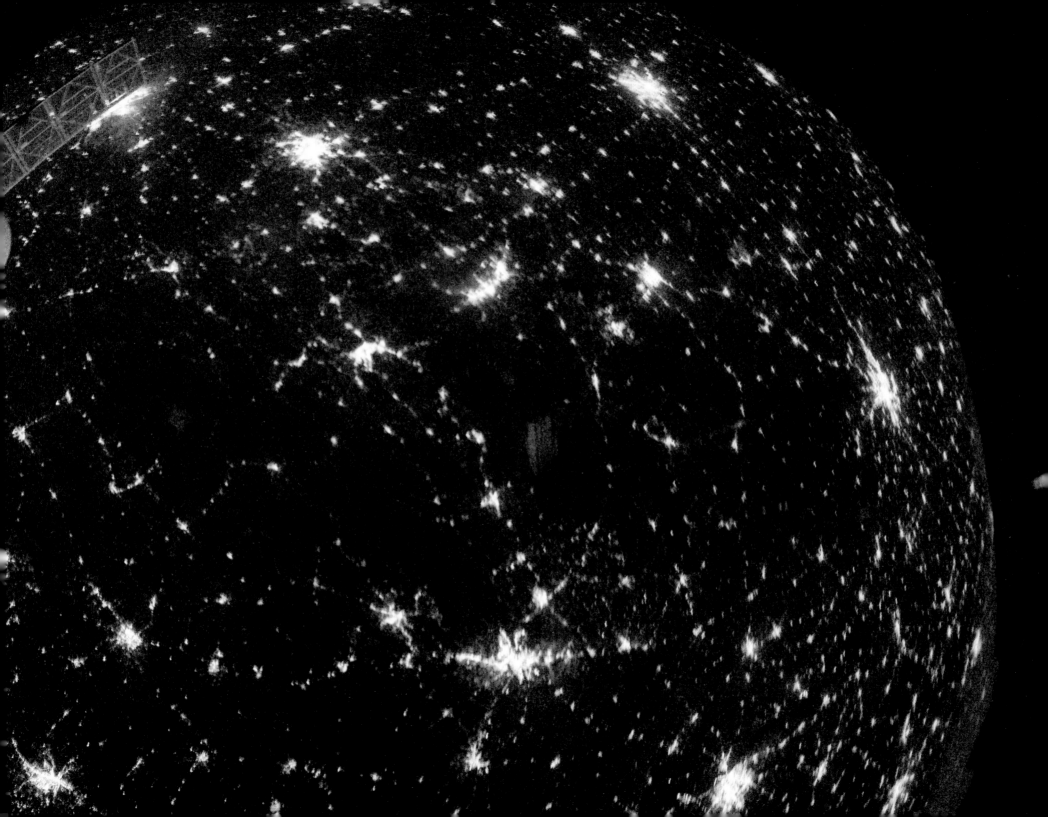

The United States/Panoramic/ New York City to Washington, D.C., and West to Cleveland to Chicago

Panoramic images display Earth the way the astronauts see it—in long, oblique views of up to a thousand miles in any direction. These panoramics are a special treat of nighttime photography.

In the foreground is New York Harbor. The line of lights radiating out from New York are, from near to far: Newark, Philadelphia (partially obscured by clouds), Baltimore, and Washington, D.C. The coastal plains are interrupted by the Appalachian Mountains, which cut a dark path across the center of the photo. To the upper right are the cities of Cleveland and Toledo, on Lake Erie, and to the far right, Detroit, with the faint glow of Chicago just beyond.

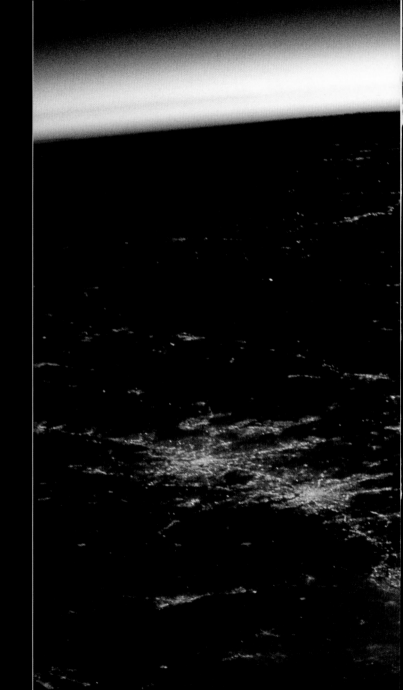

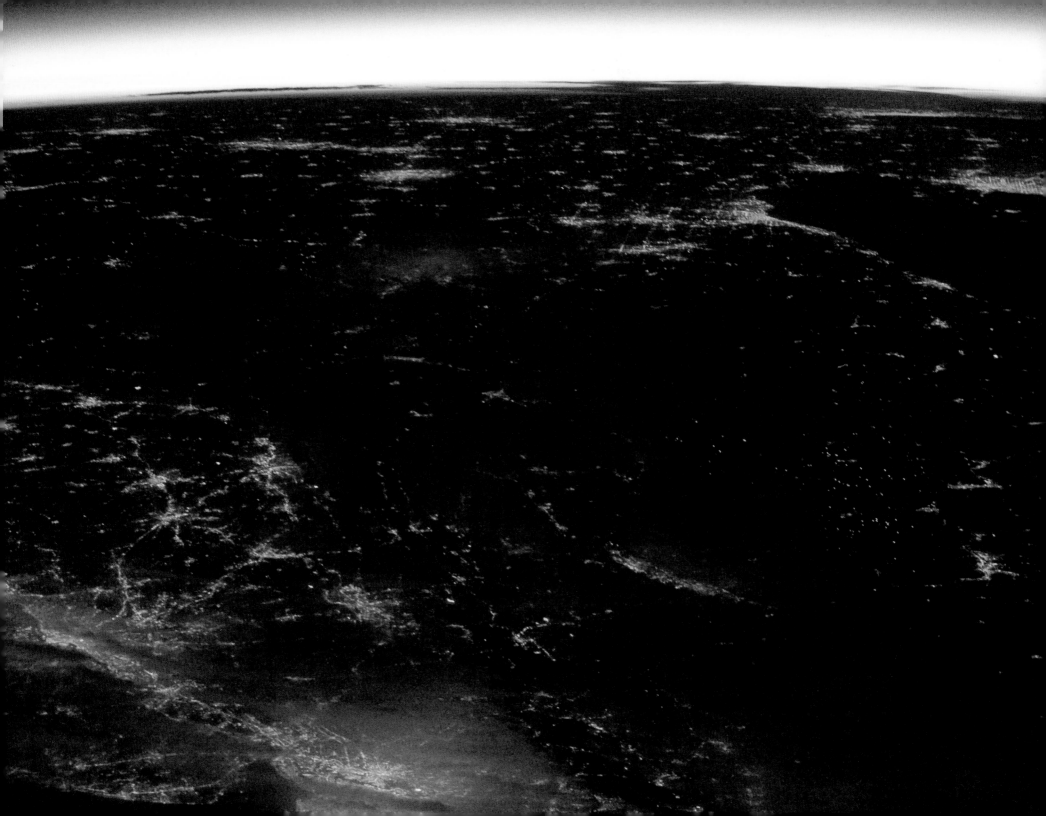

The United States/Panoramic/ Chicago to New York City

An eight-hundred-mile view across America from Chicago, Illinois, to Long Island, New York. Chicago is seen on the southern tip of Lake Michigan, foreground left, while to the right, foreground, is Indianapolis, Indiana. Indianapolis, Louisville, and Cincinnati form their well-known triangle, seen in the center. New York is visible on the horizon as are the lights of Philadelphia, Baltimore, and Washington, D.C. To the right of Washington are Richmond and Norfolk, Virginia. Norfolk is on the coast. South of Norfolk are the many cities of North Carolina and South Carolina.

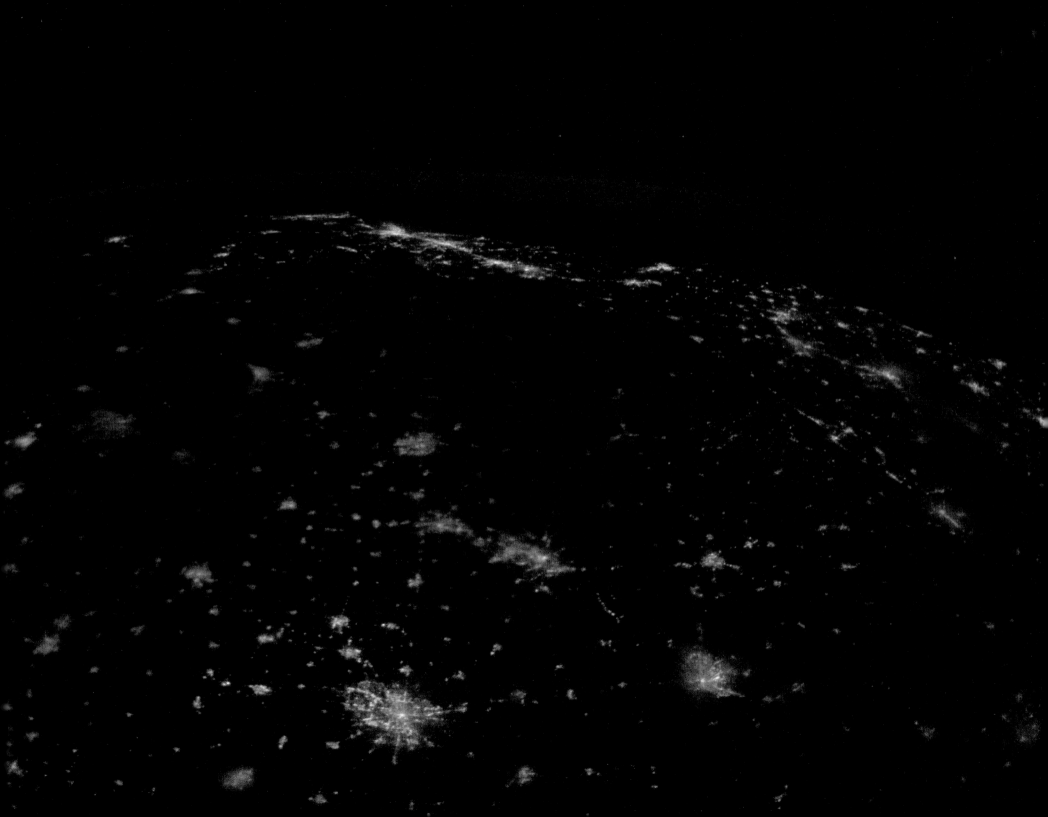

The United States/Panoramic/ Boston to New York City

(OPPOSITE) This view looks straight down the eastern seaboard from a position over the Atlantic Ocean east of Boston. New York City is in the center. Boston is to the right with the elbow of Cape Cod visible in the foreground. Martha's Vineyard and Nantucket are the dots of light to the left of Cape Cod. The matching daytime view, below, is exceedingly beautiful in its own right but is seemingly void of life, a key difference between day and night photography.

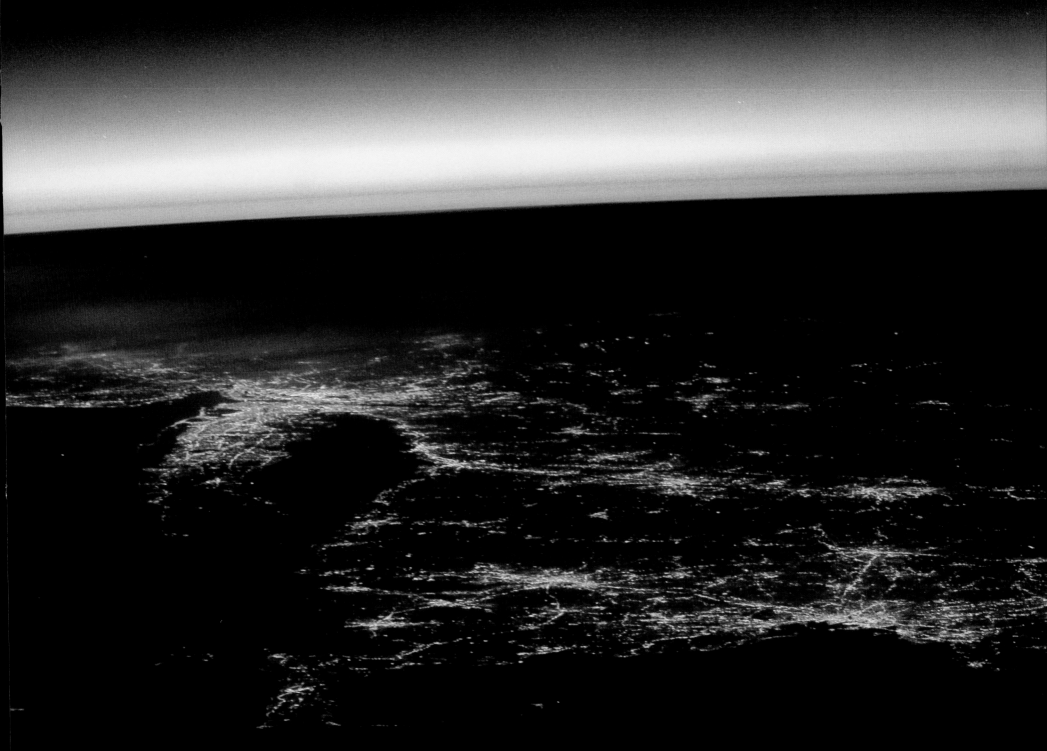

The United States/Panoramic/ Providence to Boston to Portland

Roads create spokes and rings that surround Boston and connect its nearby cities. The outermost ring connects, from the bottom moving counterclockwise to the top, New Bedford, Massachusetts, Providence, Rhode Island, and Worcester, Massachusetts, using Interstate 195 and a local road. The spokes radiating out of Boston are Interstates 95, 90, and 93. Interstate 95 connects Boston to Portsmouth, New Hampshire, and on to Portland, Maine, seen at the top right.

(OPPOSITE) Interstate 91 connects New Haven, Connecticut, Hartford, Connecticut, and Springfield, Massachusetts, although they share almost no common history.

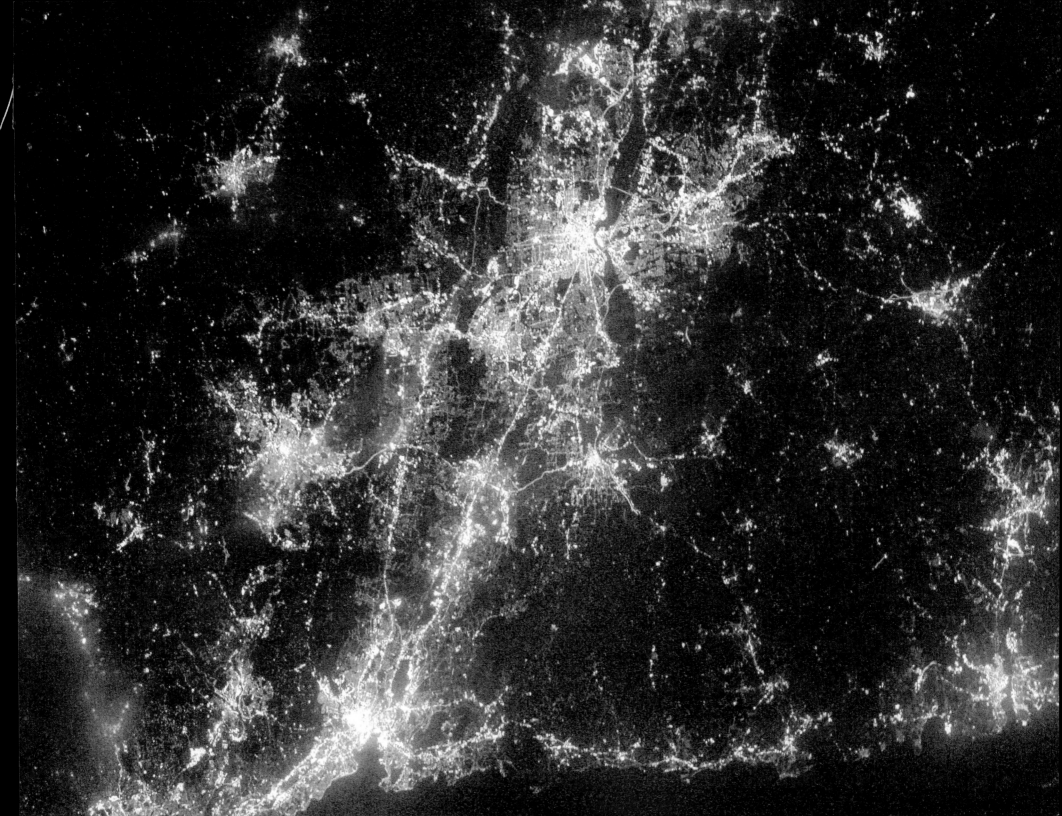

The United States/Panoramic/Norfolk to Baltimore

The cities of Washington, D.C., and Baltimore are well inland from the Atlantic Ocean as evidenced by this panoramic. Neither the mouth of the Delaware River nor that of the Chesapeake Bay offered the necessary combinations of stable soils and sheltered harbors required for a vibrant coastal city. Washington, D.C., and Baltimore are about a day's boat ride from the Atlantic Ocean.

(OPPOSITE) From the foreground, counterclockwise, are the cities of Norfolk, Richmond, Washington, D.C., and Baltimore.

(BELOW) Three cities well known to any sailor—Hampton, Newport News, and Norfolk, Virginia. Norfolk is homeport to the United States Navy's Fleet Forces Command, more commonly known as the U.S. Atlantic Fleet. In this picture, the illuminated "teeth" inside the harbor are navy piers, many large enough to handle aircraft carriers.

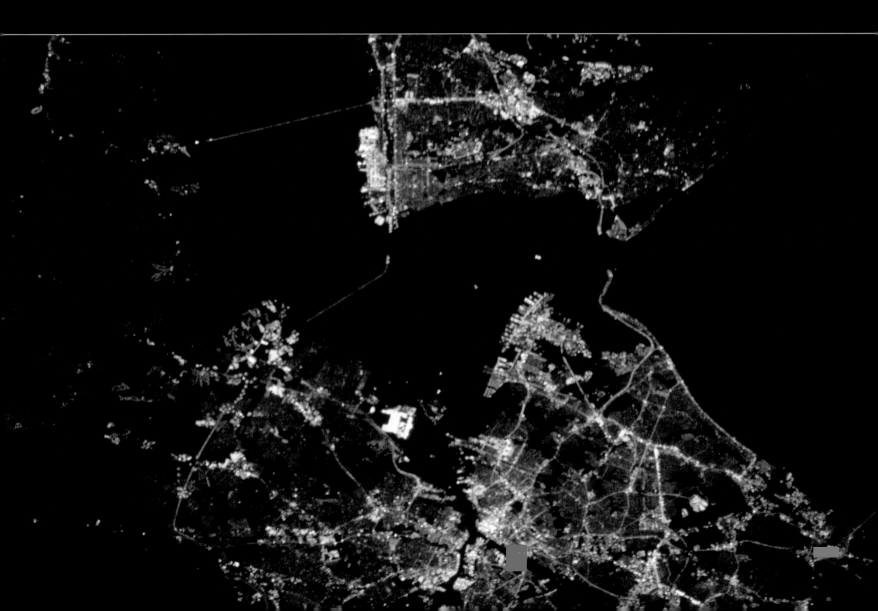

The United States/Panoramic/Texas to Florida

San Antonio is the bright light at the head of what appears to be a "comet" tracing a path across Texas. If it is, then we know that Austin is the tail. Just above San Antonio is the metroplex of Dallas–Fort Worth, clearly visible as two overlapping cities. Houston is the large, urbanized cluster of lights on the Gulf Coast while farther down the coast we see

the first outlines of New Orleans. Interstate 10 creates a string of east–west lights along the coastline while above it is Interstate 20 with lights representing the cities between Shreveport, Louisiana, and Meridian, Mississippi.

(OPPOSITE) Florida takes shape as the space station sweeps across the Southwest into the South. The grids formed by the interstates are also beginning to take shape. Directly above New Orleans is Jackson, Mississippi. The bright light in the center is Memphis, Tennessee. Atlanta, Georgia, is to the far right.

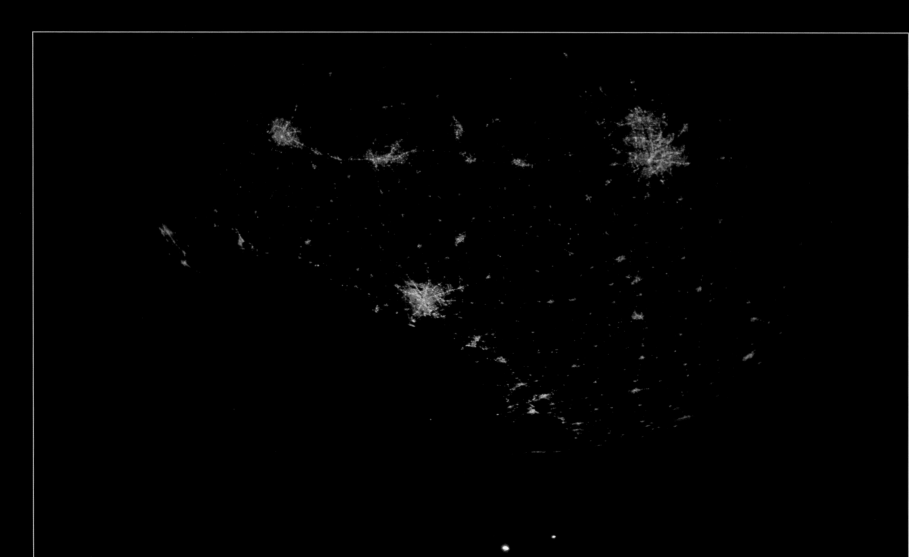

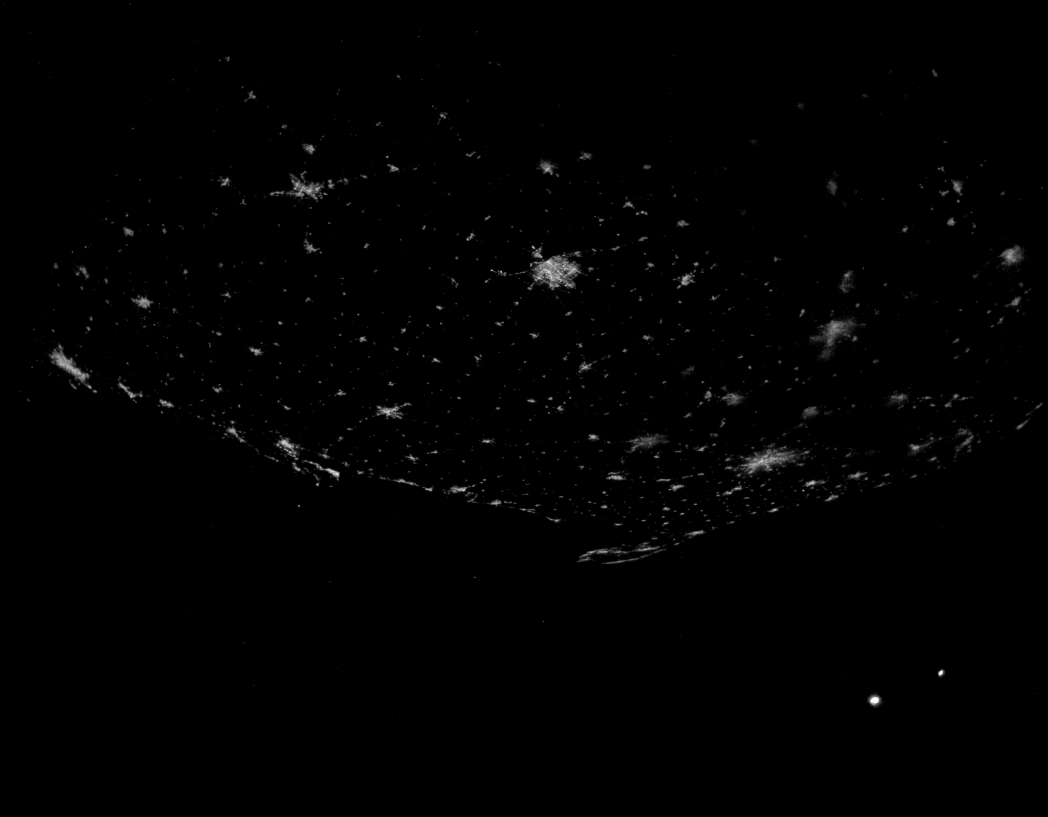

The United States/Panoramic/The South

A crystal clear night over the American South. More than forty cities in twelve states are visible in these two spectacular panoramic vistas of some nine hundred miles.

(OPPOSITE) Much of the Old South is captured in a single image spanning the 917-mile distance between Chicago and Mobile, Alabama, bottom, left. Atlanta is the dominant light in the center. The cities along the panhandle are, from left, Mobile, Alabama, and Pensacola, Panama City, and Tallahassee, Florida.

(BELOW) Along the Atlantic Coast are, from the neck of Florida north, Jacksonville, Savannah, Charleston, and Myrtle Beach. Tampa–St. Petersburg is in the foreground with Orlando clearly visible inland. The faint glow of New York City is clearly visible at the upper right. This is a 1,140-mile panoramic.

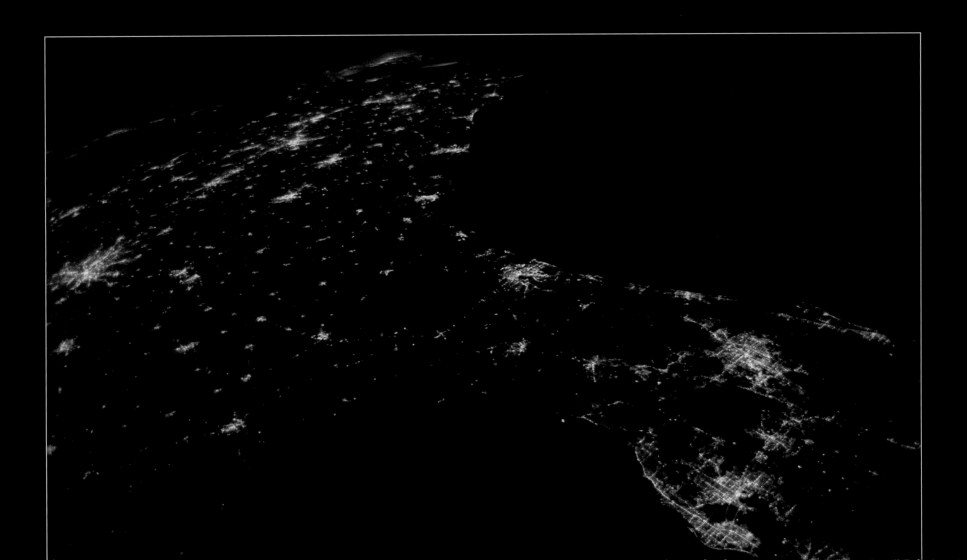

The United States/Panoramic/ San Francisco to San Diego

This one-of-a-kind panoramic captures almost all of California's major cities in one photograph. On July 16, 1769, San Diego de Alcalá became the first of twenty-one missions to be opened by Spain in a trail that would stretch from San Diego to San Francisco, California. For almost one hundred years, soldiers, missionaries, and colonists would travel the dusty trail until it became a stagecoach route and, finally, in 1922 a road. Today El Camino Real is Highway 101. The last mission built by the Spaniards was Mission San Francisco Solano, opened in 1823, a little more than two decades before California became part of the United States. What took a week to travel is now captured in a single photograph, the entire 517 miles between San Francisco and San Diego, with the lights of Tijuana added as a bonus. The lights to the north of Los Angeles are the inland cities of Victorville, Santa Clarita, Bakersfield, Fresno, Stockton, and Sacramento. On the page opposite is a view of the California coast framed by the windows of the Cupola. This picture was taken out over the Pacific Ocean. To the east, are, from left, the lights of Reno and Las Vegas, Nevada, and Phoenix, Arizona.

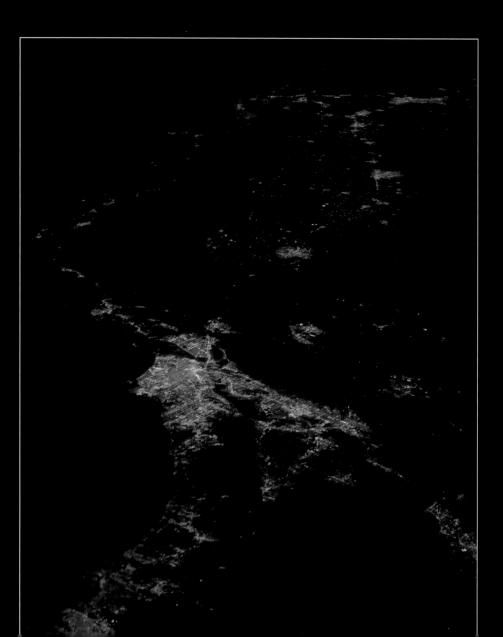

The United States/Panoramic/ Los Angeles to Ensenada, Mexico

This panoramic presents a beautiful portrait of Southern California. The squared-off bay of Ensenada, Mexico, is the last cluster of lights to the bottom right. Slightly north is the telltale "hook" of San Diego Bay, which clearly marks San Diego's harbor front. At the top is Los Angeles. The dark wedge slicing into the top of the city represents the Santa Monica Mountains, which run from the Hollywood Hills to Point Mugu. The large dark area roughly from the center of Los Angeles and extending south down behind Newport and San Clemente and then to San Diego, is the Santa Ana and the Palomar Mountain Range. Los Angeles is the only major city in the United Sates to be bisected by mountains.

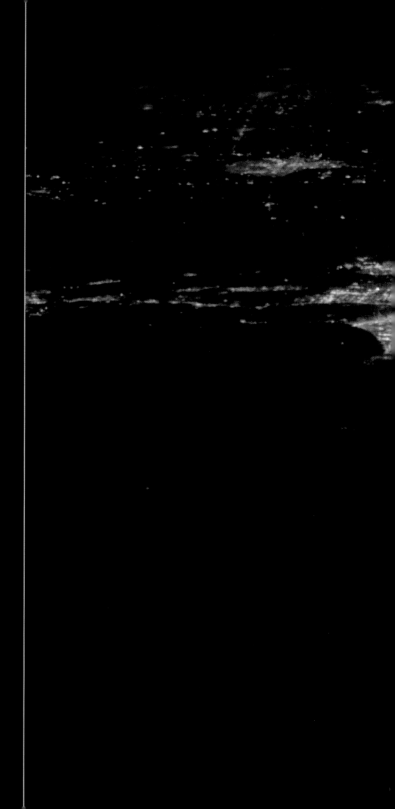

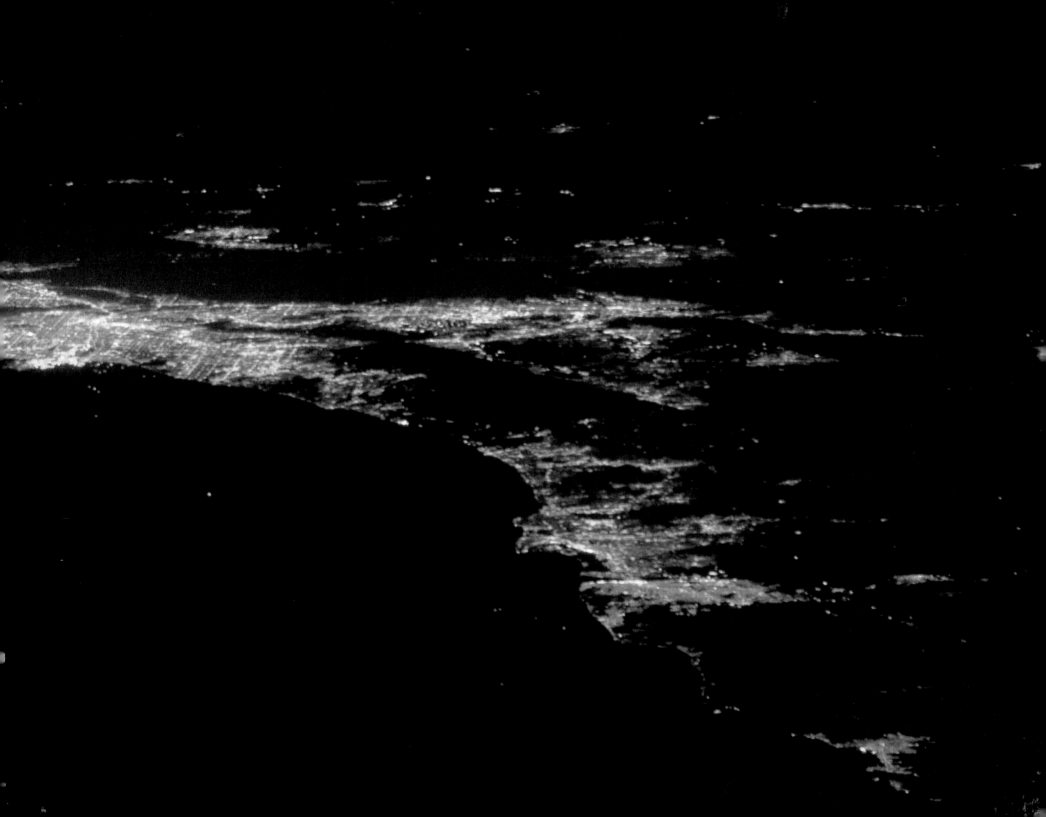

The United States/Boston and Providence

Boston is one of the nation's oldest cities. Settled by the Puritans in 1630, Boston saw early growth driven by its abundance of natural resources, good fishing grounds, and a natural harbor. The Puritans' intolerance for other religions led to the settlement of Providence, when a group of exiles established a village there in 1636. Today, universities and colleges are major employers in both cities.

(LEFT) Boston is to the left near the top of this photograph. Cape Cod is clearly visible across the bottom and up through the "fist." Logan International Airport is the white spot inside Boston Harbor close to downtown. The dark slashes across downtown near the harbor mark the Charles River Basin and Mystic River. Providence is the bright light to the bottom left. It is at the head of the Providence River and connects to Narragansett Bay. To the right of Providence are the lights of Fall River and New Bedford, Massachusetts.

(OPPOSITE) The Providence-Boston region by day.

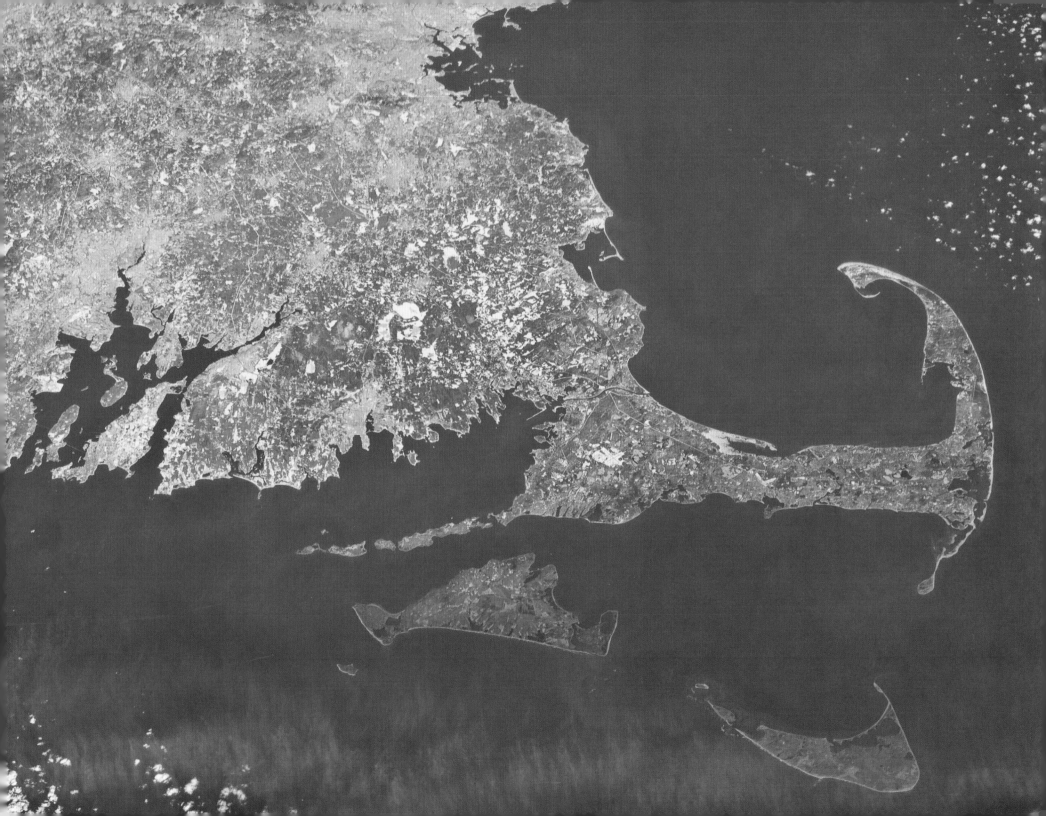

The United States/New York City

Like an alligator nudging his snout up against the banks of a creek, Long Island nudges up against Manhattan and forms part of the barrier that shelters one of the finest harbors in the world. The thin line of blue at the mouth of New York Harbor is the Verrazano-Narrows Bridge. The main span is 4,260 feet long. It is named for the first explorer to see the Hudson River, Giovanni da Verrazano. What began as a Dutch trading post has become one of the financial capitals of the world. New York City has a population of more than eight million, with nineteen million in the greater metro area.

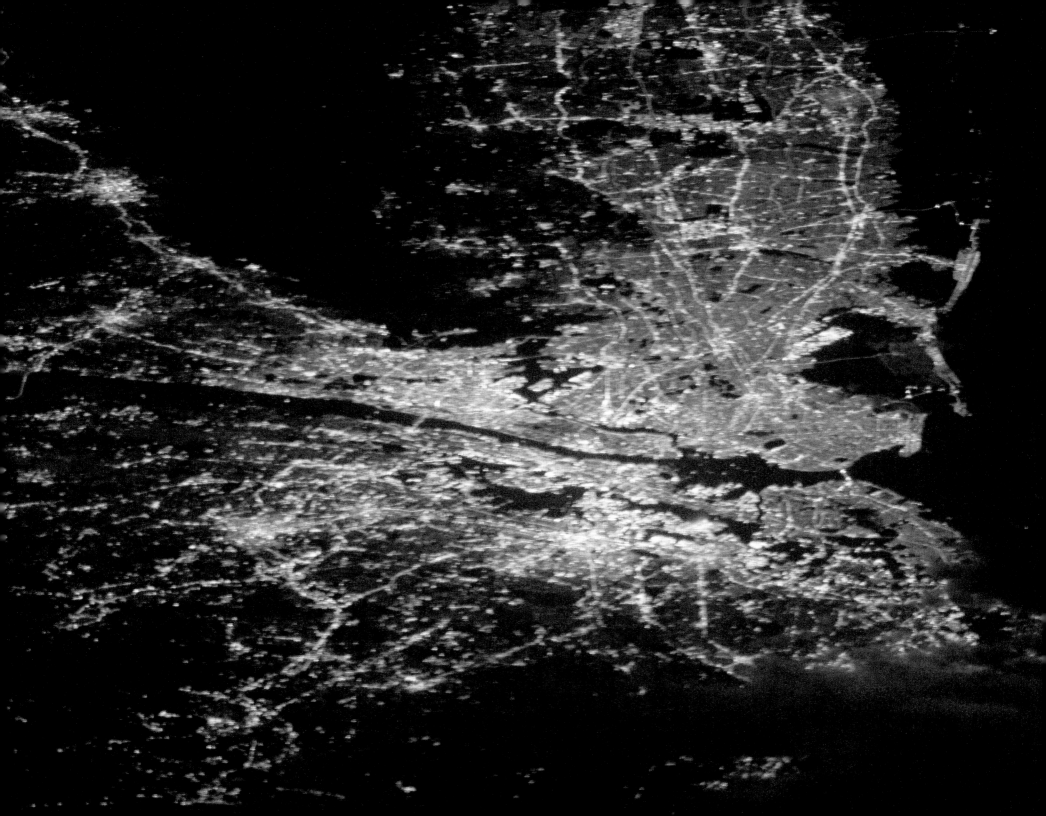

The United States/New York City

These day and night overhead views of New York show the four principal landmasses that surround New York Harbor. Clockwise from the bottom center: Long Island, Staten Island, New Jersey, and the island of Manhattan. The dark square area on the tip of Long Island is Dyker Beach Park. Just behind it is the complex containing the Prospect Park Zoo and the New York Botanical Gardens. On the island of Manhattan, Central Park is clearly visible as a thin, dark rectangle.

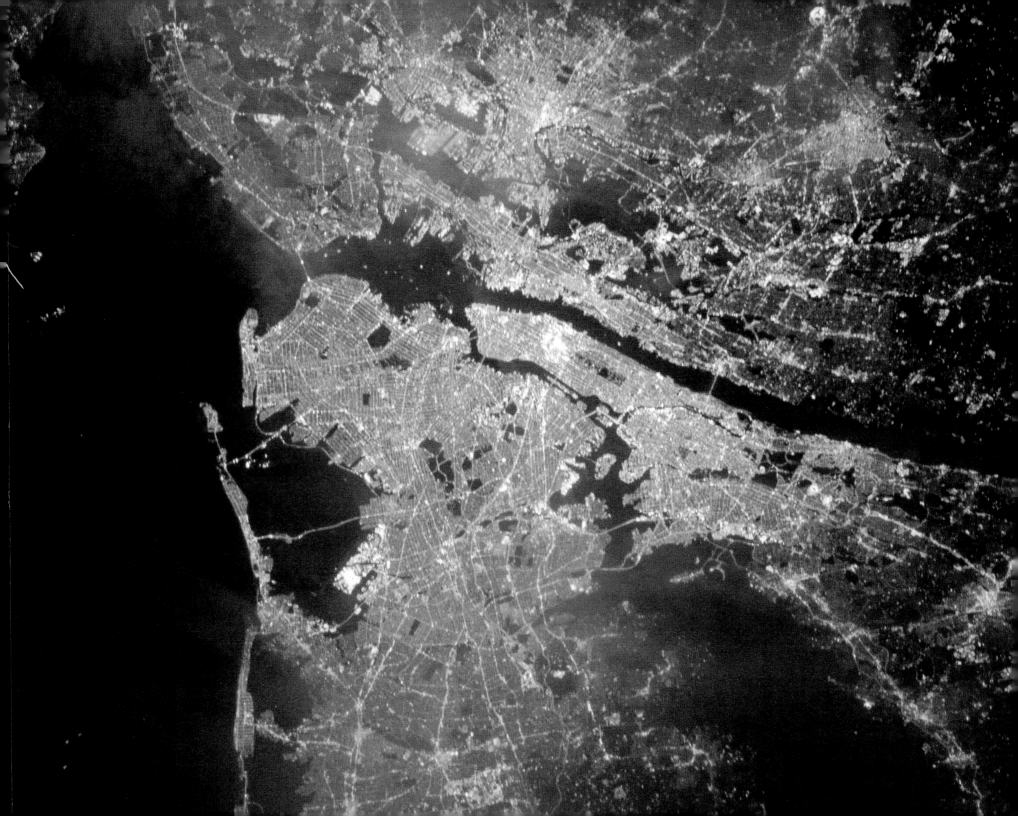

The United States/New York City

A light cloud cover provides a striking composition. The first lights in sharp focus on the Connecticut side of Long Island Sound are, from left, Bridgeport, Stratford, and New Haven. The towns of Westport, Norwalk, and Stamford have just been clouded over. The dark triangle at the bottom center of Long Island is Jamaica Bay. The white rectangle on the edge of the bay is John F. Kennedy International Airport.

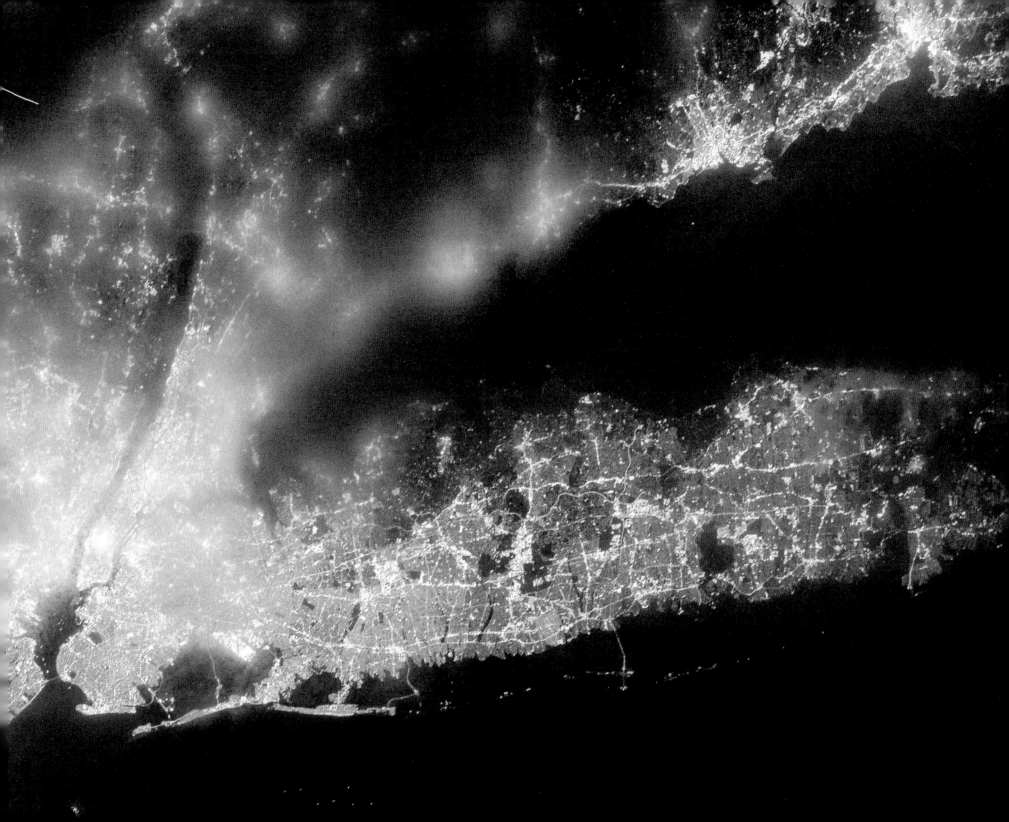

The United States/Philadelphia and Baltimore

Moving goods by water costs less than by land, so even the cost of an extra day's sail was well worth the time. Philadelphia and Baltimore were thriving colonial seaports and remain thriving seaports today.

(OPPOSITE) Philadelphia's city center straddles a slight peninsula defined to the east by the Delaware River and to the west by the Schuylkill River. In this image, New Jersey is in the foreground. The University of Pennsylvania, founded by Benjamin Franklin, is across the Schuylkill.

(BELOW) Baltimore wraps around the tidal estuary formed by the outflow of the Patapsco River as it enters the Chesapeake Bay. The Chesapeake Bay connects Baltimore to the Atlantic Ocean.

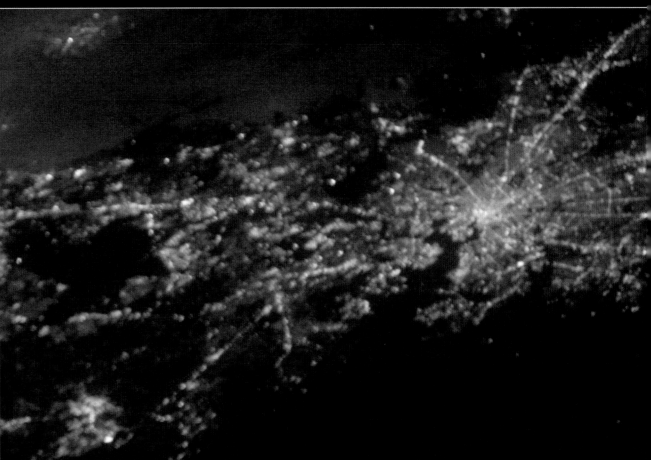

The United States/Washington, D.C.

The cities of Washington, D.C., and Baltimore are well defined when viewed from space. The idea of a capital city created a divide among the colonial states. In Europe, capital cities were some of the most prosperous cities a nation had, and it was assumed that Washington, D.C., would follow suit. That it would not had to do with its location—ideal for a city (George Washington selected the site) but a poor port. It wasn't until the Civil War that Washington began to grow as more workers were required to run the war department.

(BELOW) The Washington-Baltimore metroplex.

(OPPOSITE) Elements of Pierre Charles L'Enfant's plan for Washington, D.C., are visible in these photographs. The National Mall is the clearly lit, thin rectangle in the middle of the city off of which to the left is the White House spur. The well-defined elliptical "lens" along the Potomac River is the East Potomac Park.

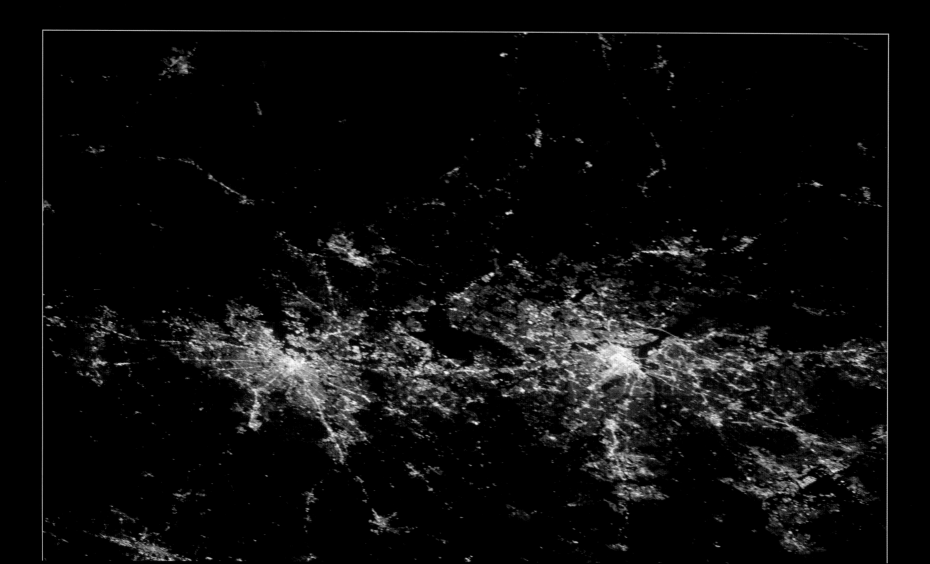

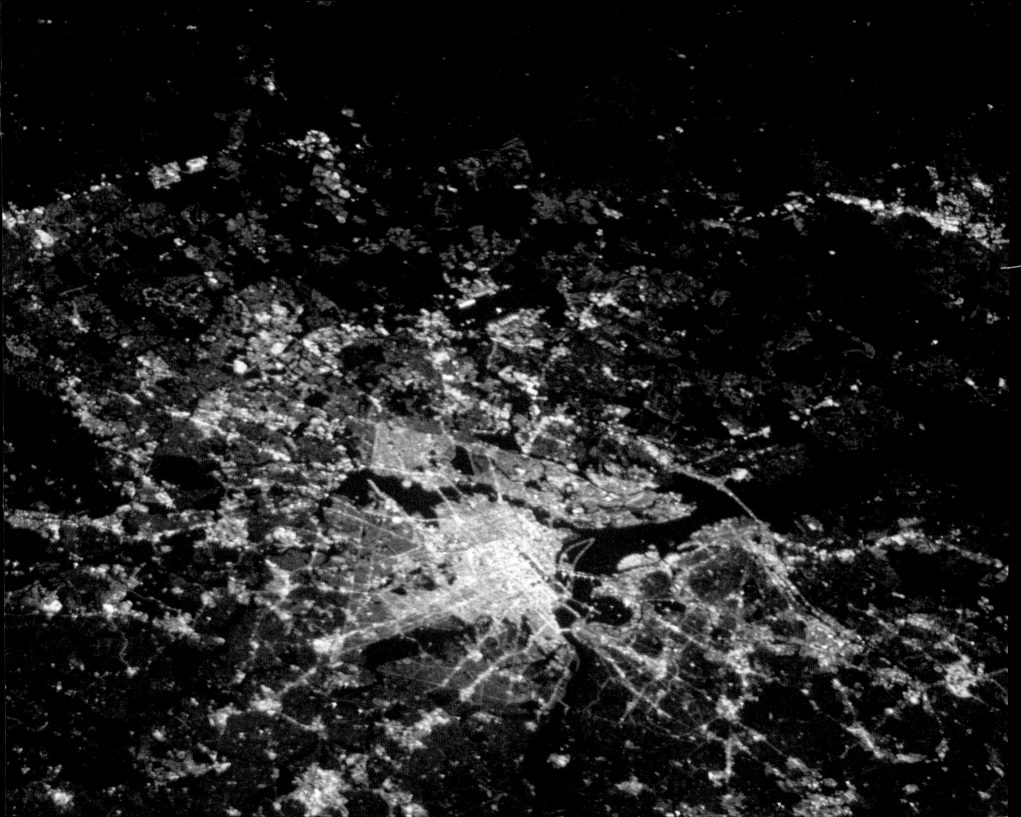

The United States/The Midwest

The United States/The Midwest

Time and again the Earth at night suggests a planet of tranquility and peace, as is does again here.

Looking south over Wisconsin toward Chicago. St. Louis is to the right. The Interstate 65 corridor of Indianapolis–Louisville–Nashville runs down the center.

(RIGHT) Once again, cities disappear in the daytime shots.

As the last light drains from the sky, the lights of the Midwest wink on.

(OPPOSITE) From bottom left coming down and around Lake Michigan are Milwaukee and Chicago. Detroit and the faint lights of Toronto are above Chicago. Indianapolis is the city in the middle of the photo. The mini-metroplex of Cincinnati-Dayton-Columbus is directly behind it.

(RIGHT) Looking back towards Lake Michigan, coming down from the north are Green Bay, Milwaukee, and Chicago. To the right of Chicago are South Bend and Fort Wayne, Indiana, and Kalamazoo and Grand Rapids, Michigan. This panoramic is silhouetted by the aurora borealis.

The United States/Chicago

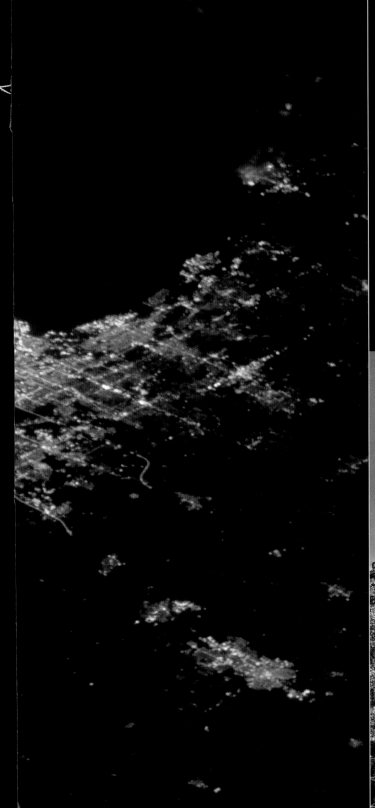

Chicago was first settled in the 1770s, but it wasn't until 1833 that it began to take shape as something more than a remote village of 150 people. A federal program was launched to solve lingering problems with Native Americans, forcing more than three thousand to leave the Chicago area for reservations in the West. No longer at risk, new settlers arrived and major construction projects began. In 1848 a shipping canal was completed that linked Chicago to the inland river systems including the Mississippi River. At approximately the same time, Chicago's first railroad arrived. Chicago quickly became a transportation hub. Within eight years, ten rail lines with some three thousand miles of track terminated in Chicago. More than one hundred trains arrived daily, many of them filled with cattle to be slaughtered and the meat sold for high prices in the East. The opening of the Erie Canal and the St. Lawrence Seaway connected Chicago all the way to the Atlantic.

The United States/Detroit and Cleveland

Detroit sits on the Detroit River between Lake Erie and Lake St. Clair. Across the river from Detroit is Windsor, Canada. Detroit is a major port city and is the automotive capital of America.

(OPPOSITE) From the left down and around to the right, Detroit, Toledo, and Cleveland. In 1796, the Connecticut Land Company purchased a parcel of land along Lake Erie from the state of Connecticut and developed Cleveland. Large coal and iron ore deposits, as well as natural access to the Great Lakes, propelled the city's early growth. Toledo got off to a slower start despite its proximity to two major canals. With the addition of a railhead and a spur that directly linked the city to the canals and waterway, Toledo flourished as a manufacturing center for a number of products including glass.

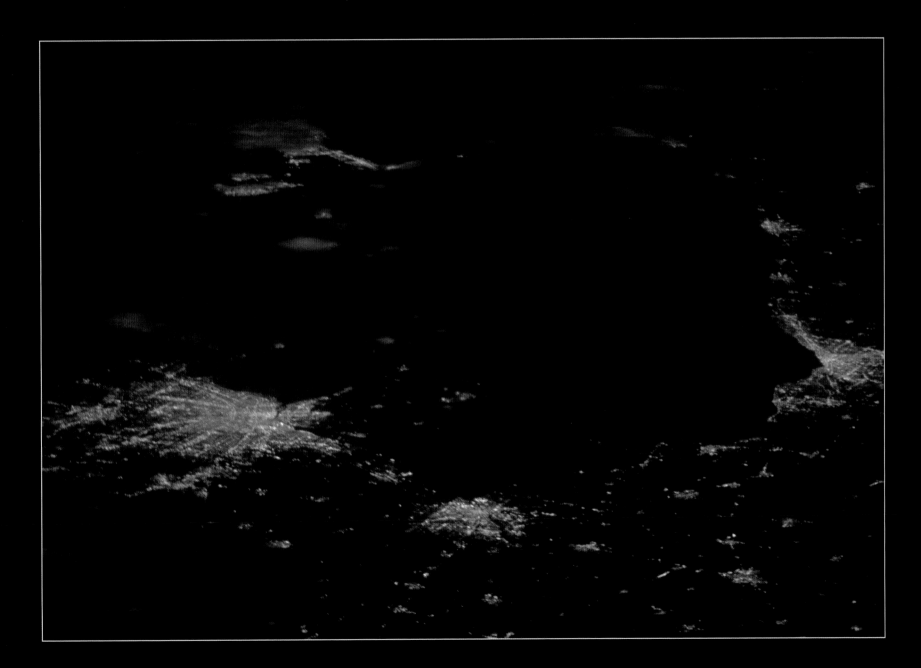

The United States/New Orleans

The lights of New Orleans are particularly helpful in orienting a city on a land bridge between a lake and a river.

(OPPOSITE) In this nighttime panoramic of the Gulf Coast, Houston is the prominent light to the left. To the upper right, New Orleans and Baton Rouge are the brightest lights. The two thin lines of light that extend down to the Gulf of Mexico trace the outlines of the Mississippi River delta.

(RIGHT, TOP AND BOTTOM) New Orleans backs up to Lake Pontchartrain but faces the Mississippi River, seen twisting through the downtown area. Levees and canals shape the sides of New Orleans, as is clearly visible to the west of the city. These images are all post-Katrina.

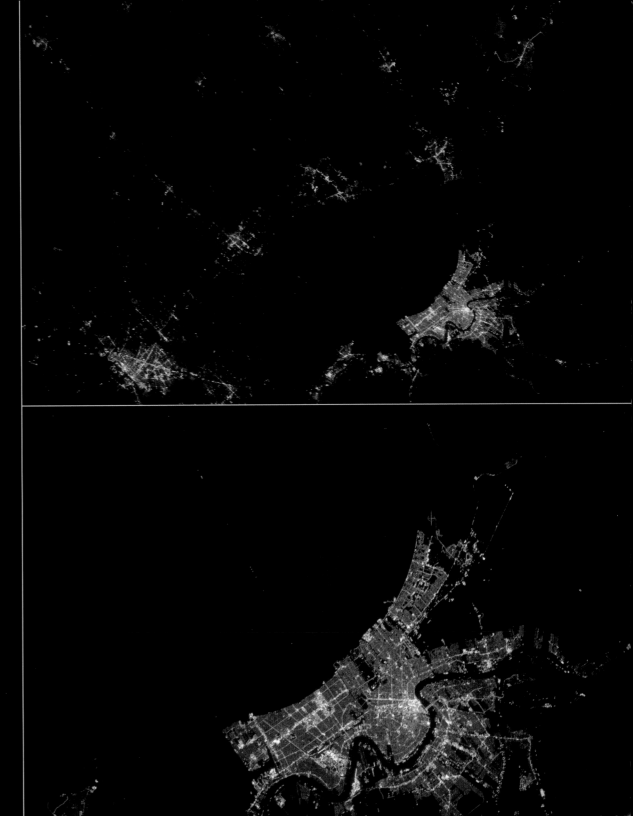

(OPPOSITE) Charleston sits on a peninsula of land at the confluence of the Ashley and Cooper Rivers, but its shape is altered in night photography. Both rivers are edged by marshy wetlands, making them appear wider then they are. The bright, golden area across the bay is the highly secured North Charleston Container Yard.

(BELOW) The Savannah River cuts a sweeping curve in this nighttime photograph. To the right of the river are the lights of Savannah; to the left, a thinly populated area of South Carolina. Most of the dark areas are marshes, wetlands, and woods. The downtown bridge, faintly visible, passes over the Savannah River into South Carolina.

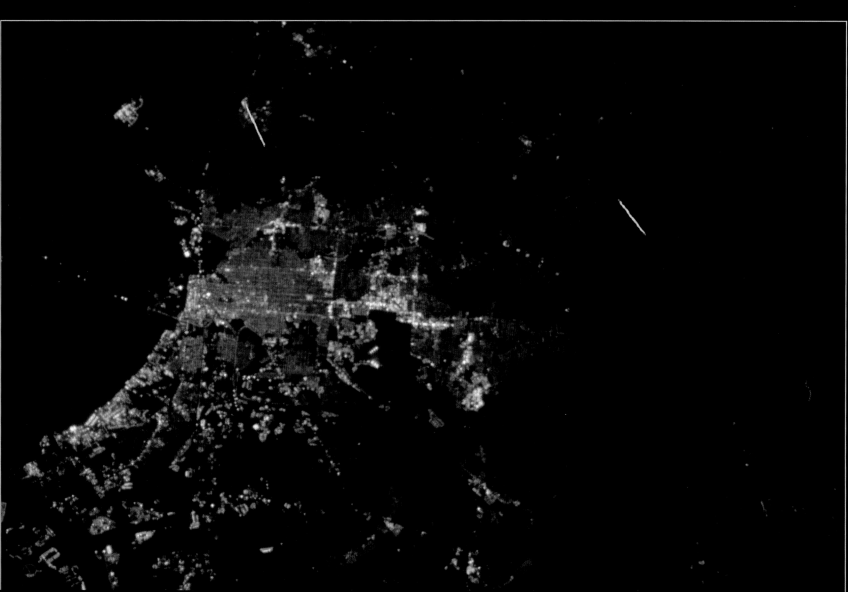

The United States/Florida

Moonglint silhouettes Florida. The Florida Keys trail
off to the bottom right while Freeport, Bahamas,
appears as a dot of light just offshore of Miami.

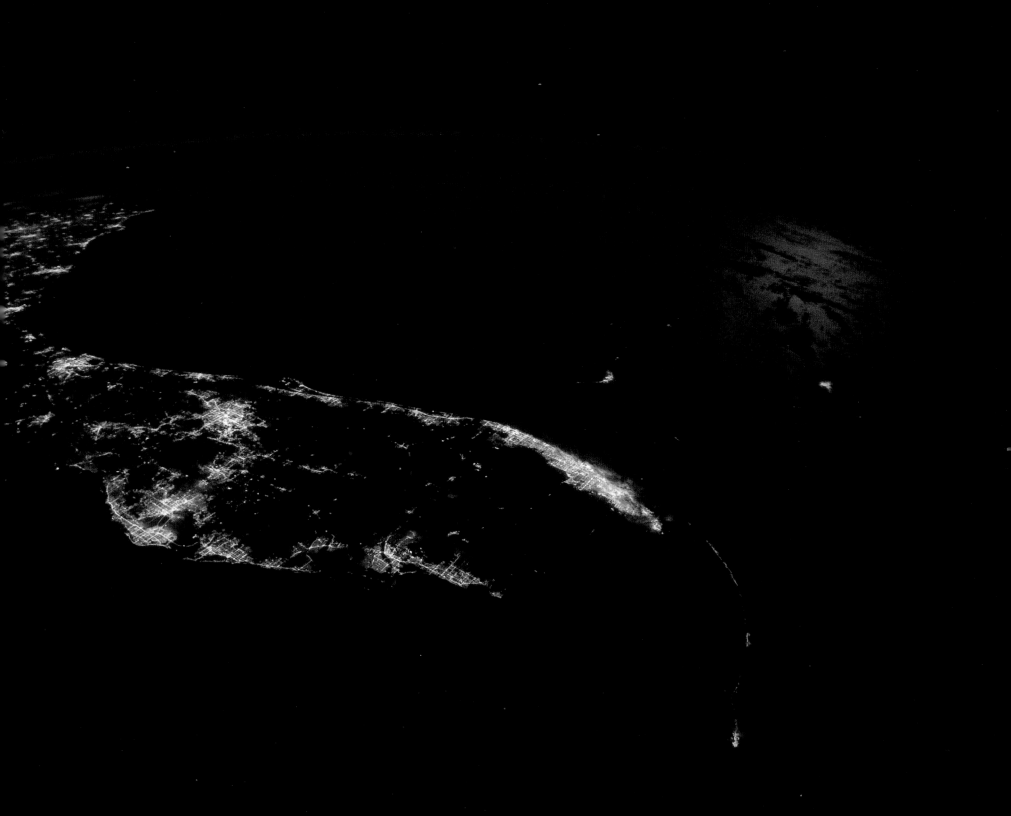

The United States/Florida

The glow of dawn suffuses this photograph with a turquoise sheen that perfectly blends with the city lights to give us this unique portrait of Florida. This low angle demonstrates Florida's susceptibility to hurricanes. Most of the state lies at or near sea level. Its highest point is just 345 feet above sea level. Ponce de León discovered Florida during Easter in the early 1500s, naming it La Florida in honor of the Spanish Easter season, Pascua Florida.

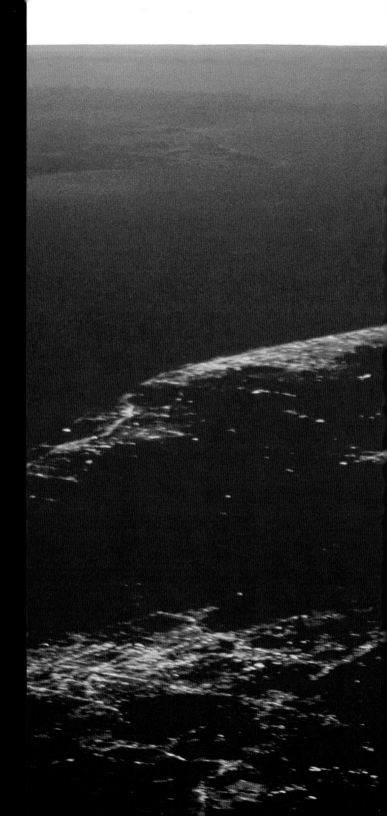

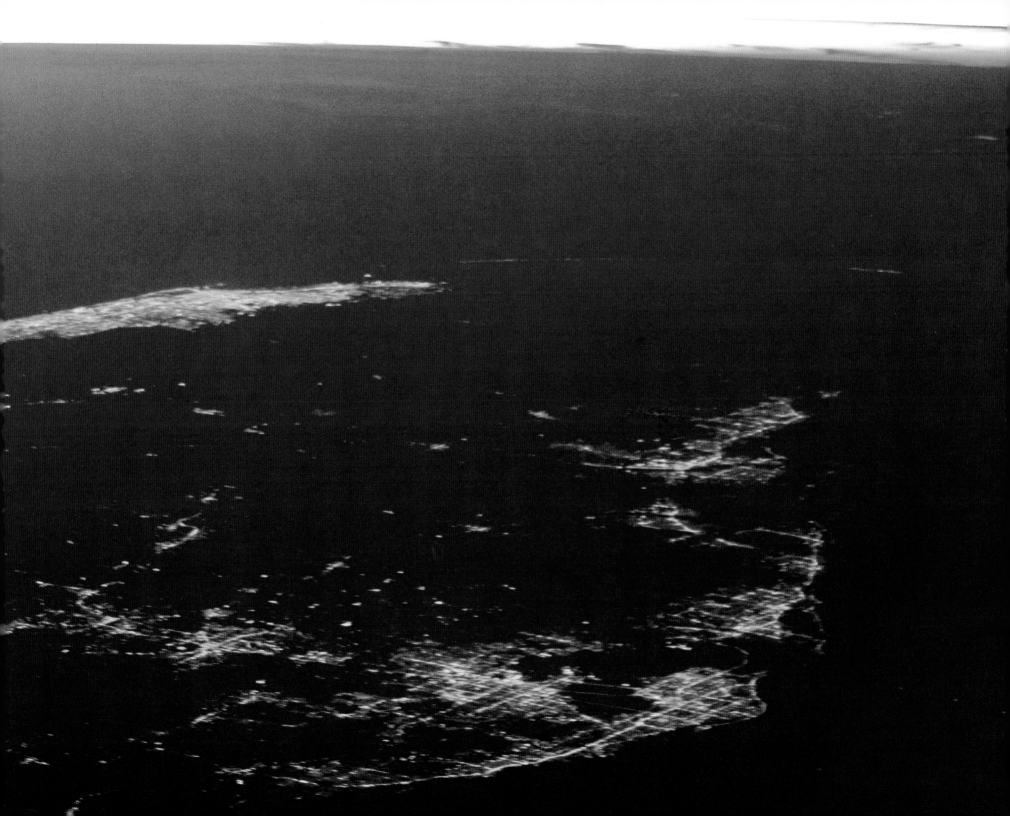

The United States/Florida

A view of Florida's Gulf Coast. From left to right are the cities of Tampa, St. Petersburg, Bradenton, Sarasota, Fort Myers, Naples, and Marco Island. The dominant lights inland are those of Orlando while to the north, on the East Coast, we see Jacksonville. Florida's horse country, orange groves, and farms darken much of the interior; however, the larger square between Orlando and Tampa is the 110,000-acre Green Swamp Wilderness Preserve.

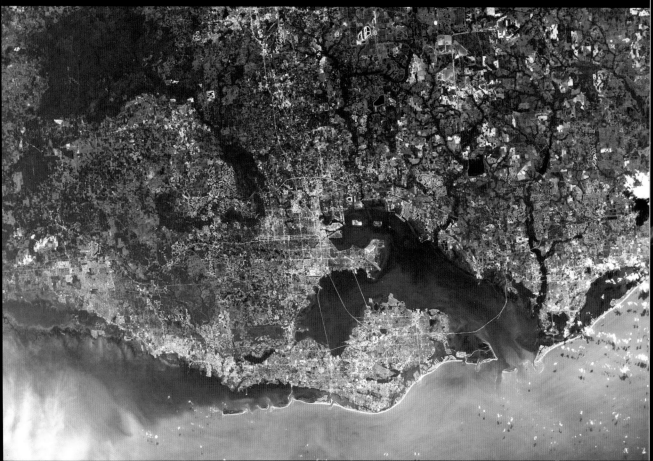

The United States/Florida

The Cuban Missile Crisis of 1962 started with the discovery of Soviet-made missiles on the island of Cuba. President John F. Kennedy demanded that the missiles be removed and that Soviet Premier Nikita Khrushchev stop the cargo ships that were on their way with more. The world anxiously waited as the two superpowers stood at the brink of war. Thankfully, Khrushchev backed down. In a view never seen during the Cold War, these photographs provide vivid evidence of just how close ninety miles really is. Havana, Cuba, is the bright light in the foreground.

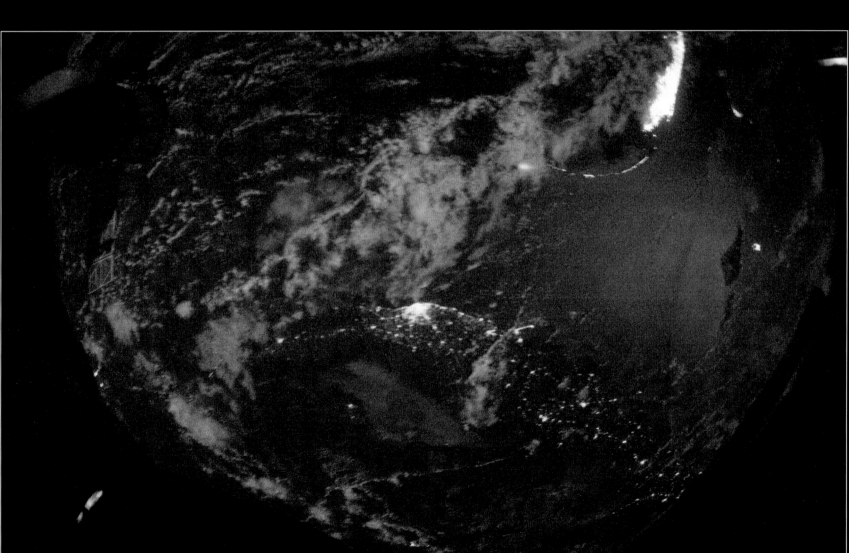

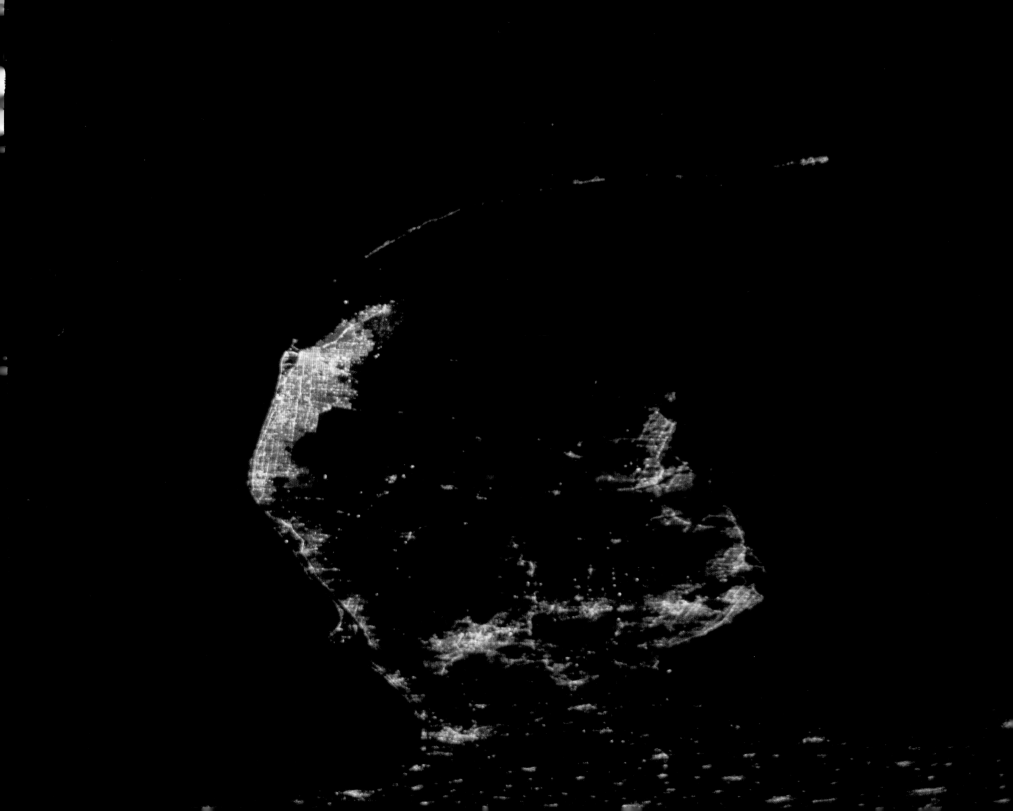

The United States/Florida

By day, our human footprint is nearly nonexistent. By night, Earth becomes an electric planet. By night, we see Florida's population of eighteen million come to life. Most of Florida's cities are laid out in grids, giving the state a skeletal look. Miami is at the top with the Florida Keys arcing into the ocean.

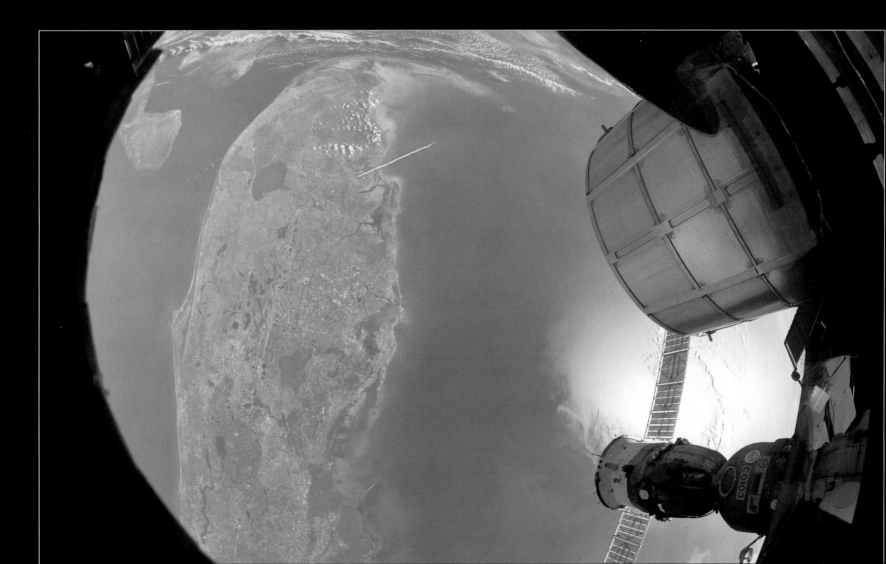

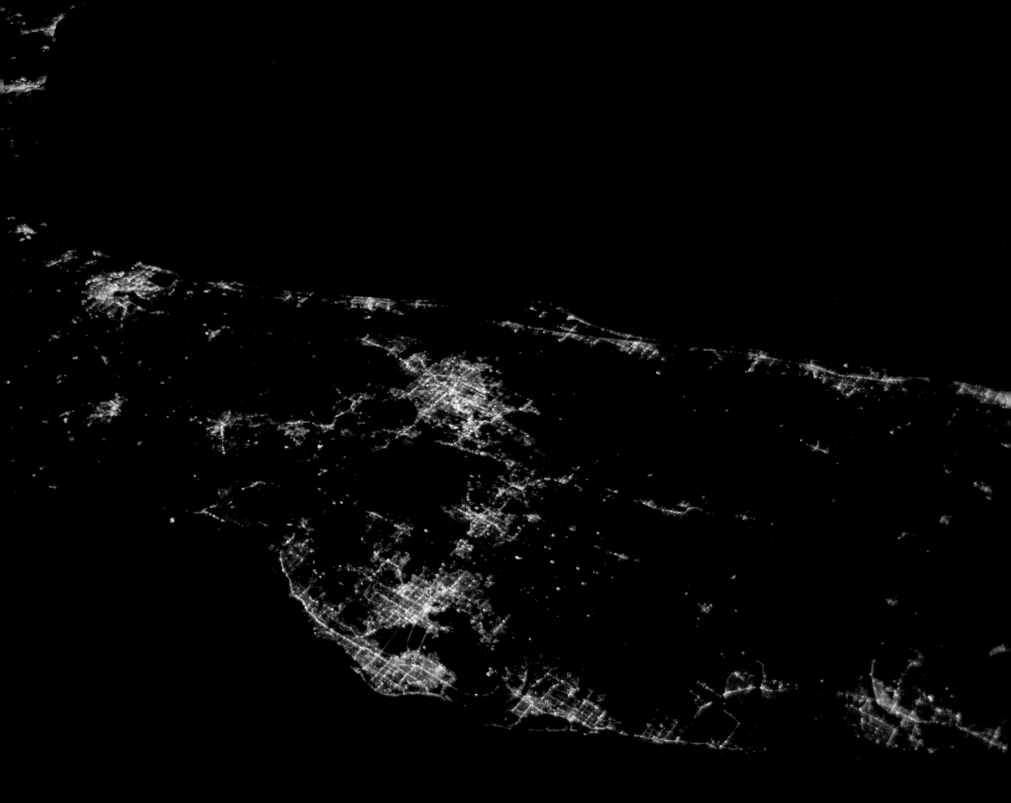

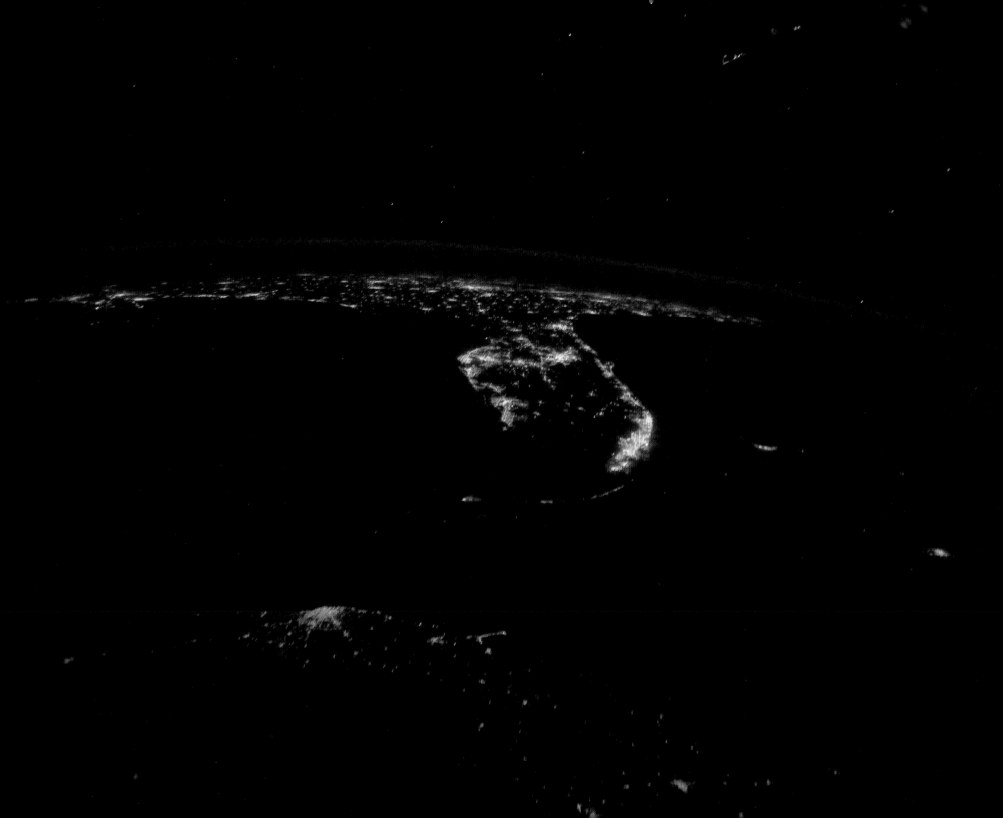

The United States/Dallas–Fort Worth

Fort Worth, Texas, is thirty-two miles from down-town Dallas, and yet this ever enlarging metroplex continues to swallow up land and merge into one. The distinctive terminal buildings of the Dallas–Fort Worth International Airport are seen in orange half-circles between the two cities. Hints of emerald green can be seen coloring the Dallas and Fort Worth suburbs. Both cities benefited from the discovery of oil in Texas.

(OPPOSITE) Fort Worth on the left and Dallas on the right. Fort Worth was established as an army outpost on the West Fork of the Trinity River. When the first railroads arrived here, Fort Worth became an end point for cattle drives. Great cattle pens and meatpacking plants swelled the city's population as laborers came in to take the plentiful jobs.

(BELOW) Dallas was settled in the 1830s on the Trinity River as a farming community. The cash crop was cotton. The arrival of railroads in the 1870s gave Dallas access to the cotton markets in the East and Midwest. Numerous bridges span the Trinity River as it weaves through downtown Dallas.

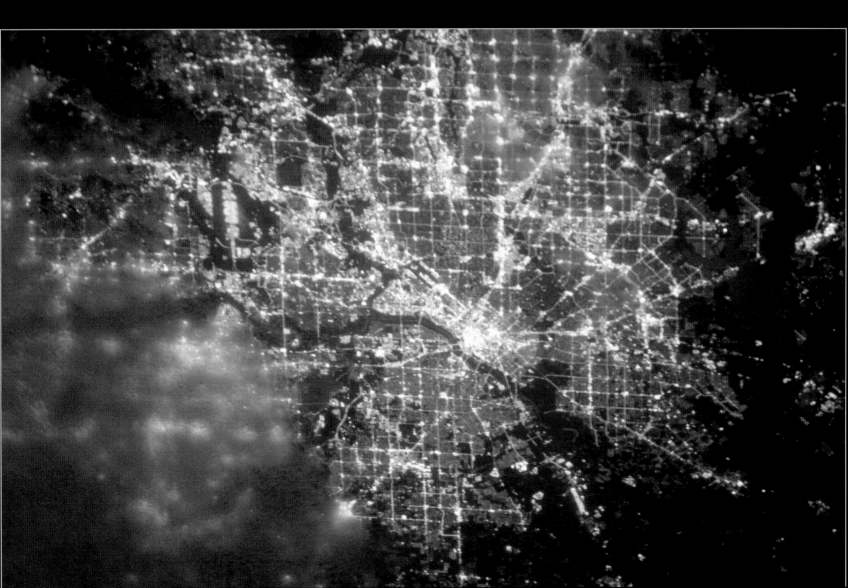

The United States/Houston

Houston was founded in 1836 by two New York real estate entrepreneurs as a farming community, but the engine that propelled it into a city of 5.9 million people was oil. Almost one million barrels of oil are refined daily at the Baytown and Texas City refineries just outside Houston. Through the Houston Ship Channel, the city has direct access to the Gulf of Mexico. Houston is home to the Johnson Space Center, where the astronauts in this book are based. Clearly visible as two dark areas to the northwest of the city are the eight-thousand-acre George Bush Park and the executive airport.

(BELOW) Houston is the largest light. Galveston is immediately offshore. Corpus Christi is visible in the background.

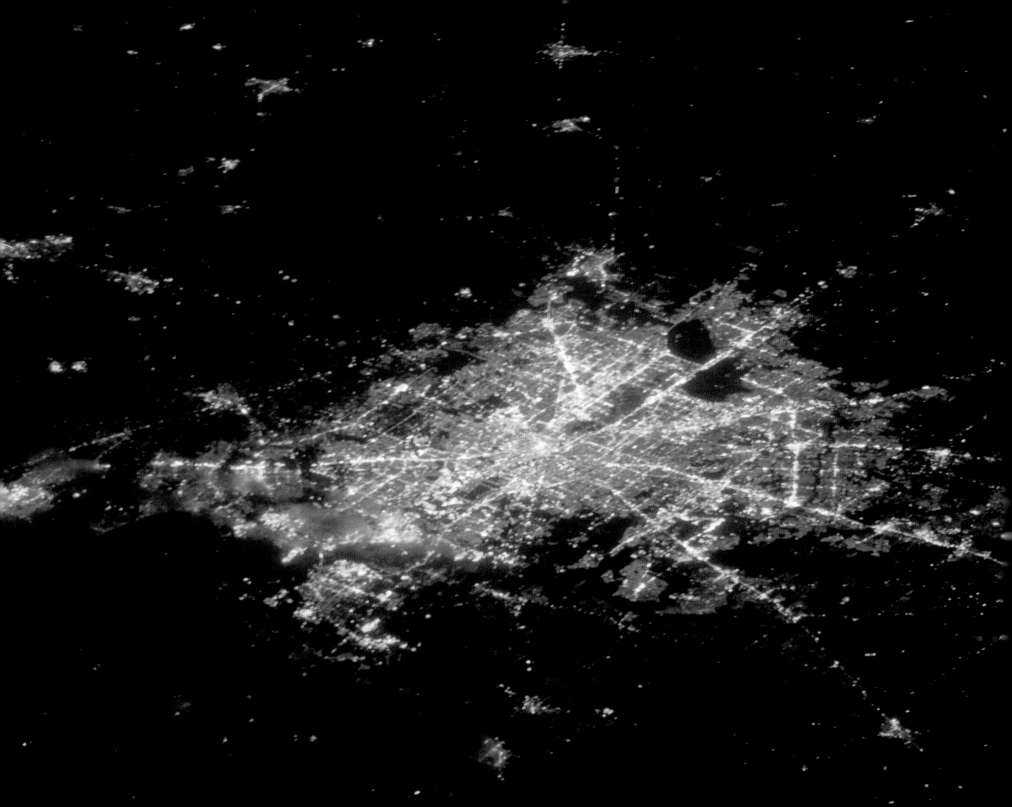

The United States/El Paso, Denver, Phoenix-Tucson

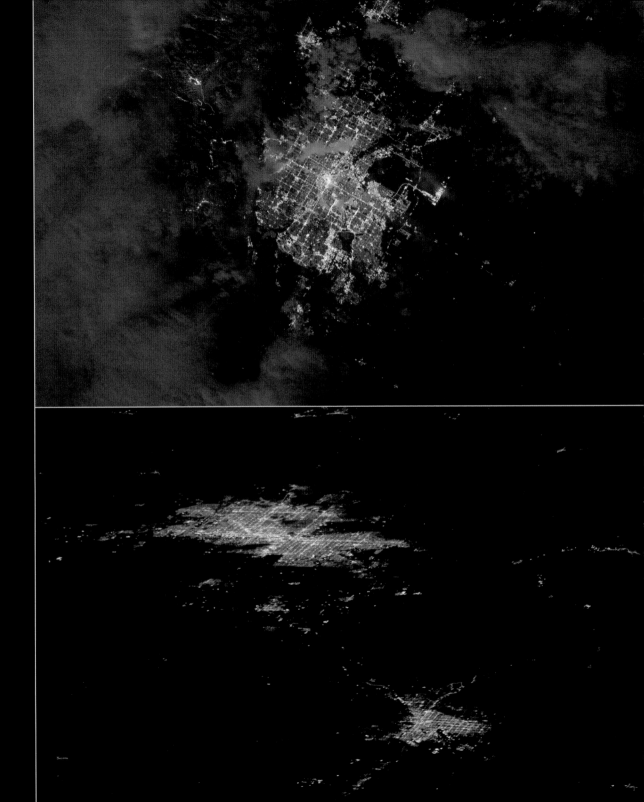

(OPPOSITE) Ciudad Juárez butts up against El Paso, Texas, a study in contrasts not only in urban densities and urban planning, but also economic opportunity.

(RIGHT, TOP) Denver speaks out through a broken cloud cover. The terminals of Denver International Airport are to the right of the city.

(RIGHT, BOTTOM) Phoenix and Tucson create a desert panoramic.

By day, San Francisco is a lovely port city with sweeping vistas. By night, it turns into a jagged, hard-edged force of nature that muscles its way around rugged mountains and the shorelines of San Francisco Bay. Two dots of light mark the twin supports of the Golden Gate Bridge and are clearly visible. Oakland is across the bay from San Francisco. Metro San Francisco is home to 4.3 million.

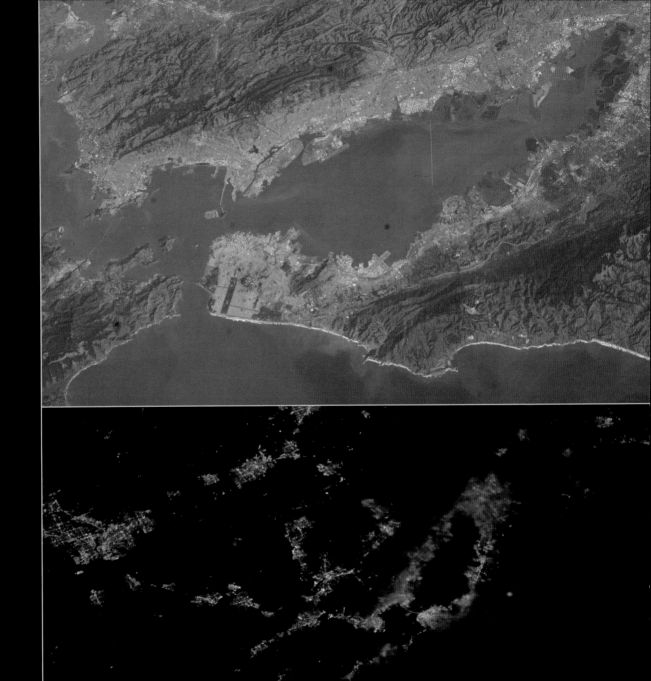

Seattle sits on a narrow isthmus that separates Puget Sound from Lake Washington. The Lake Washington Ship Canal can be seen as the knee joint running across the isthmus to the left of the downtown area. The Ship Canal connects Lake Washington to Puget Sound and is laced with piers, boats, and processing plants. The lights of Tacoma can be seen on the sound to the far right of Seattle. Directly across Lake Washington is Bellevue.
The day and night photographs, right, show the topography of the Seattle-Tacoma area. Fur trading and fisheries were the early economic engines of the Northwest.

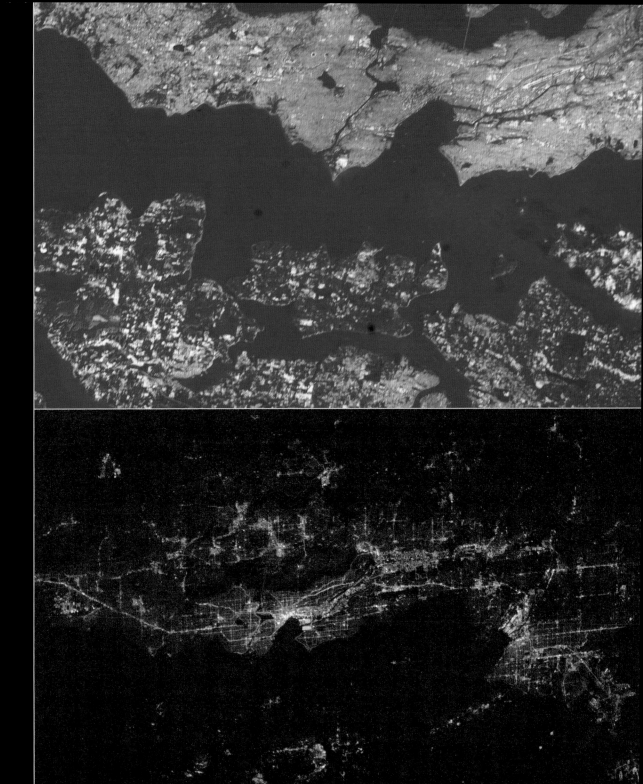

The United States/Los Angeles

Canada/Montreal to Quebec

With 596 square miles and an island population of 965,000, Oahu radiates a dramatic image to space. At night the population flows down the sides of the mountains like lava. The largest pools of light are Honolulu and Pearl Harbor, both in the foreground. Across the mountain ridge is Kaneohe.

Los Angeles enjoys one of the most powerful economic engines in the world, with an $833 billion economy. And yet it started as a pueblo of farmers living around the Mission San Gabriel Arcángel, erected by Franciscan missionaries from Spain. It wasn't until 1892, when oil was discovered there, and 1920, when the aviation and movie industries took root, that Los Angeles began its ascendancy. By 1923, movies, oil, and aviation were powering the most explosive growth of any American city since the immigration wave of the 1800s. Los Angeles itself is packed into 470 square miles; LA County spreads over two thousand square miles. The entire metro area, from Long Beach to Riverside, has a population of eighteen million people. The tight cluster of white lights in the center is downtown Los Angeles. The lights of Century City and Sunset Boulevard are at the edge of the Hollywood Hills. Los Angeles International Airport is in white near the coastline. To the left the orange cluster of lights is the cargo handling facilities in the Port of Long Beach.

This four-hundred-mile-long panoramic begins in the foreground with Montreal and continues left to the city of Trois-Rivières and on to Quebec City. Montreal is an island-city on the St. Lawrence River. Trois-Rivières is one of the oldest industrialized towns in Canada. The first forge in Canada was built there. Quebec province is bordered by Maine, New Hampshire, Vermont, and New York.

(BELOW) Founded in 1608 where the St. Lawrence River narrows, Quebec City is one of the oldest cities in the New World. The night photograph clearly shows the island called Ile d'Orleans. Quebec's metro population is just over 7.9 million.

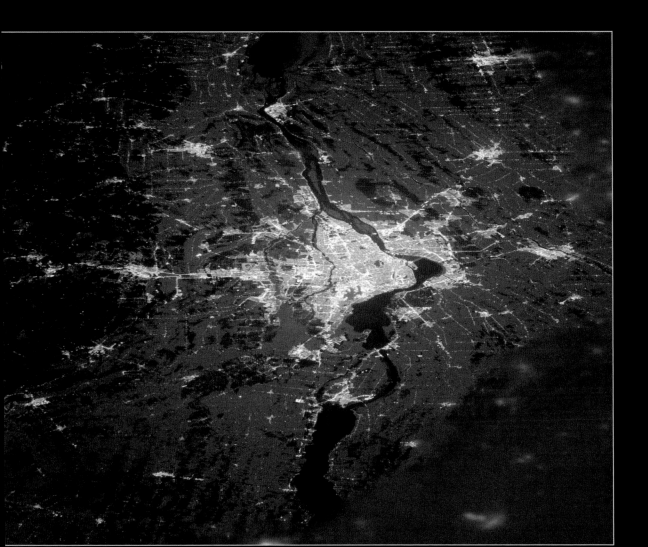

(LEFT) Montreal is on an island thirty-one miles long in the St. Lawrence River. More than 3.8 million Canadians live there. Montreal was settled in 1611 as a trading post. The Lachine Canal, opened in 1834, was a major economic stimulus for the city. The canal bypassed rapids on the St. Lawrence, giving Montreal navigable access to the Atlantic Ocean. By the late 1800s Montreal's harbor was thick with steamships and sailing vessels coming in and out of port. Montreal wraps around the Mount Royal mountain, from which it derives its name.

(OPPOSITE) In 1750 Toronto was settled by the French on the shores of Lake Ontario at the end of an Indian footpath that connected Lake Huron with Lake Ontario. During the War of 1812, the town was sacked and burned to the ground by American military forces (leading to the sacking and burning of Washington, D.C., later in the war).

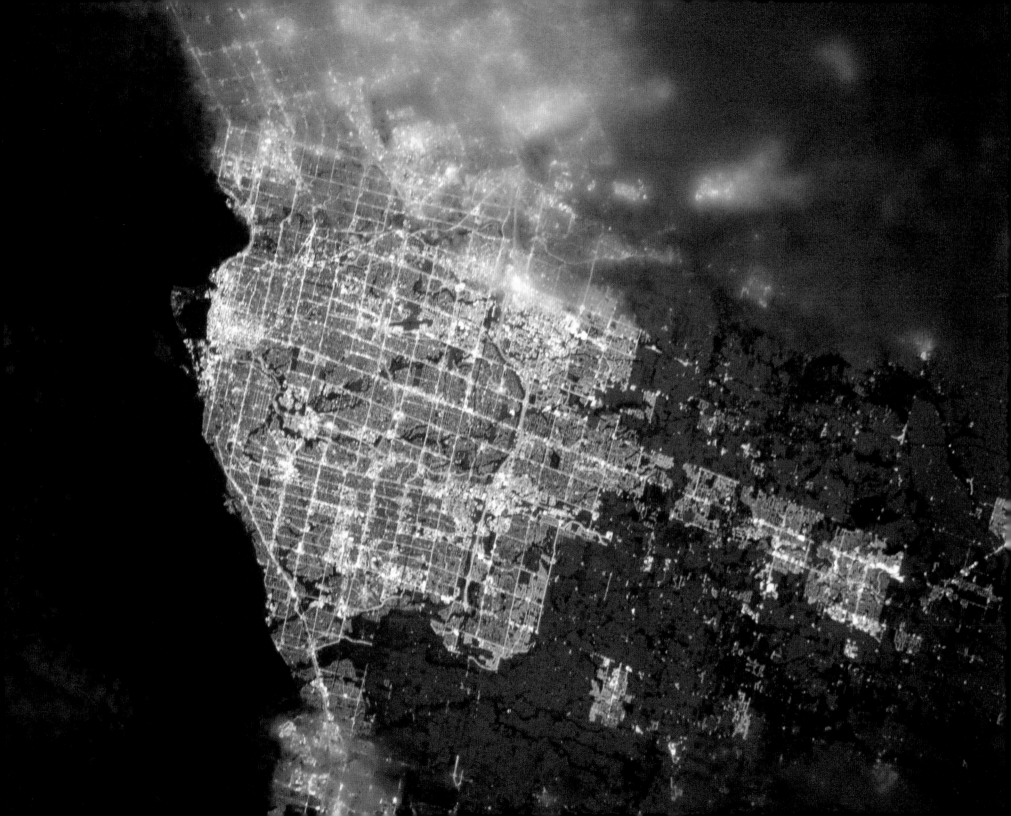

THE UNINTENTIONAL ARTWORK OF MAN

There are eighty-eight figments of our human imagination joyfully romping across the nighttime sky: bulls, bears, and mythical gods described in pinpoint clusters of stars with names given to them by the Greeks and the Romans and other ancients. Man, too, has his own constellations, lights that speak to our presence on Earth. To see these Earth-bound constellations takes little more than what the ancients applied to the task—an imaginative eye. Is that Cape Town or an Incan god? Is that Valencia, Spain, or a mythical eagle with golden wings? The astronauts coined a phrase that answers these questions and more: "the unintentional artwork of mankind." Indeed.

(BELOW) Alien monster about to strike. Ilha de Itaparica, Baía de Todos os Santos, Salvador, Brazil.

(OPPOSITE) Fishing fleets off the coast of Vietnam.

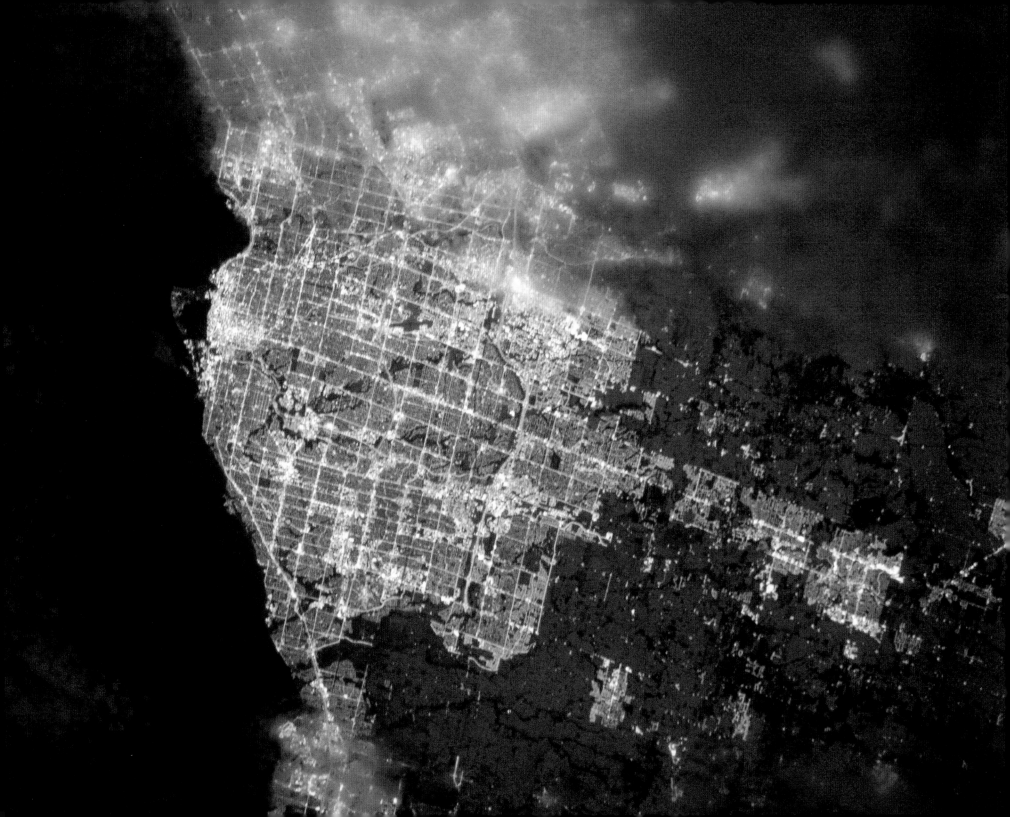

THE UNINTENTIONAL ARTWORK OF MAN

There are eighty-eight figments of our human imagination joyfully romping across the nighttime sky: bulls, bears, and mythical gods described in pinpoint clusters of stars with names given to them by the Greeks and the Romans and other ancients. Man, too, has his own constellations, lights that speak to our presence on Earth. To see these Earth-bound constellations takes little more than what the ancients applied to the task—an imaginative eye. Is that Cape Town or an Incan god? Is that Valencia, Spain, or a mythical eagle with golden wings? The astronauts coined a phrase that answers these questions and more: "the unintentional artwork of mankind." Indeed.

(BELOW) Alien monster about to strike. Ilha de Itaparica, Baía de Todos os Santos, Salvador, Brazil.

(OPPOSITE) Fishing fleets off the coast of Vietnam.

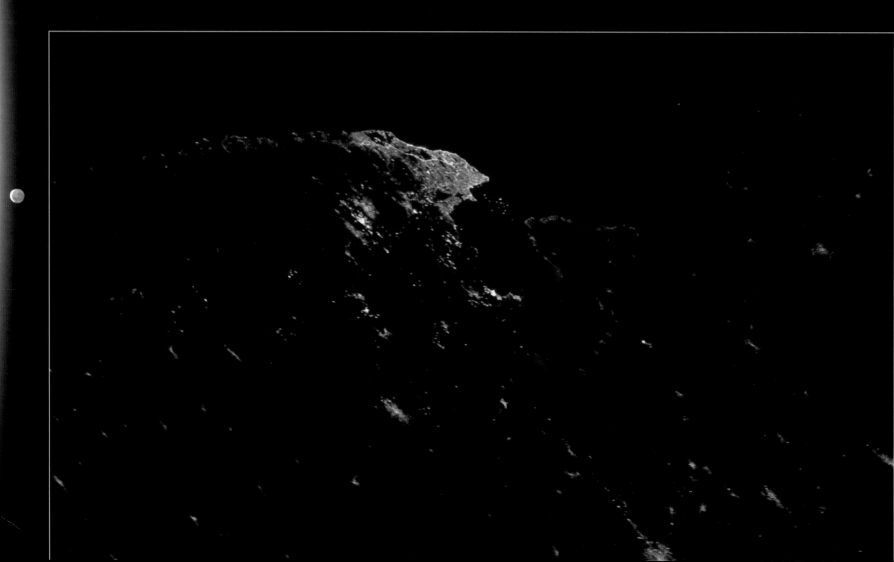

Reining in an ostrich. Abu Dhabi.

(OPPOSITE) A Venus flytrap snags a bug.
Unknown city.

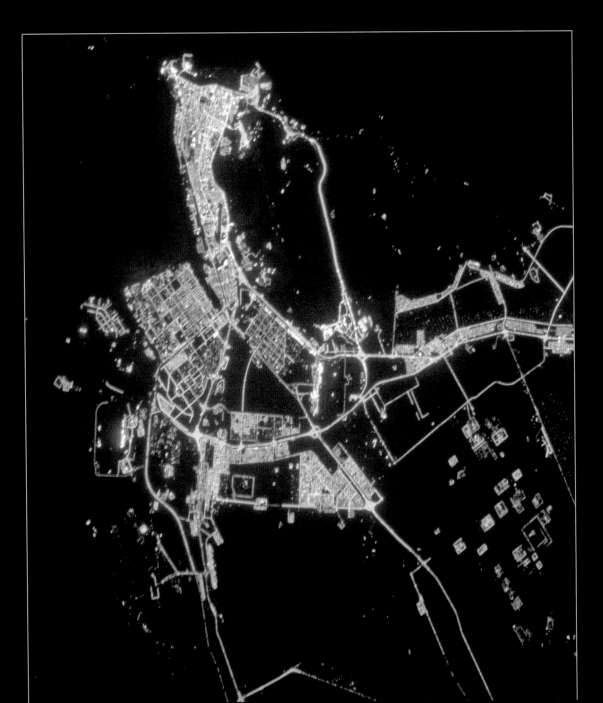

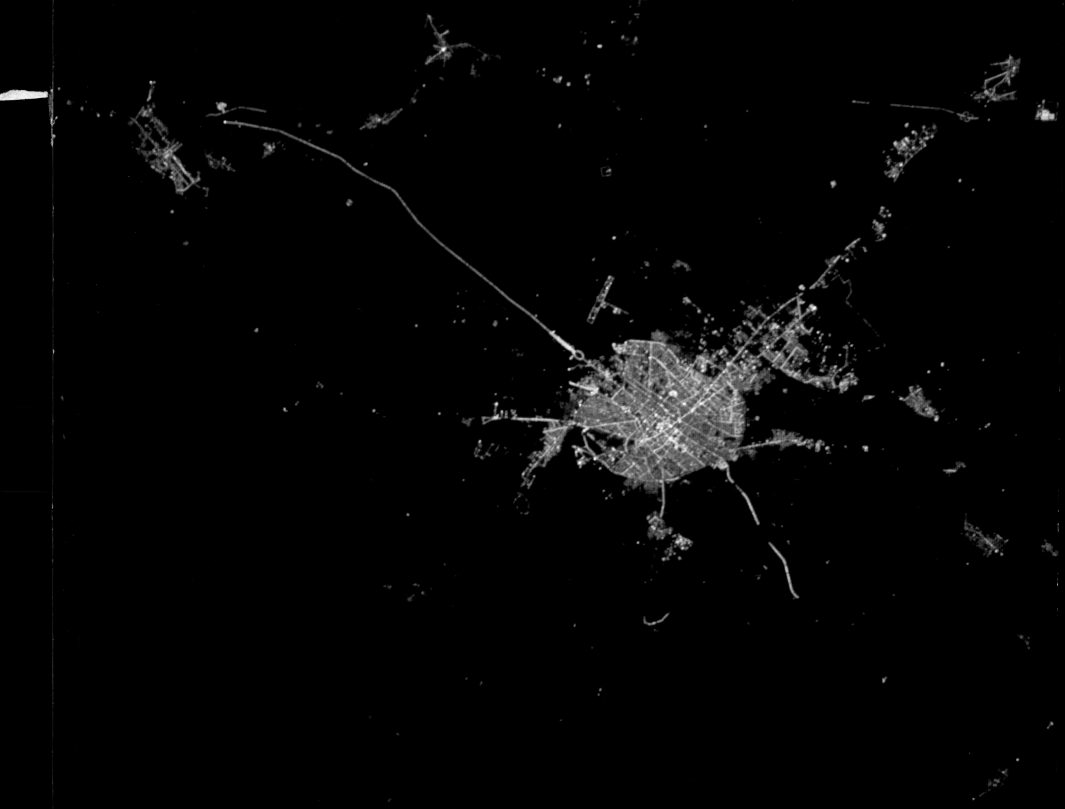

A bird feeding a worm to her babies. Samara, Russia.

(OPPOSITE) A mythical creature pulls a young one by the tail. The city of Saratov pulls Engels, Russia.

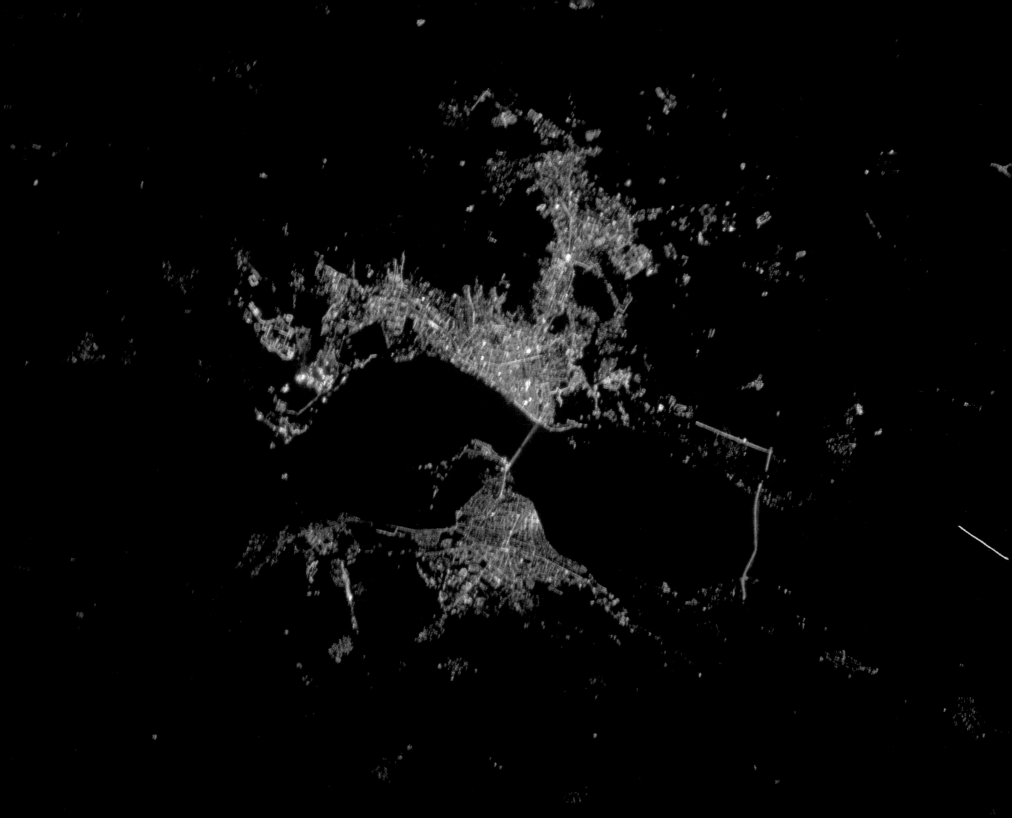

A primitive drawing of an eagle. Cape Town, South Africa.

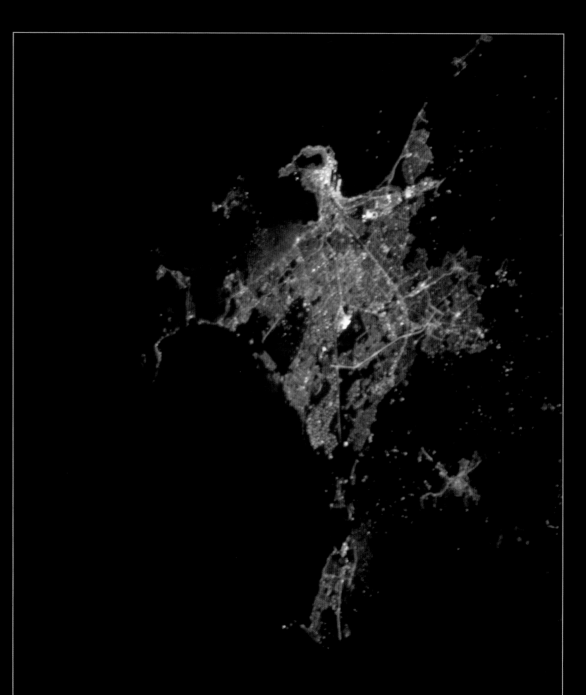

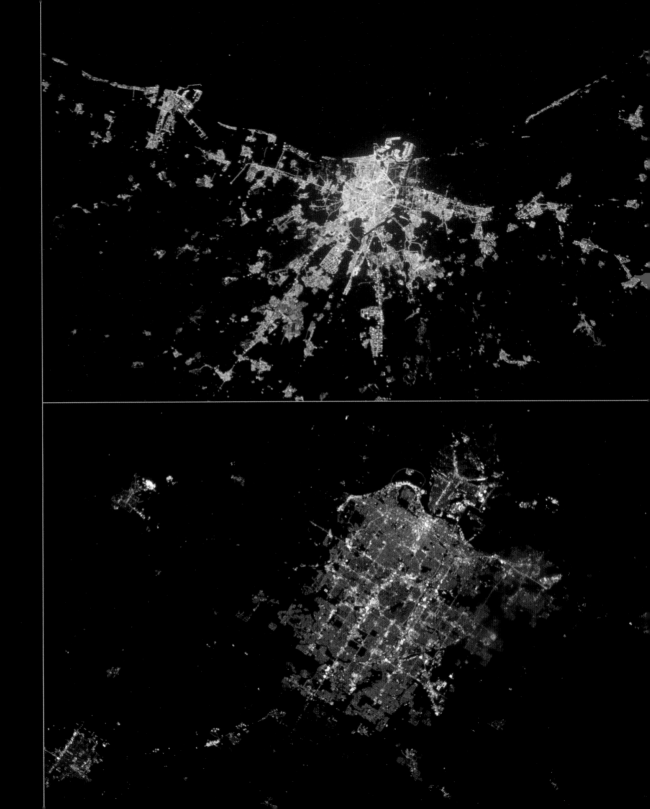

(RIGHT, TOP) A mythical bird triumphantly spreads wings of gold. Valencia, Spain.

(RIGHT, BOTTOM) A turtle makes its way across the road. Omaha, Nebraska.

The human brain. Ridges of gray matter create hills and valleys within which mysterious lights beckon.

(OPPOSITE) A monkey races along the coastline of Oman.

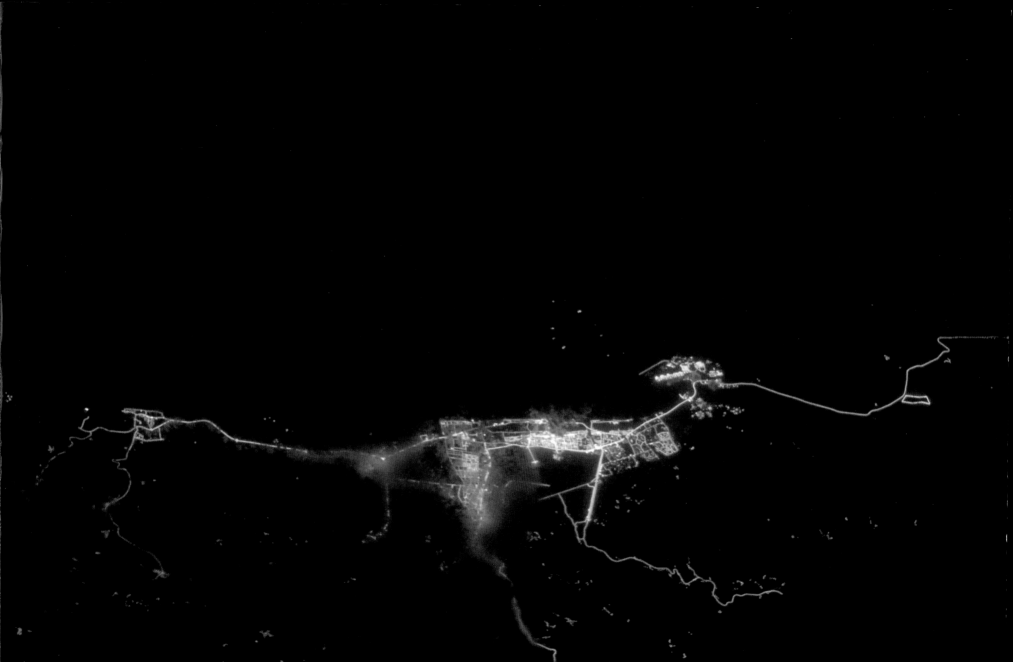

SEVEN WONDERS OF THE NIGHTTIME WORLD

In presenting our planet at night for the first time ever, it seemed appropriate to complement the Seven Wonders of the World with the Seven Wonders of the Nighttime World. That was, however, anything but easy. Over the course of five nonstop months, more than two hundred thousand images were reviewed for this book, out of which some thirty-four hundred became finalists. Of those thirty-four hundred, just four hundred made it into the book, and of those, seven stood head and shoulders above the rest. Not surprisingly, they are all panoramic photographs with impressive views of our planet at night. Here are the Seven Wonders of the Nighttime World.

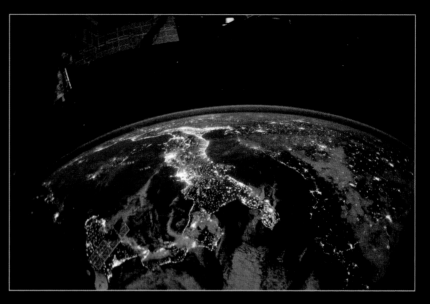

Italy

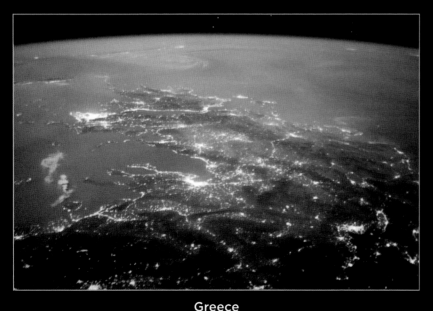

Greece

The Korean Peninsula

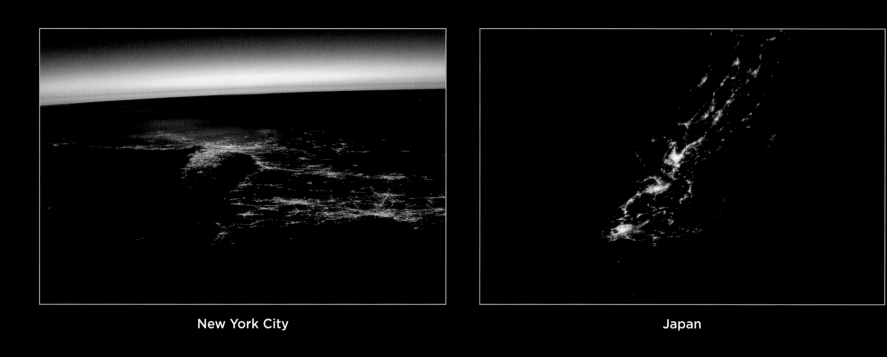

New York City

Japan

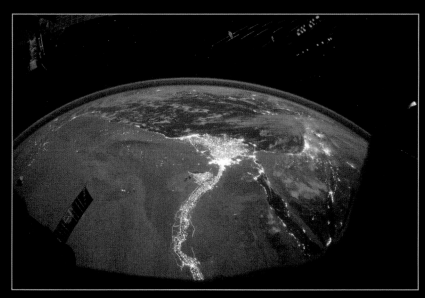

The Nile

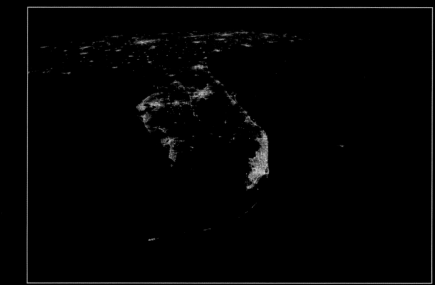

Florida

EPILOGUE: HOME

One of the rarest of human experiences will now begin as the Soyuz booster is rolled out to the pad. Three astronauts will fly up to the space station to replace three who have just returned. Because three astronauts are always manning the station, a human being has continuously been in space for ten uninterrupted years. Sadly, with the retirement of the space shuttle, there is only a slight chance that once returned to Earth, astronauts will ever ascend to the stars again.

EPILOGUE: HOME

As he contemplated the trip home, astronaut Doug Wheelock tweeted a message that resonated with tens of thousands across the world:

"The Earth at night is a masterpiece of light and motion. Aurora australis dancing on a moonlit night . . . a new dawn just beyond the horizon. . . . Tonight we set sail for the blue planet. It has been nearly six months, and we are being called home. I hope to one day return to this place. Seems I've lived a hundred lifetimes . . . yet I blinked, and the time has slipped away. What will that first breath be like when the hatch opens on Earth? . . . I can only imagine."

— Astronaut Douglas Wheelock

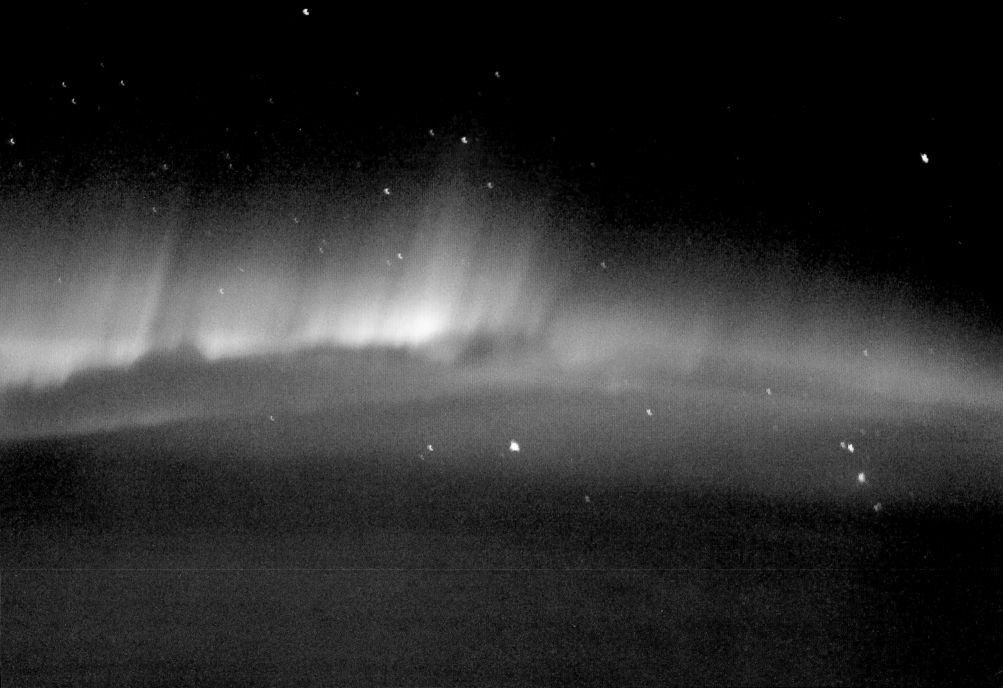

Cupola

A favorite astronaut pastime is to watch the Earth go by. The best windows for that are in the new, seven-paned Cupola, which was added to the space station in February 2010. Far from the windowless confines of the other modules, astronauts now have a place that opens to the world. The Cupola's windows are made of fused silica and borosilicate glass panes finely polished to provide almost 95 percent light transmittance. To protect the glass from micrometeoroids, the windows are shuttered when not in use. The main window is thirty-one inches in diameter, making it the largest window in space.

(BELOW) From the left are Jeffrey Williams, Expedition 22 commander, and Douglas Wheelock, Expedition 25 commander.

International Space Station (ISS)

The first section of the International Space Station was launched in 1998. Since then there have been 112 launches to the station. The station is designed for a crew of six with three crew members rotating in and out on staggered six-month intervals. More than 350,000 sensors monitor the crew's health and the integrity of the space station, utterly vital in an environment as absolute and as unforgiving as the vacuum of space.

The space station is large. It has twenty-nine thousand cubic feet of pressurized space and is 357 feet long. It has as much room inside as a Boeing 747 jumbo jet, but creature comforts are few and far between. Each astronaut lives in a tiny, vertical crew compartment with an upright sleeping harness, a light, a mirror, and their personal belongings. Because space is limited, astronauts try to make a set of clothes last several weeks.

There is no "up" or "down" on station, at least not as we think of it on Earth; a work station may be on a wall or on a ceiling. You might work on an experiment upside down or rightside up. Astronauts sometimes require a day or two to become spatially oriented and are sometimes nauseous during their first hours aboard. A typical mission lasts six months, thus completing the transformation of manned space flight from short-duration missions to long-endurance missions.

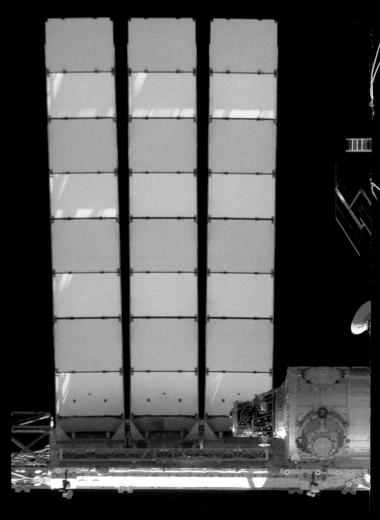

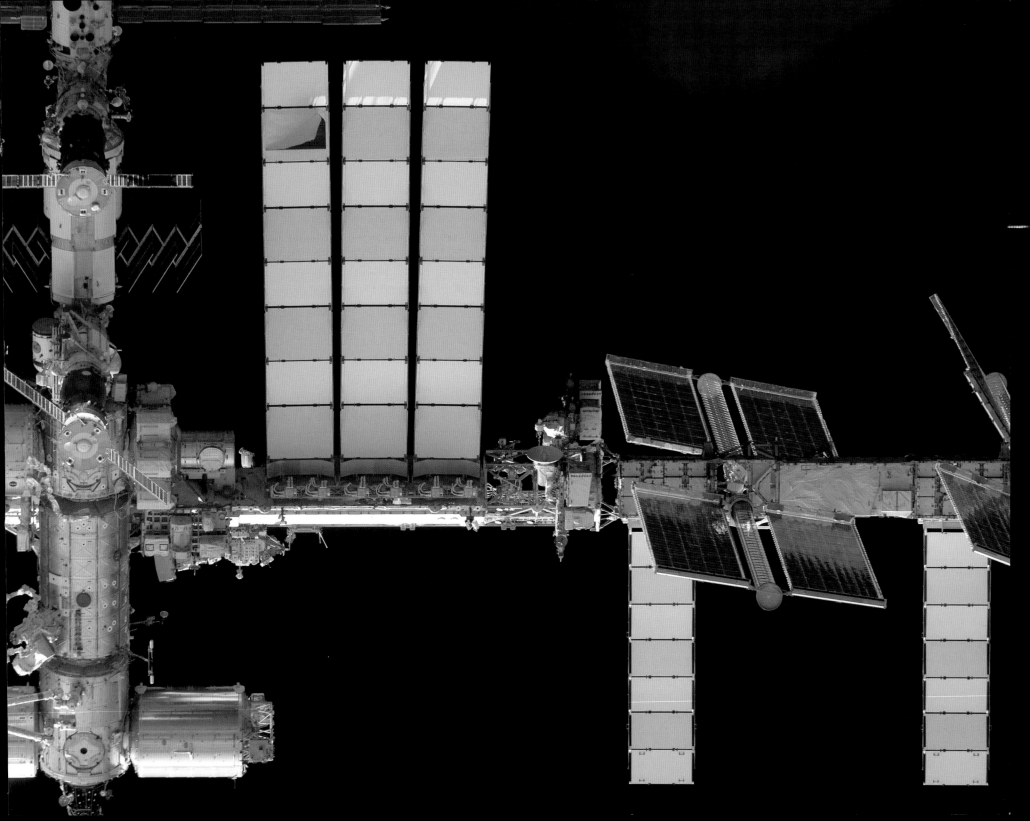

Soyuz-Progress

The three-man Russian Soyuz capsule is the sole vehicle for astronaut travel to and from space. After launch from the Baikonur Cosmodrome in Kazakhstan, the Soyuz will reach its orbital speed of 17,321 miles per hour in approximately eight and a half minutes but then will require some 2.2 days to rendezvous with the space station. For reentry, Soyuz uses a system of parachutes to land on the steppes of Kazakhstan, something one astronaut described as "being in a series of explosions followed by a car crash."

The Progress capsules are unmanned cargo ships. They are nearly identical to the Soyuz in appearance but used solely to transport cargo. A typical manifest is as follows—"1,918 pounds of propellant, 1,100 pounds of oxygen, 498 pounds of water, and 2,804 pounds of food, spare parts, experiment hardware, and other supplies for the crew members," or so said one delivery report. Progress is a one-shot vehicle. After it is unloaded, it's filled with trash, released from the space station, and burned up in the atmosphere.

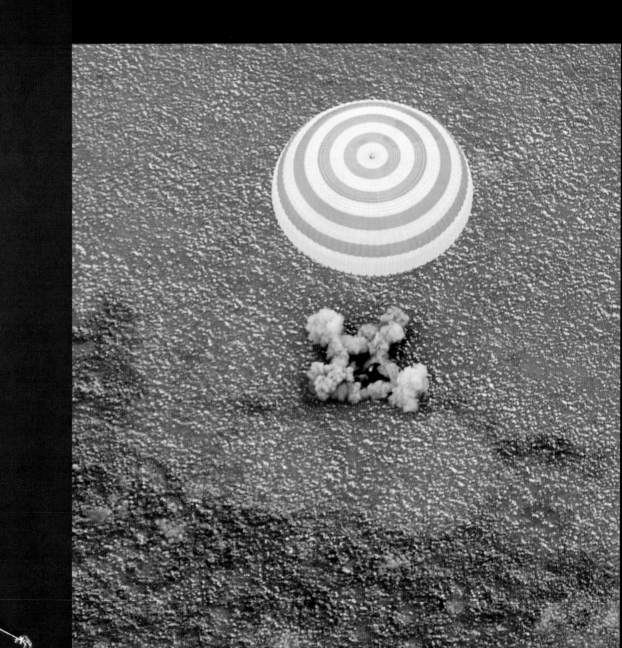

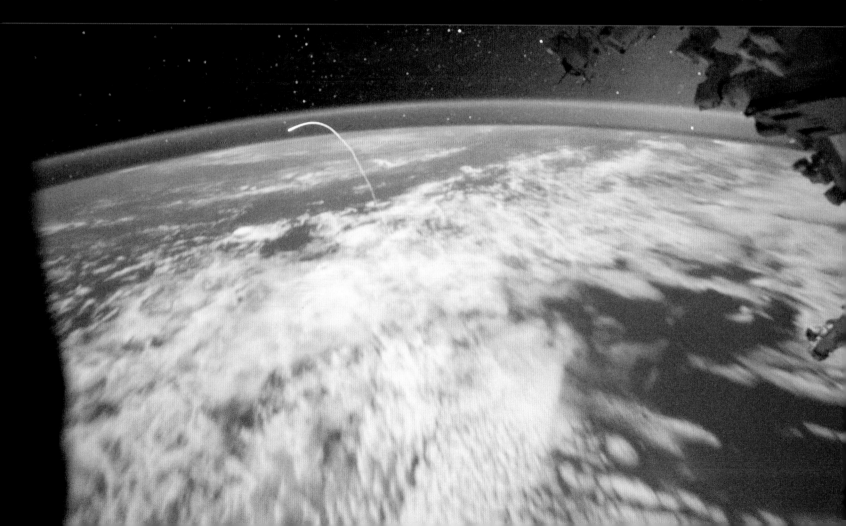

Unless otherwise noted, all photography. Courtesy Image Science and Analysis Laboratory, NASA/Johnson Space Center.

The Blue Marble Next Generation images pp. 3, 15, 59, 95, 109, 149, 161, 183 Courtesy NASA/Goddard Space Flight Center. Image by Reto Stöckli (land surface, shallow water, clouds). Enhancements by Robert Simmon (ocean color, compositing, 3-D globes, animation). Data and technical support: MODIS Land Group; MODIS Science Data Support Team; MODIS Atmosphere Group; MODIS Ocean Group. Additional data: United States Geological Survey EROS Data Center (topography); USGS Terrestrial Remote Sensing Flagstaff Field Center (Antarctica); Defense Meteorological Satellite Program (city lights).

Earth at Night 2001, pp. 8–9, courtesy NASA/Goddard Space Flight Center. (Data courtesy Marc Imhoff of NASA GSFC and Christopher Elvidge of NOAA NGDC. Image by Craig Mayhew and Robert Simmon, NASA GSFC.)

Map p. 3 Courtesy of the University of Texas Libraries, University of Texas at Austin.

Astronaut Sandra Magnus and the crew of STS-135 come home. This historic photograph captures the final flight of the space shuttle program.

INDEX

ABOUT THE AUTHOR

L. Douglas Keeney has a bachelor's and a master's degree from the University of Southern California and is the author of eleven books on military or American history. He is a cofounder of The Military Channel, a pilot, and a scuba diver, and has visited many of the cities in this book. He lives with his wife, Jill Johnson Keeney, in Louisville, Kentucky. You can visit his website at www.lightsofmankind.com.